Indigenous Beauty

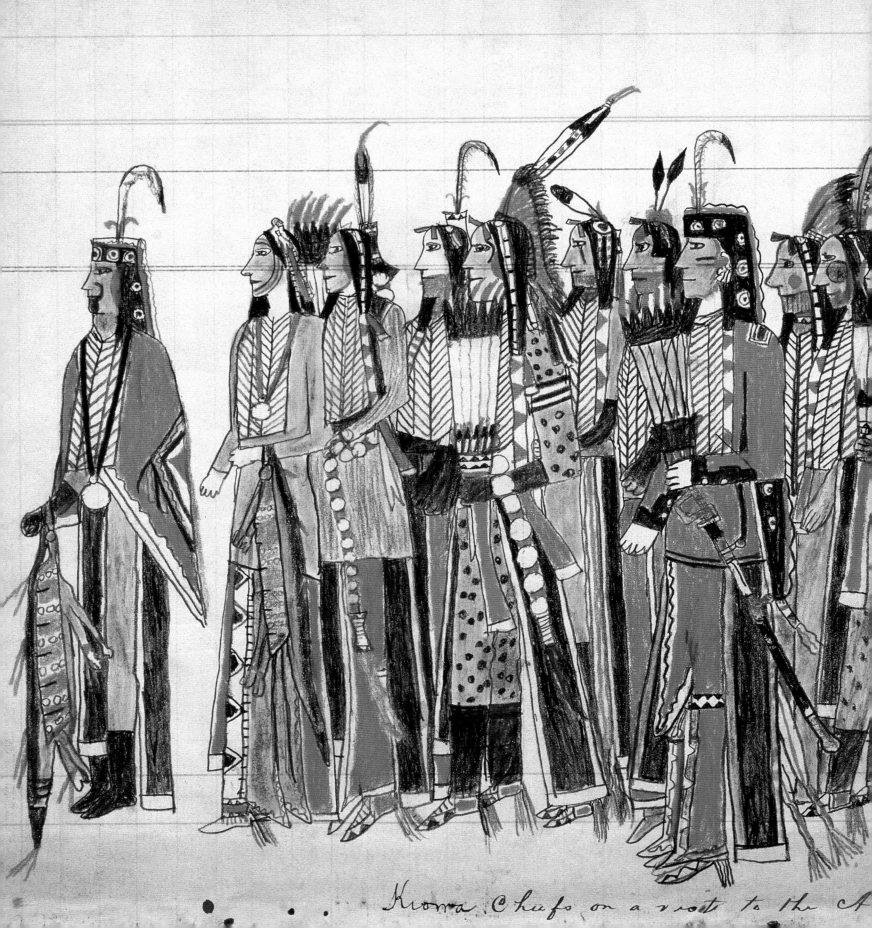

Kiowa Chiefs on a visit to the A

Indigenous Beauty

MASTERWORKS OF AMERICAN INDIAN ART
FROM THE DIKER COLLECTION

David W. Penney

**With contributions by Janet Catherine Berlo,
Bruce Bernstein, Barbara Brotherton,
Joe D. Horse Capture, and Susan Secakuku**

 SKIRA *RIZZOLI* NEW YORK

This catalogue is published in conjunction with *Indigenous Beauty: Masterworks of American Indian Art from the Diker Collection*, an exhibition organized by the American Federation of Arts.

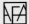

Exhibition Itinerary

Seattle Art Museum
February 12 – May 17, 2015

Amon Carter Museum of Art, Fort Worth
July 5 – September 13, 2015

Michael C. Carlos Museum,
Emory University, Atlanta
October 8, 2015 – January 3, 2016

Toledo Museum of Art, Ohio
February 14 – May 11, 2016

Indigenous Beauty: Masterworks of American Indian Art from the Diker Collection is made possible by the generosity of an anonymous donor; the JFM Foundation; the Brown Foundation, Inc., of Houston; and Mrs. Donald M. Cox.

The American Federation of Arts is a nonprofit institution dedicated to enriching the public's experience and understanding of the visual arts, and which organizes art exhibitions for presentation in museums around the world, publishes exhibition catalogues, and develops educational programs.

The American Federation of Arts is grateful to the following for their support: Ms. Lee White Galvis, Mr. and Mrs. Gilbert H. Kinney, Ms. Elizabeth Klein, Mr. and Mrs. Robert E. Linton, Ms. Clare E. McKeon, Mr. and Mrs. James J. Ross, and Mr. and Mrs. Stanford Warshawsky.

Guest Curator: David W. Penney

For the American Federation of Arts:
Managing Curator: Suzanne Ramljak
Manager of Publications and Communications: Audrey Walen
Editor and Interim Manager of Publications: Kate Norment

For Skira Rizzoli:
Publisher: Charles Miers
Associate Publisher: Margaret Rennolds Chace
Editor: Susan Homer
Design: Roy Brooks, Fold Four, Inc.
Design Coordinator: Kayleigh Jankowski

Library of Congress Control Number: 2014952883

ISBN: 978-0-8478-4523-1 (Skira Rizzoli hardcover)
ISBN: 978-1-885444-44-8 (AFA paperback)

First published in the United States of America in 2015 by

Skira Rizzoli Publications, Inc.
300 Park Avenue South
New York, NY 10010
www.rizzoliusa.com

in association with

American Federation of Arts
305 East 47th Street, 10th Floor
New York, NY 10017
www.afaweb.org

Photo Credits
Unless otherwise noted, all photographs of works of art reproduced in this volume were provided by the Charles and Valerie Diker Collection, and photographed by Dirk Bakker.

On the front cover: Maskette, 1780–1830 (cat. 1); Heddle-woven sash, ca. 1800 (cat. 116, detail)
On the back cover, clockwise from left: Qötsa Nata'aska Katsina, 1910–30 (cat. 54); Water jar, ca. 1900 (cat. 63); Heddle-woven sash, ca. 1800 (cat. 116, detail); Basket bowl, 1907 (cat. 44)

Printed in China

Contents

Foreword

Charles and Valerie Diker

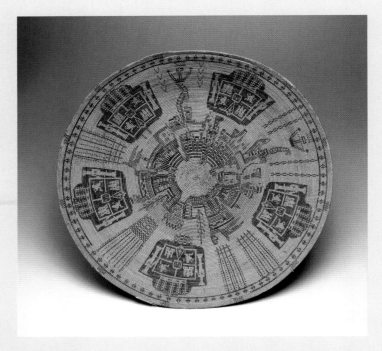

When the American Federation of Arts (AFA) approached us about organizing a traveling exhibition of our collection, we were intrigued. Previously our collection had been shown primarily in New York City—at the Metropolitan Museum of Art and the Smithsonian Institution's National Museum of the American Indian. Only a selection of our contemporary Plains Indian dolls had been exhibited elsewhere—at the Denver Art Museum and at the National Museum of the American Indian in Washington, DC. We saw the AFA exhibition as an opportunity to share the full range of our collection in other venues across the United States.

Our collection was last shown in 2004–5. Since then it has grown substantially, with additions from all across North America. We have chosen to make our collection encyclopedic in nature, rather than focusing on one region or one type of object. It includes pieces from the Northwest, the Southwest, the Great Lakes, the Eastern Woodlands, the Northeast, and the Southeast. Our rationale for exhibiting the collection once again is that we would like to introduce more people to the infinite beauty and diversity of these Native American objects, as well as to their cultural and historical significance.

Having previously immersed ourselves in viewing and collecting modern art, we look at American Indian art with a perspective that is primarily aesthetic rather than ethnographic. Our eye for indigenous art has been influenced by many considerations that evolved out of collecting modern and contemporary art.

When we were first shown the tightly woven Chumash basket bowl (fig. 1), for instance, we were struck by the juxtaposition of the abstract iconography in its center with the realistic-looking Spanish coins woven around its edge. Although the design may suggest a specific narrative or a spiritual meaning for its weaver, for us, the central pattern is a beautiful abstract moment within the overall design of this unusual nineteenth-century basket.

Another example of how Native Americans juxtapose design elements in a single work of art is found in our "pumpkin pot" (cat. 61). The top of this striking clay pot is decorated with abstract geometric designs common to artists of the Acoma Pueblo, while the bottom features depictions of plump, ripe pumpkins and full-grown grapes, which is more unusual. This unique piece was the first in our collection, and it continues to fascinate and engage us.

Other aspects of modern art that influenced our appreciation of Native American art include elements of surface, shape, design, and form: The patina of our Northwest Coast Indian sculptures is critical to the refinement of each piece. The shapes of our baskets and pots are an essential aspect of their beauty. The intricate, balanced patterns in our beadwork often convey a sense of contemporary design. The forms of our carved wooden pieces create abstract, sculptural drama.

To us, a magnificent carved wooden gunstock club from the western Great Lakes (fig. 2) looks like a modern sculpture; it combines a handsome surface, an elegant shape, a minimalist design, and an abstract form. This gunstock club is one of our most prized pieces— we call it our Brancusi!

In collecting modern art, we often seek the work of specific artists from a particular period. With Indian art, however, we are primarily interested in the aesthetics of each piece and its geographic origin; in most cases we do not know the identity of the specific creator. In both realms of our collecting, simplicity and refinement remain of paramount importance. Although we are not experts in the fields of American Indian culture or history, we recognize that the objects we love so much have long and sometimes tangled histories. While assembling our collection, we have learned a great deal from anthropologists, art historians, Native scholars, artists, and others who have helped to enrich our collective understanding of these marvelous treasures.

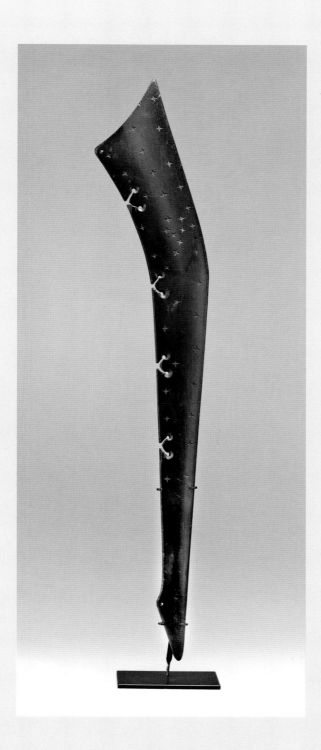

Fig. 2. Gunstock club, ca. 1800.
Pawnee (?), Nebraska. Wood,
red ochre pigment, 27 ½ × 4 ⅝ in.
(69 × 11.5 cm). Diker no. 744

Native American art is not only singular in itself, it has also had significant impact on some of the best-known artists of the twentieth century, including Surrealists such as André Breton and American Abstract Expressionists such as Jackson Pollock, Adolph Gottlieb, and Isamu Noguchi. Influenced in much the same way that the Cubists were influenced by African art, modern artists seem to have found inspiration in the complex abstractions of Native decorative arts, as well as the visionary qualities of many Native expressions of spiritual belief.

For us, one of the most creative parts of collecting is deciding how to display works that represent varying cultures. We enjoy combining Native American and modern art and we find that they "speak well" to each other. The placement of our objects may be based on color, design, subject, shape, or size, and we love to change the location of pieces. Creating new combinations of familiar objects and displaying them in new contexts gives them an entirely different visual impact, allowing us to see these pieces differently than we have ever seen them before.

On one wall we have a painting by Pablo Picasso of Marie-Thérèse Walter, while on a table nearby is a contemporary clay pot by Tammy Garcia that has a stopper on which is painted a Cubist face. Garcia is clearly responding not only to her own Native traditions but also to a worldly understanding of modern art. On another wall is a serene gray-and-white portrait of two women by the contemporary Chinese artist Zhang Huan; on the dark wooden floor below stands a large Tesuque *olla*, or water jug, patterned in soft black on off-white clay. Under a hot pink, red, and smoky white painting by Mark Rothko lives a tall wooden Salish sculpture of a human figure. Beside this sculpture sits a prize-winning Washoe *degikup* basket, woven by the incomparable Datsolalee.

We will miss our Indian treasures while they are exhibited across the country. These beautiful objects have become part of our family; they are important in our lives. We love living with them and consider ourselves fortunate to be surrounded by their dynamic spirit.

We consider American Indian art to be the first art of the United States. It is our great hope that by sharing our collection, we will give others the opportunity to experience these monumental objects and the magic of their presence—and to be touched by the universal appeal of their beauty.

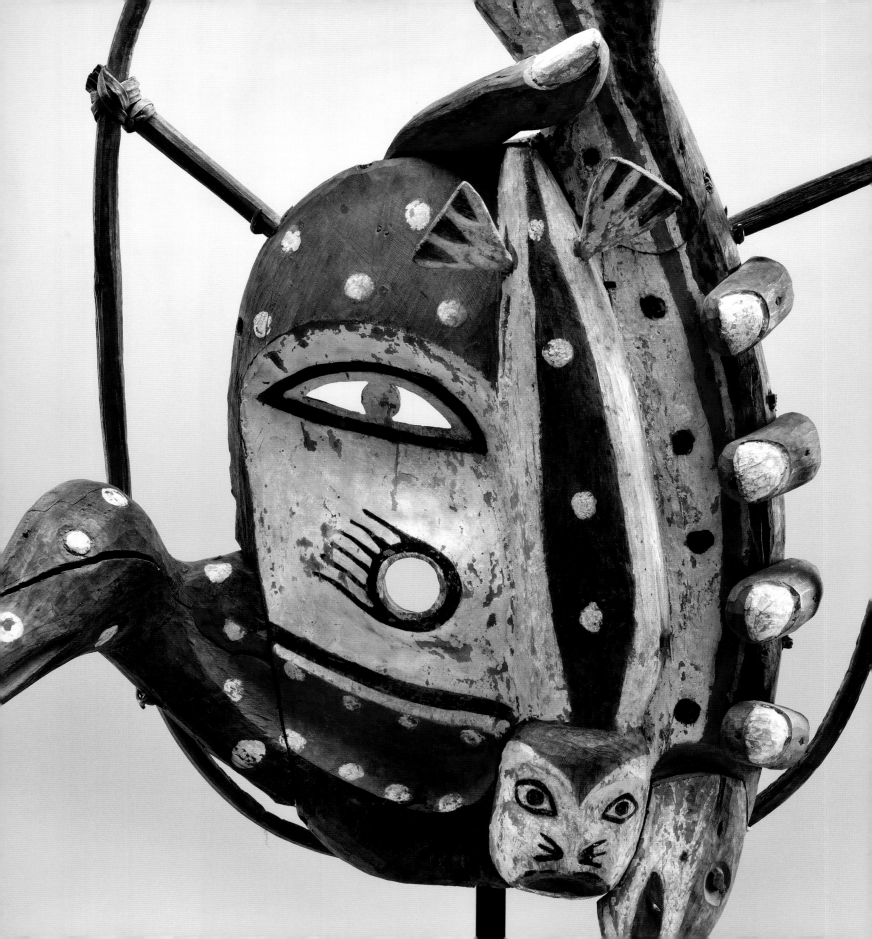

Acknowledgments

This exhibition, selected from the celebrated collection of Charles and Valerie Diker, offers the rare opportunity for audiences to experience the extraordinary diversity of Native American art. *Indigenous Beauty: Masterworks of American Indian Art from the Diker Collection* includes more than 120 fine examples from tribes across the North American continent. It is gratifying for us to help share these superb holdings with viewers throughout the United States.

This exhibition would never have occurred without the vision and generosity of Charles and Valerie Diker. Their commitment to the project and enthusiasm for sharing this work with a broad audience have been fundamental in immeasurable ways. While selections of the collection have been presented at the Metropolitan Museum of Art (1998–2000) and the Smithsonian National Museum of the American Indian (2003–6), this is the first traveling exhibition drawn from the Dikers' collection, and it features numerous recent acquisitions that have never before been seen by the public. It has been our honor to work with the Dikers on this important project.

We are indebted to the exhibition's guest curator, Dr. David Penney, for selecting works that emphasize the interrelated themes of diversity, beauty, and knowledge, and for bridging present-day values with Native realities inherent in the objects. David's expertise and knowledge were essential to the success of this project, and we heartily thank him.

This publication benefits from the insightful contributions of Janet Berlo, Professor of Art History/Visual and Cultural Studies at the University of Rochester; Bruce Bernstein, Executive Director of the Continuous Pathways Foundation, Pueblo of Pojoaque, New Mexico; Barbara Brotherton, Curator of Native American Art at the Seattle Art Museum; Joe D. Horse Capture (A'aninin), Associate Curator at the National Museum of the American Indian; and Susan Secakuku (Hopi), curator and consultant to museums and cultural organizations.

We also wish to extend our gratitude to Betsy Shack Barbanell, Collections Manager for the Diker Collection, and to Francine Sheridan, Executive Assistant to Charles Diker. The staff of the AFA deserves appreciation for their exceptional work on behalf of the exhibition and publication, with special thanks to Anna Hayes Evenhouse, Associate Director for Exhibitions; Suzanne Ramljak, Curator of Exhibitions; Kate Norment, Interim Publications Manager; Audrey Walen, Manager of Publications and Communications; Shira Backer, Curatorial Assistant; and Elizabeth Abbarno, Registrar. We would also like to acknowledge Margaret Chace of Skira Rizzoli and her excellent staff for collaborating with us to co-publish this significant volume, especially Roy Brooks for his skillful book design and Susan Homer for her editorial expertise. We are so very appreciative of their work. Critical funding for this project has been provided by the JFM Foundation, Mrs. Donald Cox, and an anonymous donor. We are deeply grateful for their support.

We also extend a special thanks to the participating venues on the exhibition tour: the Seattle Art Museum; Amon Carter Museum of Art, Fort Worth, Texas; Michael C. Carlos Museum, Emory University, Atlanta; and the Toledo Museum of Art, Ohio.

Pauline Willis
Director, American Federation of Arts

Indigenous Beauty: An Introduction to the Diker Collection

David W. Penney

Charles and Valerie Diker's collection of Native American art is one of the largest, most comprehensive, and most qualitatively superb currently in private hands. Numbering nearly four hundred pieces, it has been assembled over the past forty years by collectors informed by modernist aesthetic sensibilities and by their astute engagement with the auctions, dealers, and galleries that comprise the marketplace for Native art and artifacts. *Indigenous Beauty*—and the two exhibitions that have preceded it[1]—invite broad public and critical consideration of the collection, its significance, its educational potential, and its capacity to inspire wonder, curiosity, and aesthetic delight.

Charles and Valerie Diker are drawn particularly to the *aesthetic* qualities of Native American objects as works of art. Here, the Dikers have followed the lead of earlier generations of modern artists and theorists of modern art. "Primitive art," as the work of indigenous artists from around the world was once known, prompted early twentieth-century artists to reconsider their own European-bound traditions of art and aesthetics. These artists were inspired by the qualities of abstraction they observed in the creations of indigenous peoples and, moreover, sought to evoke the kind of humanistic spirituality they sensed within them. In an essay addressing the Diker Collection, art critic Donald Kuspit explains that, for these artists, the "aesthetic aspect" of Native American objects "invariably signif[ies] spiritual depth and complexity."[2] The elevation of Native American objects to the status of "art" over artifact is accomplished, given this kind of reasoning, through a modernist lens that privileges visual form and its expressive potential to engage innate human capacities for aesthetic and spiritual experience.

The Dikers began their collection with works by some of the great modernist masters, including Jean Arp, Joan Miró, Pablo Picasso, and Alexander Calder, and their appreciation for these artists and their ideas naturally led to their own interest in American Indian objects. In the Dikers' Fifth Avenue home (fig. 3), their Native American collection is juxtaposed with paintings by Jean Dubuffet, Mark Rothko, and Ellsworth Kelly, along with other contemporary works. This installation of their collections was, they say, inspired by their experience of the Museum of Modern Art's exhibition *"Primitivism" in 20th Century Art: Affinity of the Tribal and the Modern* (1984–85). In that landmark but controversial exhibition,

William Rubin, the director of the museum's department of painting and sculpture at the time, with the collaboration of art historian Kirk Varnedoe, examined the early twentieth-century modernists' aesthetic engagement with "ethnographic" objects and proposed "affinities" between those objects and the works of artists such as Picasso, Constantin Brancusi, Matta, and Paul Klee.[3] Curatorial concerns aside, the experience of seeing modernist and indigenous "masterpieces" from around the world installed in visual dialogue with one another was an undeniable thrill for many viewers.[4] The reverberations of that experience are apparent throughout the Diker residence, where paintings, sculpture, and assemblage are intermingled freely with baskets, beaded garments, and masks.

Of course, the notion of a global, humanist art, arrived at historically in part through a reconsideration of "primitive art"—the thread explored by the MoMA exhibition—raises some significant issues. The absorption of American Indian art into the canon of world art in the twentieth century can be characterized as "art by appropriation" in contrast to "art by intent," to borrow the expressions developed by anthropologist Muruška Svašek.[5] Art by appropriation refers to the act of taking an object intended for a very different purpose and reclassifying it as art, as famously demonstrated by Marcel Duchamp when he "appropriated" a common ceramic urinal, titled it *Fountain*, and submitted it as a work of art to the 1917 Society of Independent Artists exhibition in New York (it was rejected).[6] Likewise, many of the objects featured in *Indigenous Beauty* were never intended for display in a museum or art gallery, and yet they have been appropriated as art through a long historical process that has included modernist interventions such as Duchamp's and a consequent redefinition of what is meant by "art."

Narrowing the viewer's focus to the visual and material attributes of objects is arguably one result of this process: Duchamp's *Fountain* becomes a convincing abstract sculptural form if one forgets, for a moment, its original purpose. His Dadaist act also highlights the role of the gallery or museum in constituting an object as a work of art. Whether a urinal or an American Indian smoking pipe—to take another example—an object becomes "art" when displayed in a gallery as such. In this context, objects invite the viewer to privilege their visual properties and to experience whatever aesthetic pleasures they may evoke. For some observers, however, this response may not be possible. The organizers of the 1917 Independents' Exhibition, for instance, could not see past *Fountain*'s lavatorial associations and characterized the work as "indecent." In 1992, indigenous social activists forced the removal of American Indian smoking pipes from an exhibition at the Minneapolis Institute of Arts, arguing that their display as "art" in that context was sacrilegious. These reactions emphasize the fact that the appropriation of an object into an art gallery is a culturally rooted act. Rather than recognizing the innate "artfulness" of certain kinds of objects, such appropriations insist on the reconsideration of objects in a particular, modernist way that may be inconsistent with or even inimical to other kinds of cultural understandings. Art historian Steven Leuthold approaches aesthetics

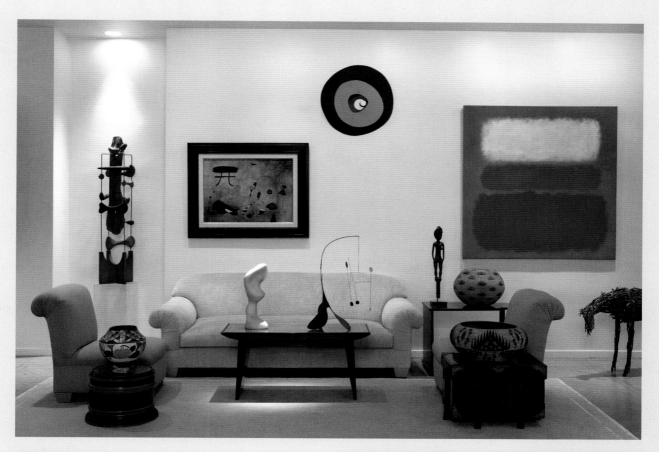

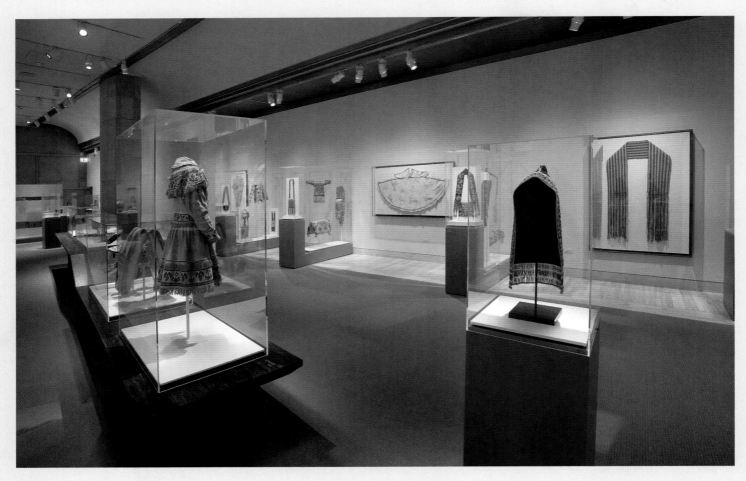

Fig. 4. Installation view of *First American Art: The Charles and Valerie Diker Collection*, at the National Museum of the American Indian, New York, 2004–6. This type of installation, in which beautiful objects are isolated in cases designed to make them visible while providing security, is the way most twenty-first-century museumgoers experience American Indian art.

as culturally specific systems of values and actions, which at their foundation may be linked to ethics, politics, economics, and religion.[7] He argues that, in addition to western aesthetics, there are many distinctive, culturally determined "indigenous aesthetics." The appraisal of objects based on purely visual criteria is a culturally constructed experience that derives partly from modern aesthetic theory and practice. Neither innate nor culturally "universal," this way of looking at objects must be learned, practiced, and developed as a skill, as any docent in a modern art museum well knows. This kind of cultural knowledge, burnished to a high level of sophistication and skill, has informed Charles and Valerie Diker as they have built their collection of Native American art.

Most viewers seeing the objects in this exhibition will initially draw upon similar skills and a familiarity with viewing that is now fairly common among the museum-going public. Museums of art, with their conventions of presentation, depend on nurturing such skills and knowledge, and they invite still, quiet encounters that allow for personal epiphanies and points of connection. In this context, a thoughtful viewer might even reflect upon the culturally contingent nature of such experiences and their origins in modernist aesthetic theory. Certainly Pop art and postmodernism, along with the work of a

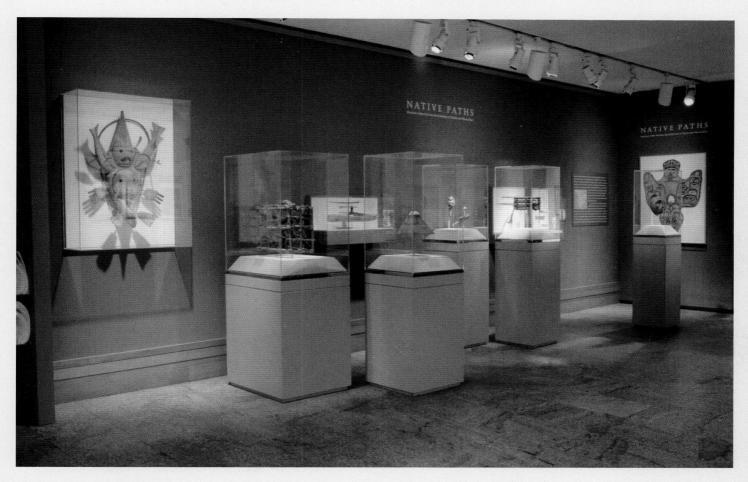

Fig. 5. Installation view of *Native Paths: American Indian Art from the Collection of Charles and Valerie Diker*, at the Metropolitan Museum of Art, New York, 1998–2000. © The Metropolitan Museum of Art. Image source: Art Resource, NY

rising number of international and indigenous artists within the contemporary art world, encourage readings of diverse cultural codes and references. While the formal qualities of the many superlative objects from the Diker Collection may inspire a kind of modernist aesthetic appreciation of form and abstraction, as well as a generalized humanistic and spiritual connection, even the most casual observer will, inevitably, also be drawn to reflect upon whatever cultural knowledge, assumptions, or predispositions he or she may have about American Indians.

A culinary implement, an article of clothing, a receptacle for storage or conveyance —these were some of the purposes once served by objects in the Diker Collection, before they were "reconsidered" as works of art. With questions of cultural meaning and historical context, the focus turns back to their original intents and cultural utility, their functions and purposes. Do these objects then revert to the category of "artifact," as some have argued? The contrast between "art" and "artifact" is again our own distinction, one rooted in contemporary theories about art on the one hand and ethnography on the other. The notion of an artifact suggests evidence —a sample or data that, when analyzed, quantitatively constructs a particular kind of scientific knowledge. But the present-day and historically

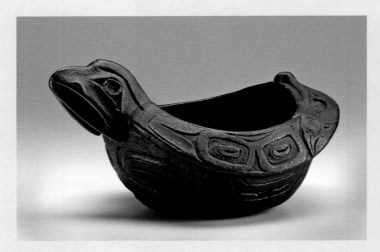

Fig. 6. Grease dish, ca. 1750 (cat. 23)

constructed distinctions between the categories of art and artifact have little bearing on the cultural values that determine the identities and meanings of objects within their source communities. Such meanings are internalized by members of a given community by virtue of their participation and experience. As curious outsiders, we seek at best a partial translation of that cultural experience in terms we can comprehend. To this end, the objects in the Diker Collection offer the potential for something more than aesthetic appreciation as artworks or scientific analysis as artifacts: they act as invitations to explore other worlds.

When the Dikers began to collect Native American art, they decided to consider objects from all across North America, rather than specializing in one particular area or region. This inclusive approach to collecting was consistent with prevailing attitudes about the unity of Native American culture as distinct from the cultures of Europe, Africa, or Asia. However, though "American Indian" is a familiar category, it is also an artificial one, since the term refers collectively to many hundreds of indigenous cultures and the thousands of independent communities that existed in the lands now occupied by the United States and Canada. In the United States alone there are more than 565 sovereign indigenous Nations currently recognized by the federal government, more still seeking recognition, and more still who, by death, attrition, or merging with other groups, became extinct. The terms "Native American," "American Indian," and "First Nations" reference this great diversity of indigenous peoples, distributed across a vast continent.

As the Dikers began to broaden their collection, they realized that the objects they encountered fell into many different formal categories: pottery, distinguished by designs unique to individual villages or Pueblos; beaded and embroidered pouches, moccasins, and garments, representing seemingly countless tribes, each favoring different techniques, color combinations, and other formal attributes; baskets from various locations on the West Coast, each differentiated by materials, shapes, and designs; and so on. The range of objects reflects not only the diversity of American Indian cultures but also diverse responses on the part of artists and their communities to historical developments that played out over centuries. The diversity of the Dikers' collection belies the generalities, stereotypes, caricatures, and facile characterizations that come with narrowly conceived ideas of American Indian cultures.

Making sense of the great visual and material variety of the Diker Collection requires extensive knowledge. There is a long distance, temporally and culturally, from the present day to the times and places when and where many of these objects were originally made, used, and circulated. The educational potential of the objects within the collection stems in part from their connection to the past, to the skilled acts of fabrication that produced them, and to the various communities through which they passed. Objects are connected to social worlds through memories, stories, dances, songs, ceremonies, replicas, and through their influence on other related categories including documents, field notes, letters, invoices,

inventories, catalogue records, and exhibitions such as this one. These traces help to restore an object's origins, and to reveal something of its journey. This deeper understanding expands our own perspective, allowing us to experience more than the simple wonder and pleasure evoked by purely aesthetic consideration.

Like art appreciation, traditional Native American art making relies on vast cultural knowledge. This includes information about the collecting and processing of materials that will become media; about techniques of manufacture as well as design repertoire; and, perhaps more unexpectedly, about song, prayer, and ritual, which may be considered integral to the process of creating a work. As a result of difficult, sometimes cruel histories, objects such as the ones in the Diker Collection have become separated from these bodies of knowledge, as they were sold, given away, or otherwise removed from the communities in which they were made and used. The names of the makers and the details of their lives are often lost as well, further impoverishing our knowledge. Even for known artists—frequently, those who produced objects specifically for trade or sale outside their communities—the curio and crafts market tended to conceal or misrepresent individual identities and life stories in favor of "primitivist" stereotypes. Over the last few decades, however, scholarship and collaborative efforts between museums and indigenous communities have recovered some of this information, increased the accuracy of provenance, and even unearthed the histories of particular objects.

It is most enlightening to consider each object independently, and in this catalogue, the authors direct their attention to some of the particular qualities and unique histories of individual masterworks. But beyond presenting the collection object by object, this exhibition organizes it in ways that emphasize broad historical trends and commonalities in regional artistic traditions within the greater diversity of indigenous North America. The pages that follow present eleven clusters, each corresponding to several coordinates relating to object type, technique of fabrication, place of origin, and historical period. In some ways, the result resembles the "cultural region" approach, common in writing about American Indians since the beginning of the twentieth century.[8] Unlike cultural regions, however, the groupings in this book are not defined by geography alone. Though geography and geographical proximity played important roles in the development of regional artistic traditions, the clusters show how permeable and expansive such traditions may be within dynamic, pan-generational histories of American Indian art. The groupings are not intended to be definitive but rather to suggest distinct themes and episodes in the art history of indigenous North America. Each cluster is introduced by one of several scholars, each with a slightly different background and set of interests, who have selected a few particular works for more extensive commentary.

The first cluster represents a particular strength of the Diker Collection and a regional tradition of longstanding interest to enthusiasts of modernist abstraction. The Nations of the British Columbia coast and southwestern Alaska—the Tlingit, Haida, and Tsimshian—created a rigorous sculptural practice to convey ancient

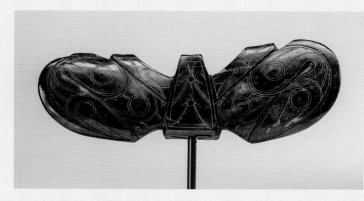

Fig. 7. Harpoon counterweight
(Winged object), 5th–9th century
(cat. 32)

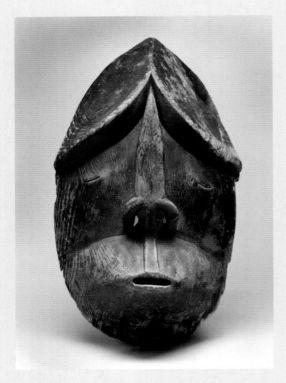

Fig. 8. Mask, ca. 1870 (cat. 36)

family stories. This cultural heritage is embodied in masks, props, and rhythm instruments for dramatic performances, along with boxes, dishes, and spoons displayed at feasts known as potlatches, which are hosted by different families in turn. The Dikers' focus is mainly on rare objects dating to the first half of the nineteenth century, which often entered into commerce through early exploration, missionary work, and whaling excursions. Their exquisite, small grease dish (fig. 6, cat. 23) was an heirloom when it was collected by the Reverend Robert James Dundas from the Tsimshian village of Metlakatla in 1863. Barbara Brotherton, Curator of Native American Art at the Seattle Art Museum, writes about this tradition, as well as about a second group of sculptural objects made by Salishan speakers of Oregon and Washington State.

I introduce the next grouping, a selection of carved and engraved implements from the Bering Strait region, made mostly of walrus ivory. Originating within ancient Arctic cultural groups whose territory once straddled present-day Russia and Alaska, the objects were recovered from middens on the sites of long-since abandoned settlements. These objects have been known to archaeologists only since the 1920s or so. The remarkable and enigmatic Old Bering Sea winged object (fig. 7, cat. 32), a fragment of a harpoon, has been included in several landmark exhibitions on both sides of the Atlantic as an exemplar of ancient Arctic artistic achievement.[9]

The Dikers have also assembled a small group of masks from the Arctic region. Surrealist expatriates newly arrived from Europe in the 1940s, such as Max Ernst, were particularly drawn to masks from Alaska's Kuskokwim River region, with their inventive portrayals of spirit creatures encountered by Yup'ik shamans during their visionary journeys (cats. 37–39). Startlingly abstract masks from the Aleutian archipelago region (fig. 8, cat. 36) are also included in this group. Art historian Janet Catherine Berlo offers her insights on both the formal qualities and the community contexts of these fascinating objects.

The Diker Collection is especially rich in California baskets, one of the earliest types of American Indian art to enter a broad market-place. These baskets were collected enthusiastically by Americans in the late nineteenth and early twentieth centuries, and were appreciated as forms of contemporary art or craft. Many California Indian families, even entire communities, threatened by oppressive American settlement and marginalized economically, organized themselves around basket production.[10] Patrons and artists found mutually agreed-upon aesthetic criteria: both valued fine workmanship, high stitch count, and formal innovation. Washoe basket artist Louisa Keyser, working under the pseudonym Datsolalee (a name invented by her dealer), gained some celebrity and obtained relatively high prices for her baskets during her lifetime (fig. 9). Other artists achieved renown by winning prizes at Indian fairs and "field days." Bruce Bernstein, a curator and anthropologist, writes sensitively about the artistic practices of basketry, and about the life stories and accomplishments of several of the greatest basket artists.

Susan Secakuku, a Hopi curator and community organizer, offers insight into the Dikers' small collection of Katsina dolls. The

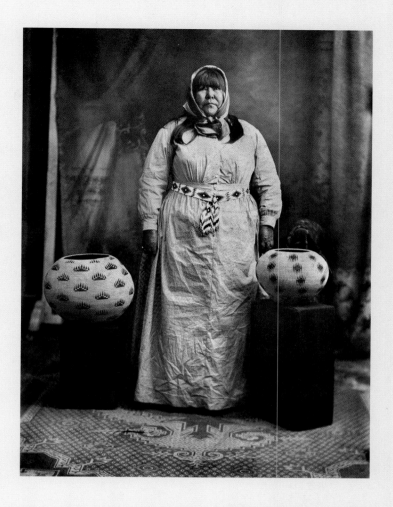

Fig. 9. Louisa Keyser (Datsolalee) with two of her baskets. Photo courtesy Nevada Historical Society

very private and insular communities of Hopi and Zuni in America's Southwest did not permit the sale of Katsina dolls to outsiders until the first decades of the twentieth century. One of the dolls in the Diker Collection still retains a sticker from the trader's shop at Hopi where it was sold (cat. 54). Other aspects of community religious life remain shielded from outside view, and the Zuni and Hopi peoples have sought repatriation of masks and other objects instrumental to Katsina ceremonies that had left their communities inappropriately to circulate in the art market. Secakuku eloquently describes the Katsinas' role in providing spiritual guidance and other assistance to Hopi people.

Pottery from the Southwestern Pueblos is represented in the Diker Collection by an impressive range of objects. The earliest works date from the twelfth century, while the most recent were made by artists still active today. Among the ceramic works assembled here, one can see the subtle responses of artists to the historical changes and challenges that faced their communities in the wake of first Spanish and later American colonization. The "Anglos" (Americans), in particular, who began to visit the region in great numbers by railroad as tourists in the late nineteenth century, helped to create a market for Pueblo pottery, inspiring major innovations in design

and technique. Around 1918, San Ildefonso potters Maria and Julian Martinez famously created the enduring "black-on-black" slip technique after studying ancient pottery shards recovered from archaeological excavations of ancestral Pueblo sites near their community (fig. 12, cat. 64). Early in the twentieth century, virtually all Pueblo pottery production turned to the outside market, and every generation since has built upon the work of their forebears with increasing innovation, creativity, and technical mastery. Bruce Bernstein describes some of this history in his essay.

The Dikers were fortunate to assemble a small collection of drawings made by men of several Plains Nations at a particularly poignant and consequential moment in their history. Drawn on the pages of bound books of paper (ledgers or diaries), a length of cotton muslin cloth (cat. 71), and a model tipi intended for sale as a curiosity (cat. 72), the drawings represent the life experiences of men as combatants in conflict or as participants in ceremony. They were created during a period of profound cultural change in the late nineteenth and early twentieth centuries, as traditional buffalo

Fig. 10. Qötsa Nata'aska Katsina, 1910–30 (cat. 54)

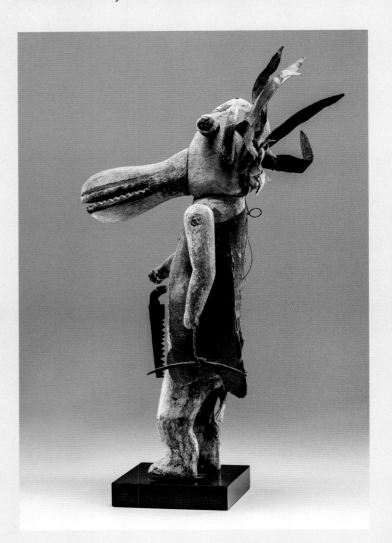

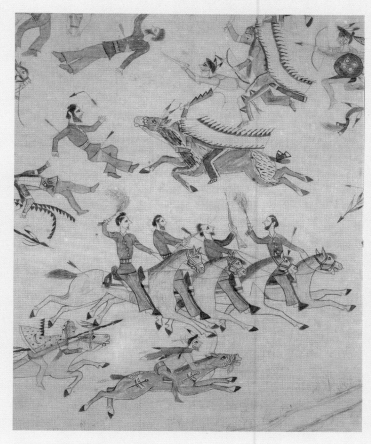

Fig. 11. Standing Bear, *The Battle of the Little Bighorn*, ca. 1920 (cat. 71, detail)

economies collapsed, armed resistance failed, and community life became confined to reservations administered by ill-informed and under-resourced government officials. The drawings build on an ancient Plains tradition in which men documented their battle honors using a pictographic visual language engraved on rock or painted on garments or lodges. In "ledgerbook art," as it has come to be called, men recorded notable incidents of combat or ceremonies that were then under assault by government officials. Such rituals can be seen in the pages of the famous Julian Scott ledger drawn by the unknown Ka'igwu (Kiowa) man known only as "Artist A" (cat. 74). "Regulations to Civilize the Indians," contained within government-issued documents for reservation officials, largely forbade religious practices and "Indian dancing."[11] Books of drawings like this one were purchased by sympathetic reservation workers, and by travelers, military men, and others, who saw the value of these works as documentation of a passing way of life. Janet Berlo, who organized a significant exhibition of Plains Indian drawings in 1996, writes insightfully about the Diker drawings.

Next follows a large and strong assortment of Plains formal clothing and personal accessories—pouches, bags, and storage containers—distinguished by elaborate geometric ornament in glass-bead appliqué or painting. The visual vocabulary and techniques were developed and passed down by women from generation to generation, as core cultural values of traditional femininity. During the latter half of the nineteenth century, a number of factors combined to reinforce strong tribal distinctions in beadwork styles, establishing a kind of national character in formal regalia worn for religious and social ceremonies. Apsáalooke (Crow)–style beadwork made from 1860 to 1920, with its oblong panels of pale blue and pink and intricately nested geometric shapes, is particularly easy to recognize (cat. 78; fig. 13, cat. 82), although the Apsáalooke's neighbors on the Plateau shared a variation of the style (cat. 86). The production of regalia and the social occasions on which it was worn persisted and even expanded in the context of reservation life, when traditional clothing became increasingly important as a means of expressing cultural resiliency and perseverance in opposition to baleful govern-ment policies. Joe D. Horse Capture, an A'ani (Gros Ventre) scholar and curator, writes about this important selection of objects from the Diker Collection, including a detailed account of an elaborate ensemble of miniature clothing and accessories combined in a contemporary ensemble of dolls made by Rhonda Holy Bear (cat. 77), one of the greatest artists working in the idiom of Plains traditional beadwork today.

The indigenous peoples of eastern North America have now endured nearly five hundred years of colonialism. Among a group of rare sculptural objects in the Diker Collection are several that reflect early diplomatic or commercial transactions between Native Nations and the newcomers; some of these objects descended through the families of military officers and administrators of the colonial era. An early and distinctive smoking pipe bowl in this group might have first changed hands as a diplomatic gift (cat. 99). The "fur trade"—

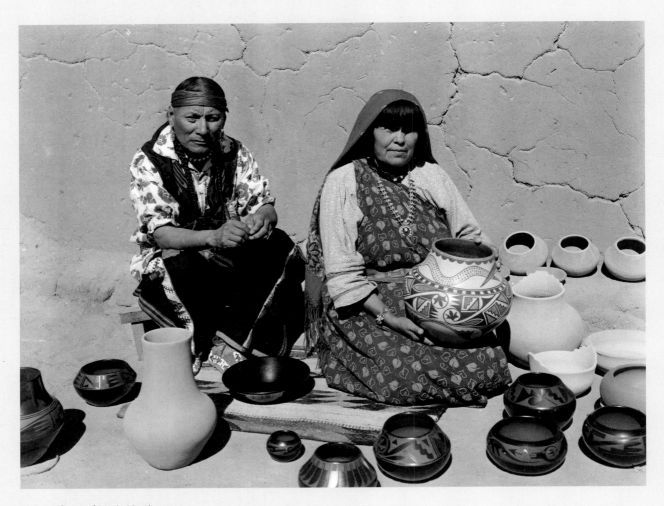

Fig. 12. Julian and Maria Martinez
displaying finished pottery, San
Ildefonso Pueblo, New Mexico,
ca. 1937–38 (?). Photo by Wyatt Davis,
Courtesy Palace of the Governors
Photo Archives (NMHM/DCA), New
Mexico History Museum, Santa Fe
(004591)

a shorthand term for the complex trans-Atlantic logistical arrange-
ments that facilitated the exchange of animal pelts for the products of
European factories—dominated social relations between European
and indigenous Native Nations for centuries. Protecting their
economic and territorial interests, Native Nations of the East became
implicated as allies or as enemies of Europe's imperialist ambitions
and struggles. Managing these relations required delicate diplomacy,
which was often accompanied by the exchange of various types of
gifts. Eastern sculptural objects preserved from old collections, such
as the clubs, drinking cups, and smoking pipes represented here, are
prized not only for their rarity and historical associations but also for
their simple, expressive forms—all of which are discussed in my text
on these pieces.

The final category of objects in this exhibition features the
clothing, regalia, and personal accessories of the eastern Nations.
These objects stem from long and difficult histories, as indigenous
Nations were forced to reconcile with the young United States and
Canada, which saw Native Americans only as obstacles to their growth
and development. The glass beads, milled cloth, and worsted yarns
used to make many of the objects included in this grouping began to

circulate through commercial transactions during the early days of the fur trade and continued to do so until the beginning of the nineteenth century, when tribal territories became overrun with homesteaders. The territorial expansionism that dominated the policies of the United States required, in the government's view, the acquisition of Indian land and the "removal" of indigenous nations from their homelands in the East and Midwest. The production of exquisitely fabricated and decorated garments made with trade materials received as part of, or purchased with the proceeds of, treaty payments and annuities inspired intense creativity. Elaborately beaded shoulder bags made by women of the Muscogee (Creek) Nation during their crises of removal and conflict were decorated with inventive designs that combined visual vocabularies of the ancestral past with motifs from European printed textiles (cat. 114). Clothing styles, techniques of fabrication, and motifs —particularly patterns loosely based on floral motifs — accompanied uprooted Native Nations during their removal to the West. The dynamism and ingenuity of these Eastern traditions, and their pan-generational evolution into the "Prairie" styles of Oklahoma (cats. 121, 122), are discussed in my text on these objects.

The eleven groupings just described encompass many of the pieces in the Diker Collection, but certainly not all of them. As a reminder that much lies beyond these categorizations, the clusters occasionally include other types of objects as acknowledgment of the fact that there are many different stories to tell. An exquisitely embroidered Acoma *manta*, or dress (cat. 62), for example, accompanies the Pueblo pottery section to indicate that the same dynamic trends visible in the history of this pottery can also be found in other expressive media of the Pueblos. A painted black ash splint basket made by a Mohegan woman from Connecticut (cat. 50), a continent's distance from the West Coast, is included among the group of California baskets to represent the indigenous basketmaking traditions originating in all corners of North America that helped indigenous people across the country to maintain cultural and economic viability. A shoulder bag (cat. 115) from northern British Columbia reveals, through its form and decoration, ties to the traditions of fur-trade material culture with deep roots in the Great Lakes region. And, finally, a few works by the contemporary Tlingit glass artist Preston Singletary (cats. 15, 34), including a collaboration with the Santa Clara potter Tammy Garcia, offer visual counterpoints to the Northwest Coast and Arctic ivory sections of the book, demonstrating that these ancestral works continue to inspire Native artists today.

In conclusion, while the Diker Collection entices museumgoers to linger over the aesthetic pleasures offered by this superb group of American Indian objects, the authors of this catalogue invite those who are curious to follow their impulses toward a greater understanding of the social and cultural worlds from which these objects came.

Fig. 13. Boy's shirt, ca. 1870 (cat. 82)

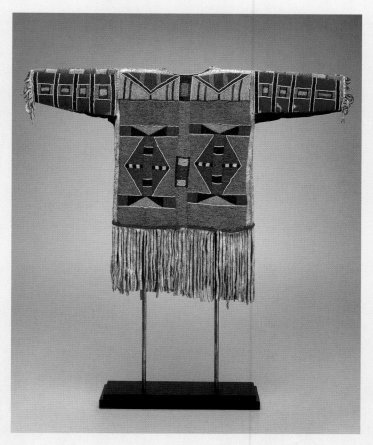

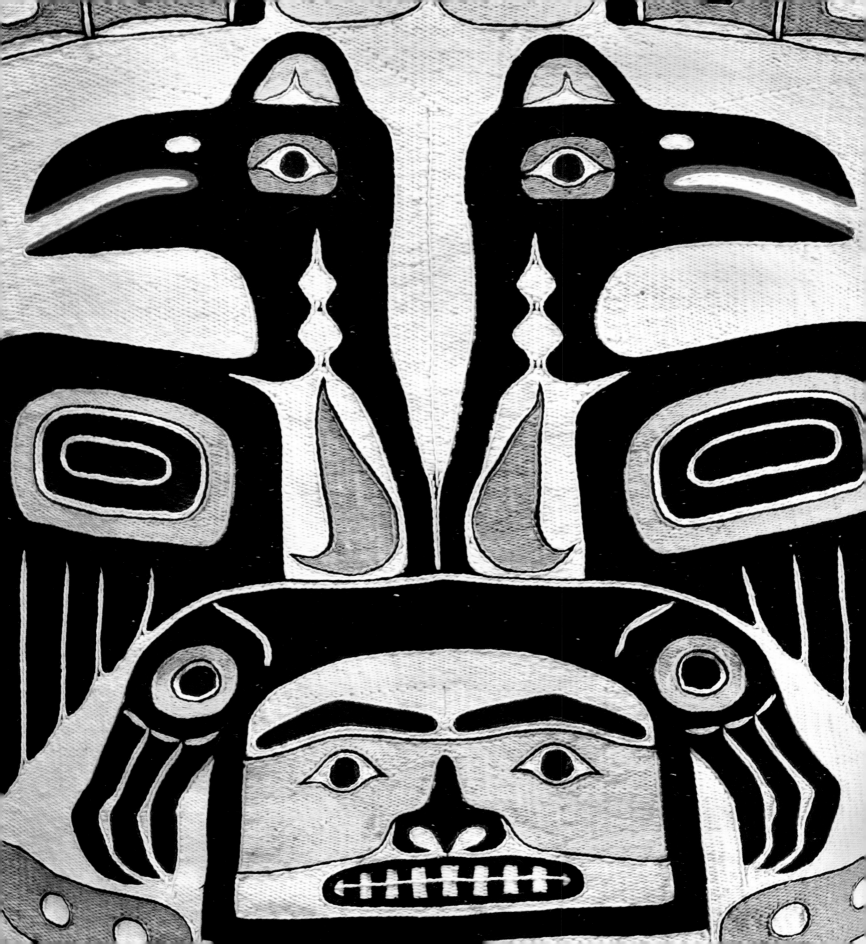

Sculpture and Formline Design of the Northwest Coast

Barbara Brotherton

The Native peoples of the Northwest Coast of North America, from the Columbia River to southeast Alaska, are linked by common material circumstances, especially reliance on salmon and cedar. Culturally, however, groups throughout the region have maintained unique approaches to art and ceremony that reflect the social, political, and aesthetic qualities distinguishing subregions, tribal groups, clans, and families. The social and economic structures that shaped the production of the visual arts developed more than five hundred years ago with the intensification of resource management, especially salmon fisheries, and the evolution of elite leadership roles and the ceremonies that validated them. In Native cultures throughout the coastal region, chiefs and heads of household maintained protocol in the social sphere while ritualists and shamans kept spiritual balance through their connections to the supernatural world. Artists supported the particular practices of chiefs and shamans with the production of cedar-plank houses, ocean and river canoes, feasting paraphernalia, and ritual regalia.

Archaeological research on the coast reveals a once-uniform practice of incising small-scale sculptures with engraved designs that incorporate features of humans and animals, along with representations of clan crests, family privileges (e.g., dances, songs, and names), and healing spirits. Since the archaeological record is scant, we have only glimpses into the stylistic evolution of Northwest Coast art. Some evidence suggests that the tradition of incising into wood, bone, antler, and stone to create positive and negative elements is very old, perhaps two thousand years or more. Environmental, cosmological, social, and cultural transformations may have contributed to stylistic changes over time, with some artistic modifications likely propelled by individual artists; this was certainly the case in the post-contact period of the late nineteenth century, for example, when Haida artists Charles Edenshaw and Tom Price refined the "formline" style in the late nineteenth century in influential ways.[1]

Examining an incised comb (figs. 14, 15) excavated near Prince Rupert, British Columbia, on the northern coast, dated to ca. 800–1000, and an antler pin (fig. 16) from the Lower Fraser River, on the southern coast, dated to 1100 BCE–350 CE, we see that a rudimentary division of positive and negative elements is created through simple, incised lines. For instance, the negative T- and Y-shaped incisions on

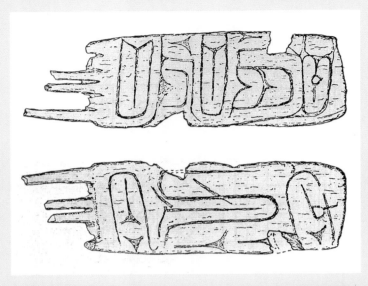

Figs. 14, 15. Photo and drawing of incised comb, ca. 800–1000. Tsimshian. Bone, length 3½ in. (8.9 cm). Canadian Museum of History, GbTo-34:1805

the surface of the comb and the lines cut out around the eye and beak of the bird are elementary means of accentuating the positive features of the creatures. Later on, art and cultural practices responded to local imperatives, creating a mosaic of idiosyncratic sculptural and decorative traits that distinguish the artistic output of the northern, central, and southern Northwest Coast. The archaeological record suggests that there was greater long-term consistency in the approach to sculpture and design in the southern region, resulting in a visual vocabulary closer to the original "root" style. The Wasco or Wishram bowl (cat. 28) in the Diker Collection displays aspects of this elementary embellishment, with faces and decorative elements made up of simple incised shapes. In contrast, the Tlingit, Haida, and Tsimshian built on that basic vocabulary over time by imposing symmetry on the overall design, which is ordered into units known today as "formline design" (see cats. 11, 13, 23, for instance).[2]

Bold sculptural forms and energetic graphic elements lend an identifiable look to the Native art of the northern Northwest Coast. The flowing lines that define the anatomies of a whole host of beings—meticulously fitted onto the curves of bowls, the lengths of totem poles, the tapers of spoon handles, and the facades of houses and chests, as well as woven into complex textiles—have lured enthusiasts and collectors since Europeans first came to the north Pacific coast in the late eighteenth century. These works provide a glimpse of what was certainly an ongoing evolution of the art form, both in sculpture and in two-dimensional design.[3]

Within the art of the northern Northwest Coast groups, the intricate two-dimensional formline design might seem like an indecipherable grid of lines and symmetrical units, but there are only a few basic principles of this rather flexible art: the organizing formlines, usually painted black, that outline the main design; secondary formlines, usually painted red, that define anatomical parts such as mouths and limbs; ovoids that function as eyes or joints; a variety of U-shapes that help to further elaborate the anatomy; and S-shapes, T-shapes (called trigons), and circular shapes that separate design units. While it is easier to see how the system works on flat pieces, such as house posts and boxes, artists cleverly maintained the integrity of the design as they decorated the curved sides of rattles, clappers, bowls, woven hats, and containers (fig. 17).

As one might expect, the principles of formline design have evolved over many generations, from their ancient beginnings to the present; they were likely refined by the innovations of carvers over time as tastes changed as well as, significantly, by colonialism, by the tourist market, and by contemporary trends. Fortunately for us, the Diker Collection is rich in objects that reflect the breadth of style on the southern, central, and northern Northwest Coast: the current grouping of objects includes more than a dozen Tlingit objects, five Tsimshian, and three Haida, including rare masks, feast bowls, baskets, and textiles. Masterworks in the collection reveal subtle group preferences as well as changes over time. An elegant, oil-encrusted bowl (cat. 21) exhibits the style at the time of contact (the late eighteenth century), a stately but static approach to surface design in

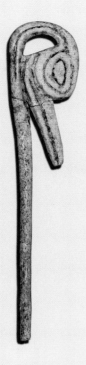

Fig. 16. Pin, 1100 BCE–350 CE. Lower Fraser River Salish, Marpole Site. Antler, height 5⅛ in. (13 cm). With permission of Musquearn Indian Band and courtesy of the University of British Columbia, Laboratory of Archaeology, Vancouver, Canada, MA8182

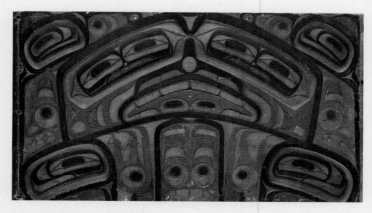

Fig. 17. Bentwood chest front, ca. 1840–60. Haida, Tsimshian, or Haisla. Yellow cedar, paint, 18 × 30 × 1 in. (45.7 × 76.2 × 2.5 cm). Seattle Art Museum, Gift of John and Grace Putnam, 2006.27. Photo by Elizabeth Mann

which the primary formlines are thick and large in proportion to the negative areas. A round bowl from a slightly later period (cat. 22) exhibits greater balance of positive and negative areas. A stunning painted design by Haida artist Tom Price (cat. 5), created in the late nineteenth century, reveals the stylistic preferences of his generation as well as his personal penchant for thin, rounded formlines.

Aspects of the formline design were adopted by women weavers who worked from pattern boards painted by male artists to create the iconic Chilkat textiles.[4] An exquisitely woven Chilkat tunic and leggings (cat. 7) from the late nineteenth century reveal vestiges of earlier Chilkat weavings in the hand-weaving techniques, in coloration, and in the inclusion of some formline elements. These elements, however, float within the design without the unbroken formline patterns of traditional weavings. This ensemble (and a similar robe) came from the Whale House in the village of Klukwan (Alaska) and might represent a particular weaver's style.[5]

The northern Northwest Coast groups shared common ceremonial practices that included initiations into secret societies and potlatch feasts hosted by chiefs to valorize their clans or to mark important life transitions. Masks, rattles, clappers, and feast bowls would have been brought out at these auspicious times. The hierarchical social structure was organized around clan membership, hence the need to display stylized yet recognizable crest creatures, such as the bear on the Tlingit dagger (cat. 19) and a whole host of crest animals carved on interior house posts and on freestanding memorial and mortuary poles.[6] While there is a consistency exhibited in the formline design, individual cultural groups maintained their own approaches to three-dimensional sculpture. The faces on the Tlingit mask (cat. 2) and the Tsimshian rattle (cat. 8) both have generally human characteristics, yet the more rounded contours of the Tlingit mask—with its sloping upper cheek and projecting mouth—differ from the pronounced skeletal structure and narrow lips of the Tsimshian face depicted on the rattle. In-depth studies in the last two decades have revealed nuances in the depiction of humans and animals in sculpture and two-dimensional design among Northwest Coast groups, providing insight into the unique approaches favored by individual groups.

Contemporary artists such as Preston Singletary have studied the traditional styles of their ancestors: a "modern" oystercatcher rattle (cat. 15) draws on a familiar iconography of the helping creatures used by Tlingit shamans to heal the sick, predict the weather, and guide warriors in battle. In Singletary's glass sculpture, he demonstrates his connection to the style of his ancestors, but envisioned in a new medium and for a new audience.

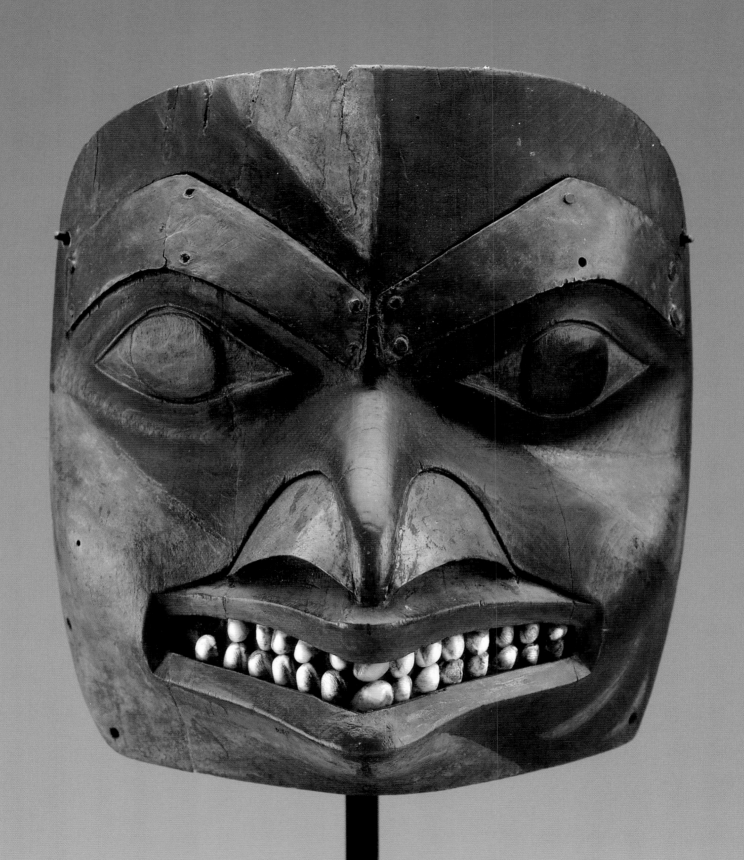

1.
Maskette, 1780–1830

Tsimshian, British Columbia
Wood, copper, opercula shell,
pigment
7 7/10 × 5 15/16 × 3 9/16 in. (18 × 15.2 × 9.2 cm)
Diker no. 681

2.
Mask, ca. 1850

Tlingit, Alaska
Wood, pigment
8 13/16 × 6 1/8 × 2 in. (22.5 × 15.6 × 5.1 cm)
Diker no. 545

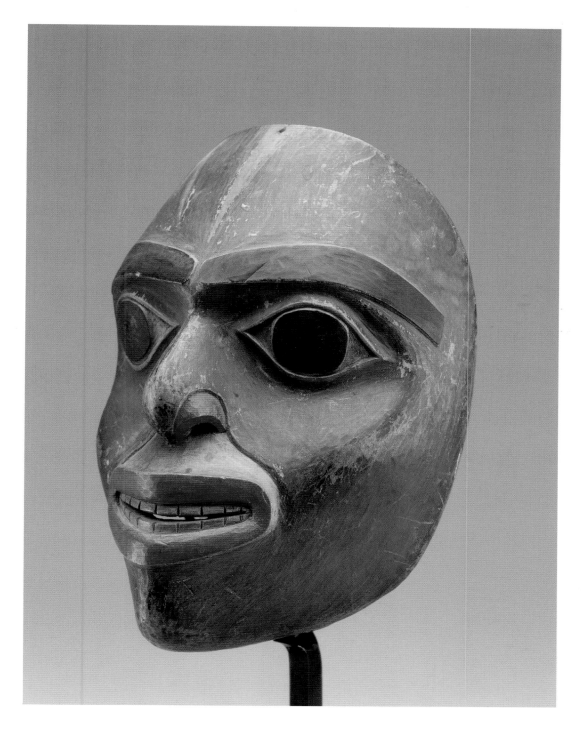

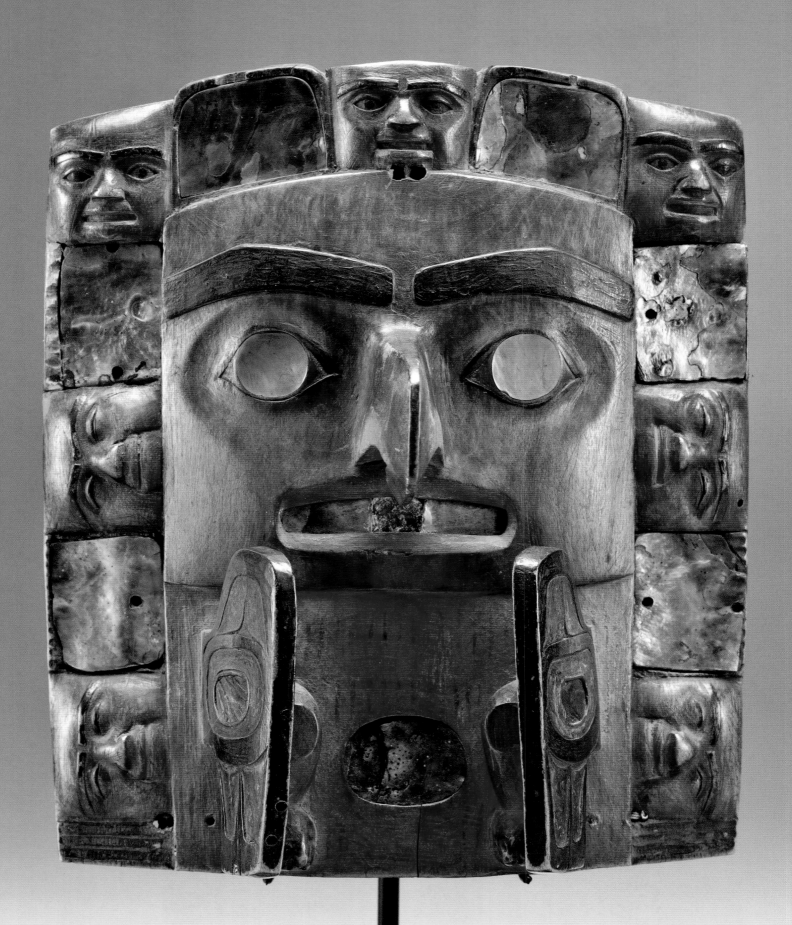

3.

Headdress frontlet, 1820–40

Tsimshian, British Columbia
Wood, abalone shell, pigment
7 × 6 × ½ in. (17.8 × 15.2 × 1.3 cm)
Diker no. 827

4.

Painted hat, ca. 1830

Tlingit or Chugach, Alaska
Spruce root, shell, ermine fur, glass
beads, pigment, cotton thread, hide
6¾ × 12⅛ in. (17.1 × 30.8 cm)
Diker no. 389

5.

**Painting attributed to Tom Price
(ca. 1860–1927)**

Haida, British Columbia

Hat, ca. 1895

Spruce root, paint, wood, ermine
pelt, cotton twine
10 × 12½ in. (25.4 × 31.8 cm)
Diker no. 811

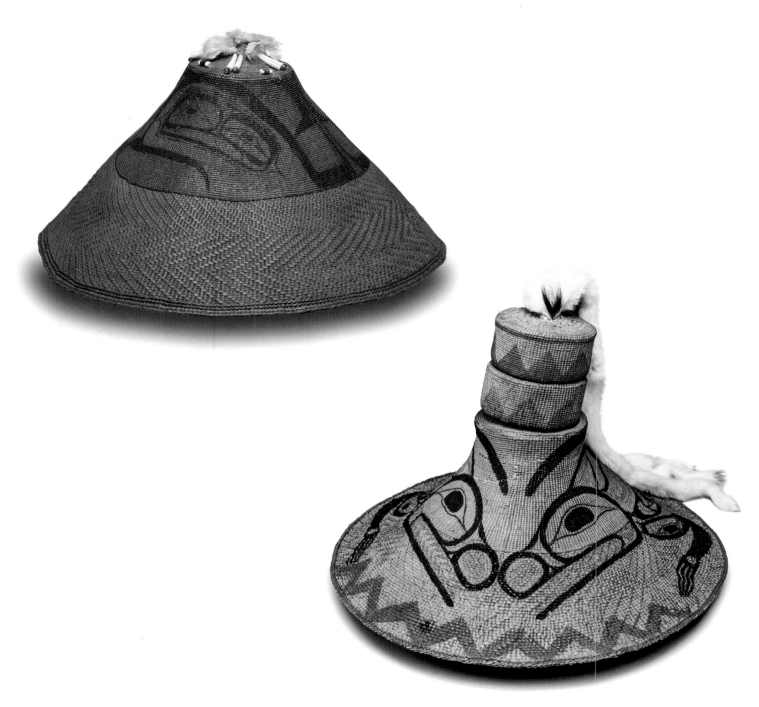

6.
Poncho, ca. 1800

Tlingit, Alaska
Hide, pigment, sinew
40 3/16 × 26 3/4 × 13/16 in. (102 × 68 × 2 cm)
Diker no. 645

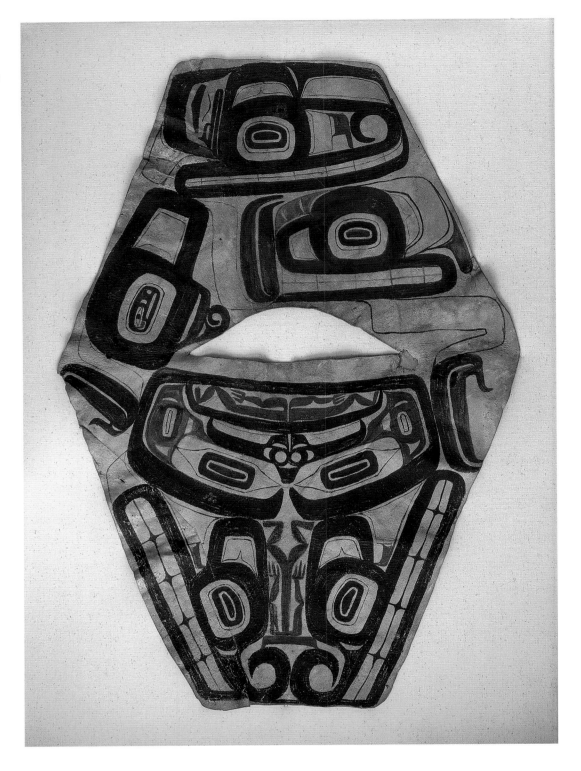

7.
Tunic and leggings, late 19th century

Tlingit, Chilkat, Klukwan, Alaska
Cedar bark, wool, metal cones
44½ × 14⅝ in. (102 × 68 cm)
Diker no. 795

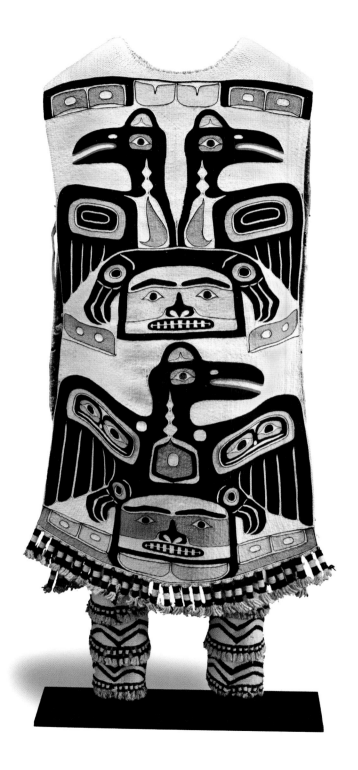
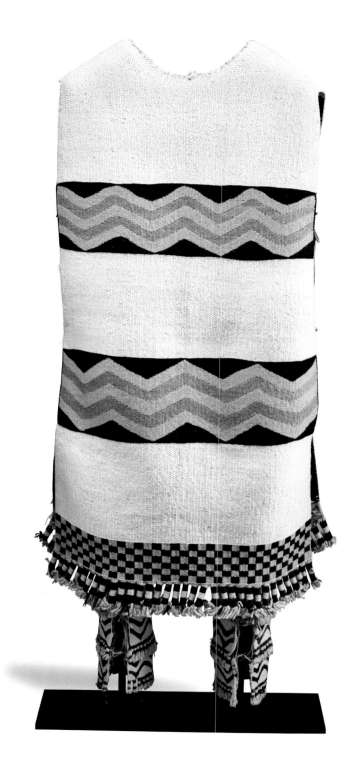

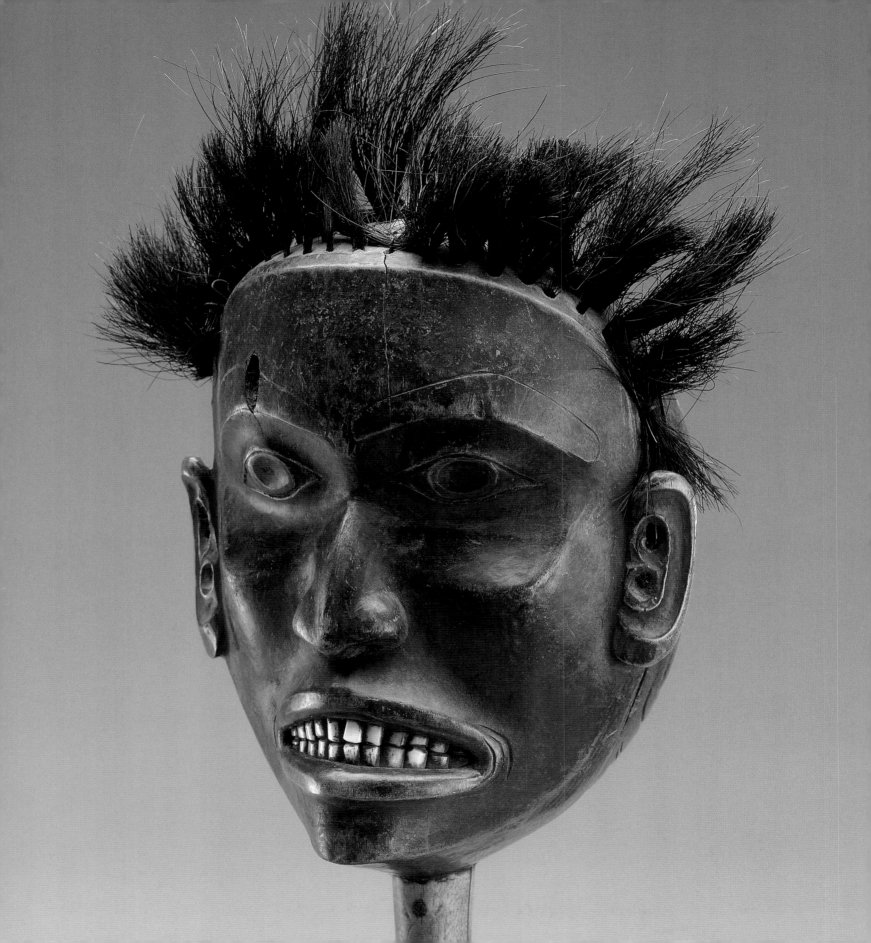

8.
Rattle, ca. 1780

Tsimshian, British Columbia
Birch, bone or ivory, bear hair,
pigment
14 ⅝ × 7 ⅞ × 5 ⅝ in. (37.1 × 20 × 14.3 cm)
Diker no. 664

Awe-inspiring and elegant, this rattle exhibits the kind of forceful presence that Tsimshian artists imparted to human faces, whether on totem poles, masks, frontlets, or rattles. Highly developed shamanic practices call for a variety of paraphernalia to aid the doctor in his dangerous but efficacious contact with powerful spirit beings. Globular rattles, with or without surface decoration, were an important part of the Tsimshian shaman's kit, which might also include amulets, soul catchers, and special headdresses. During healing rites, the shaman and his helpers used songs accompanied by drums, tapping sticks, and rattles to focus the healer and his patient.[1] The chiefs' spiritual leadership during ritual occasions when clan associations with supernatural powers were demonstrated was complemented by the role shamans played in cleansing and strengthening the community.

Known for their fine carving, Tsimshian artists depict the human face with nuances of the underlying bone structure: in this face, such subtleties can be detected in the gentle curvature of the eye sockets where they meet the cheeks, producing an almost portrait-like appearance. Open pupils that fill the irises, a delicate nose, and grimacing lips that reveal white teeth amplify the piece's striking naturalism. Stylized brows, ears, and tufts of hair complete the face, which may represent a helping spirit or the shaman himself. An abstract design executed in formlines graces the reverse side; only the shaman who owned this implement would have been able to interpret its meaning.

1. Marjorie M. Halpin and Margaret Seguin, "Tsimshian Peoples: Southern Tsimshian, Coast Tsimshian, Nishga, and Gitksan," in *Handbook of North American Indians*, ed. William C. Sturtevant (Washington, DC: Smithsonian Institution, 1990), 7:267–84.

9.
Rattle, 1850–80

Tlingit, Alaska
Copper, wood, hide, abalone shell
10 ¼ × 6 ¼ × 2 in. (26 × 15.9 × 5.1 cm)
Diker no. 849

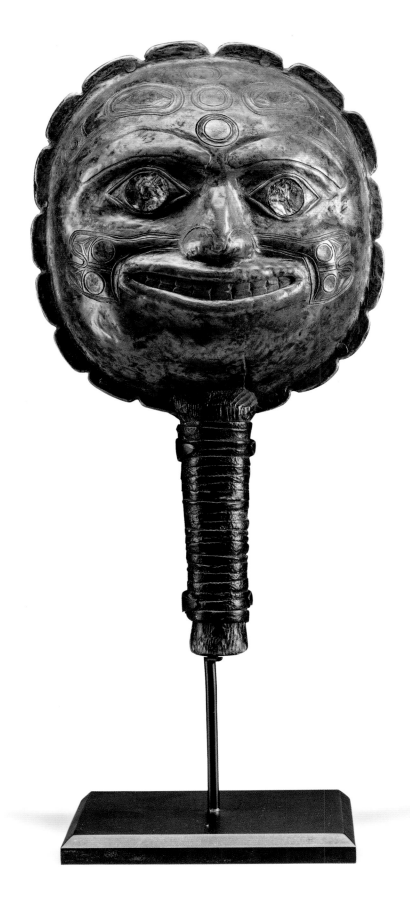

10.

**Salmon rattle and figure (figure
originally displayed inside rattle),
figure, ca. 1840; rattle, ca. 1880**

Tlingit, Alaska
Wood, pigment, tooth, ferrous nails
Rattle: 7 ½ × 24 ⁷⁄₁₆ × 4 in.
(19.1 × 62.2 × 10.2 cm); figure:
2 ½ × 11 ½ × ½ in. (6.4 × 29.2 × 1.3 cm)
Diker no. 615

11.
Raven rattle, 1850–70

Tsimshian, British Columbia
Wood, pigment, vegetal fiber,
copper wire
9½ × 4 × 2⅜ in. (24.1 × 10.2 × 6 cm)
Diker no. 618

12.
Bird rattle, ca. 1840

Tlingit, Alaska
Wood, pigment
4¾ × 8½ × 2½ in.
(12.1 × 21.6 × 56.4 cm)
Diker no. 512

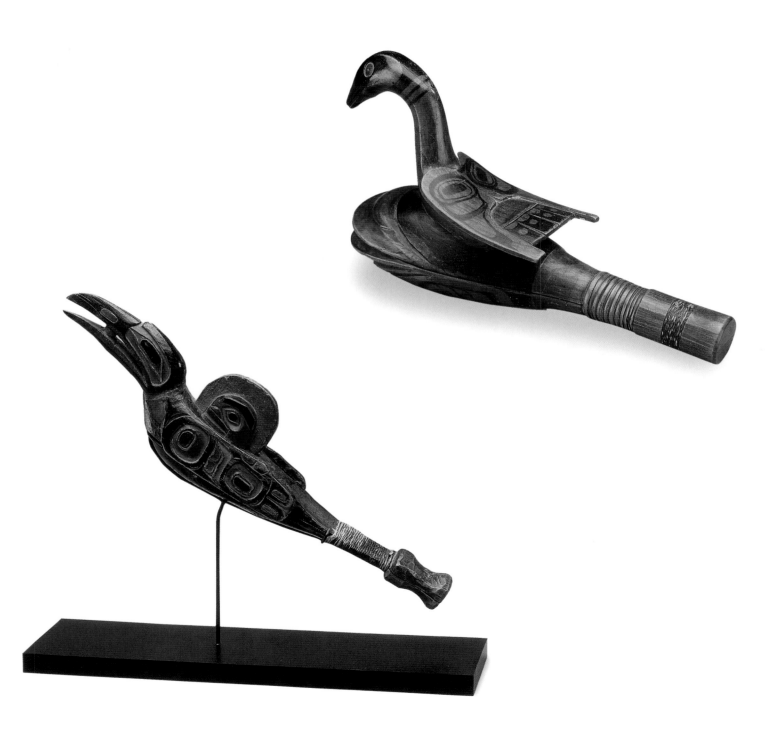

13.

Clapper, 1850–70

Haida, British Columbia
Wood, hide, pigment, nails, hair
8 11/16 × 16 3/16 × 3 9/16 in.
(21.9 × 41.1 × 9 cm)
Diker no. 679

In Haida society, musical instruments are used to accompany songs and dances for feasts, potlatches, secret society initiations, and doctoring rites. Historically, the repertoire has included a variety of rattles, clappers, horns, whistles, and box drums. In more recent times, the hand drum has become the instrument of choice. Percussive music is used to "call down" the spirits on important occasions.

Both rattles and clappers are carved in two halves. While these halves are fused together in rattles, clappers consist of two jointed parts that produce a rapping sound when shaken. Many clappers have carved creatures, often birds, as the top half of the instrument; anatomical features such as wings provide weight as the upper section hits the lower one. This beautiful example in the form of a killer whale displays classic formline design elements, which have been gracefully carved into all of its surfaces. A separate wooden dorsal fin piece is attached, as are leather tabs that represent the whale's pectoral fins and tail. All of the carved and painted design features are artfully proportioned in the manner of the best mid- to late nineteenth-century Northwest Coast designs. The broad head of the massive mammal is organized into large black eyes, red lips, and blue-green nostrils. Body joints are indicated by circular forms that resemble eyes on the top and bottom of the clapper, while stylized human-like faces appear at the base of the dorsal fin. The smooth flow of the clapper's sculptural form and surface decoration suggests the work of a carver who understood and maintained the iconic features of Haida design, even during a period when Haida arts and culture were in flux. At the time this clapper was made, many Haida artists had shifted their production toward items created for the tourist market; over the years, as a result, the quality of some of these objects waned.

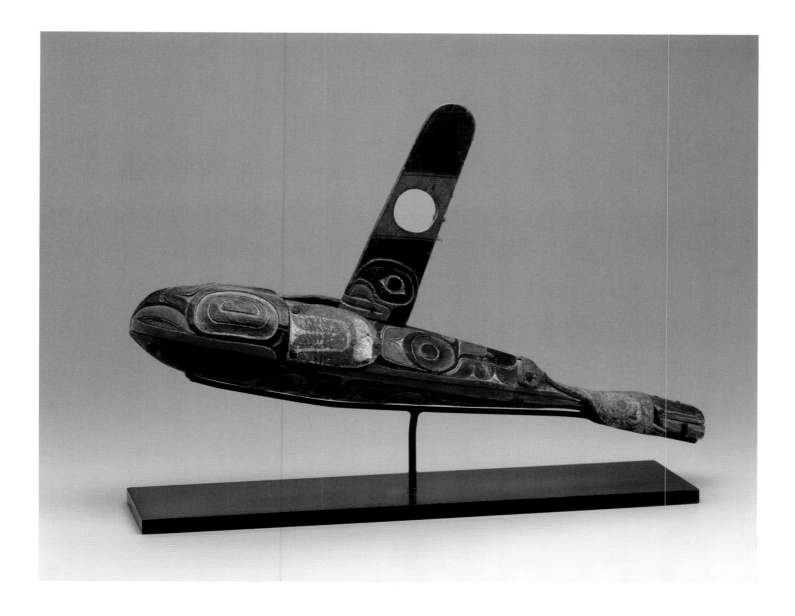

14.
Shaman's amulet, 1820–40

Tlingit, Alaska
Antler, abalone shell
2 × 5½ × ¾ in. (5.1 × 14 × 1.9 cm)
Diker no. 843

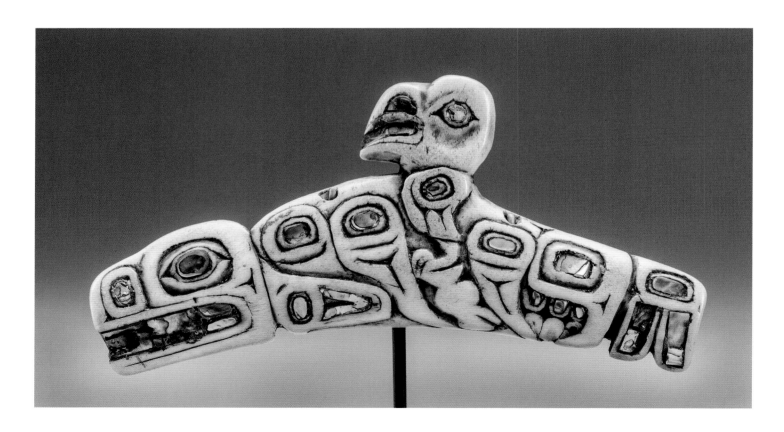

15.

Preston Singletary (Tlingit, b. 1963)

Tlingit, Alaska

Oystercatcher Rattle, 2011

Blown and sand-carved glass, human hair
22 × 17 × 6 in. (55.9 × 43.2 × 15.2 cm)
Diker no. 826

The prolific contemporary glass artist Preston Singletary made this sculpture based on a traditional Tlingit "oystercatcher" rattle. Singletary has created a series of glass sculptures based on older carvings in the tradition of northern Northwest Coast sculpture and formline design. The motif of spirit beings that seem to ride atop an animal — also seen in the Tlingit amulet in this collection (cat. 14) — is used to indicate the projection of the shaman into the spirit world so that he can discover the cause of an illness and cure it. The traditional healing paraphernalia of a shaman often combined strong sculpture with complex surface designs. In Singletary's modern version, the long-haired doctor, the land otters on either side of him, the mountain goat with a protruding tongue, and the main figure of the oystercatcher bird exhibit a variety of sculptural and relief treatments — from fully modeled to elaborately incised on the surface. Singletary achieves this through the techniques of glassblowing, modeling, and sandblasting, while retaining the feeling that a narrative scene is unfolding.

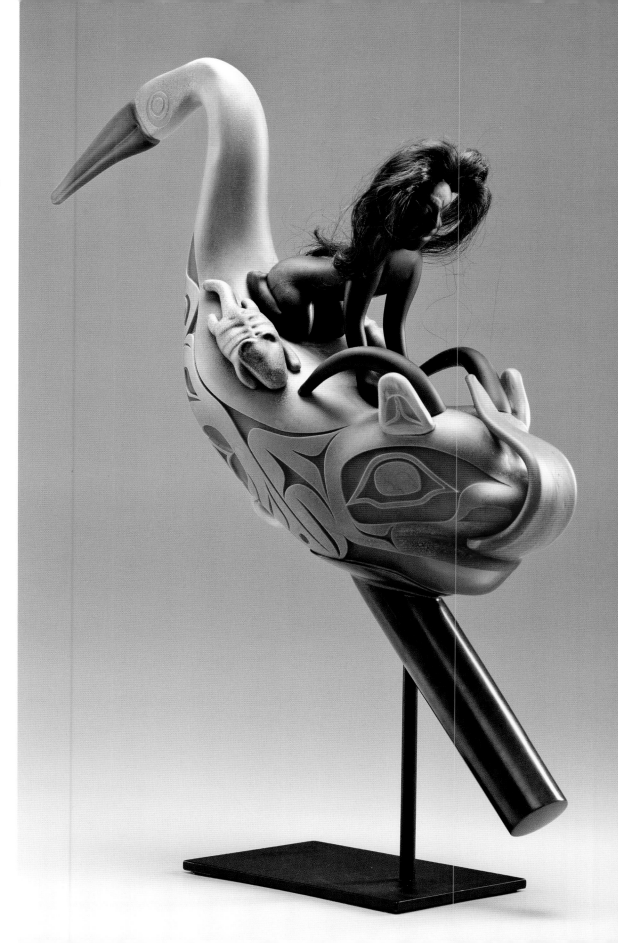

16.
Comb, ca. 1840

Tlingit, Alaska
Mountain sheep horn
5 ⅛ × 3 ³⁄₁₆ × ⅝ in. (13 × 8.1 × 1.6 cm)
Diker no. 662

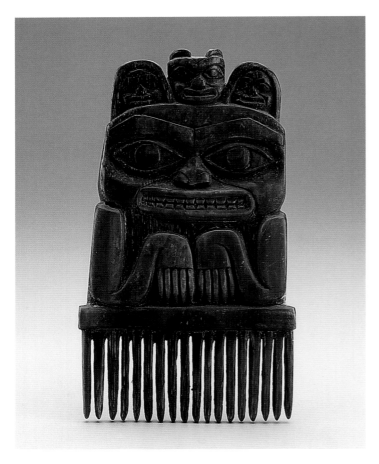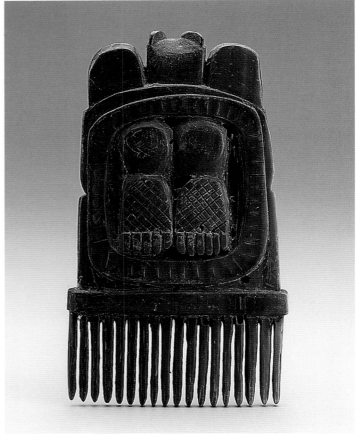

17.
Comb, 1850–80

Tlingit, Alaska
Wood
11½ × 4 × 1 in. (29.2 × 10.2 × 2.5 cm)
Diker no. 829

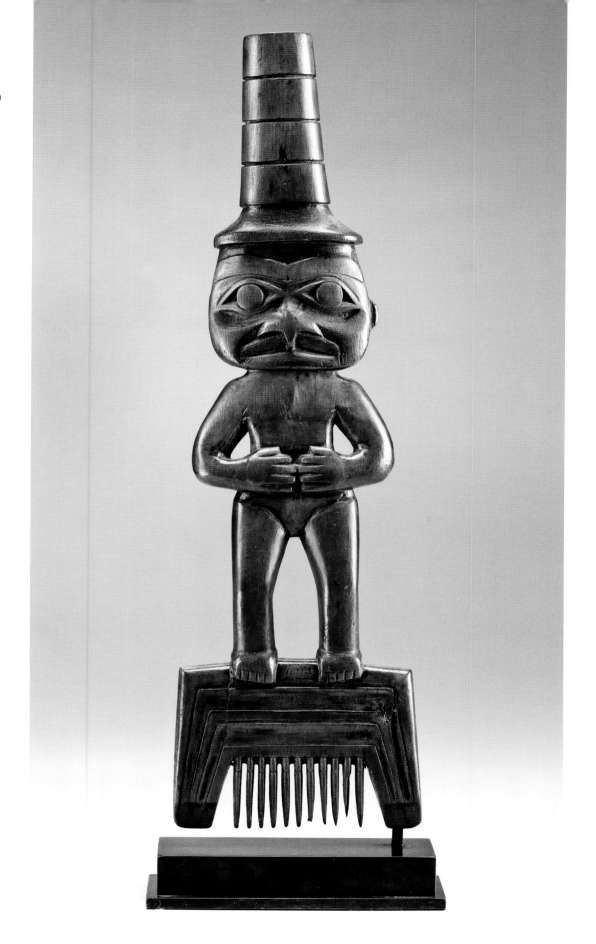

18.

Dagger, ca. 1750

Tlingit, Alaska
Iron, hair, vegetal fiber, hide, wool
18 ½ × 4 ¾ × 1 in. (47 × 12.1 × 5.1 cm)
Diker no. 610

This venerable dagger possesses a long history as an *at.óow* of the Lukaax.adi clan of Haines, Alaska. Meaning "an owned or purchased thing or object," *at.óow* refers to both actual and intangible property that is highly valued. More than mere prized heirlooms of the clan, *at.óow* function in the potlatch ceremony to bind people together in the presence of the ancestors. The display of such treasures is accompanied by the recitation of associated oral histories, songs, and names. These public presentations honor the clan, but their most important function is to explicate genealogical connections to the young people present. This dagger is similar to one in the collection of the Seattle Art Museum (91.1.75) that is documented as being made by a woman metalsmith named Saayina.aat and was called by the clan *Emaciated Shaman's Dagger*.[1] The Diker piece was reputedly made of meteoric iron, although extensive trade networks brought iron and steel into the Northwest Coast in pre-contact times.[2] The massive formline eyes, ears, and mouth, which dominate the pommel, suggest that it is older than the Seattle Art Museum piece, for which it likely served as a model. An unusual feature is the fluting on both sides of the blade, a design that lightens the weight of the object, but is usually present only on one side. The penetrating gaze of the face, which stares with hollow eyes, suggests the trance state of powerful Tlingit shamans or medicine men. Like the chief or head of house, a shaman worked for the protection of the clan, using powerful spirit beings as his allies. In order to make contact with the spirit world, he would undergo a ritual "death" — thus appearing gaunt — temporarily leaving his body to gather visions and the power needed for healing. Shamans are known to have used clubs and daggers in order to battle evil forces that challenged their power. It is possible that this piece, originally used by a shaman, was transformed into a clan *at.óow* at a later time.

1. Daggers such as this one were made in one piece, unlike some of the later period, which, made for sale, feature copper or iron blades affixed to sheep-horn hilts that have been carved into bears, birds, or other animals. Bill Holm, personal communication.

2. Nora Dauenhauer, quoted in Steven C. Brown, ed., *The Spirit Within: Northwest Coast Native Art from the John H. Hauberg Collection* (New York: Rizzoli; Seattle: Seattle Art Museum, 1995), 42.

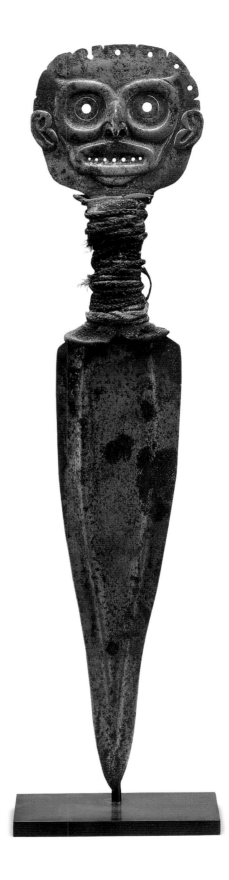

19.
**Dagger handle (blade restored),
1780–1840**

Tlingit, Alaska
Wood, vegetal fiber
18 × 2 × ¾ in. (45.7 × 5.1 × 1.9 cm)
Diker no. 828

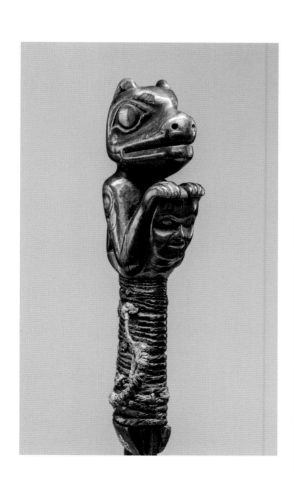

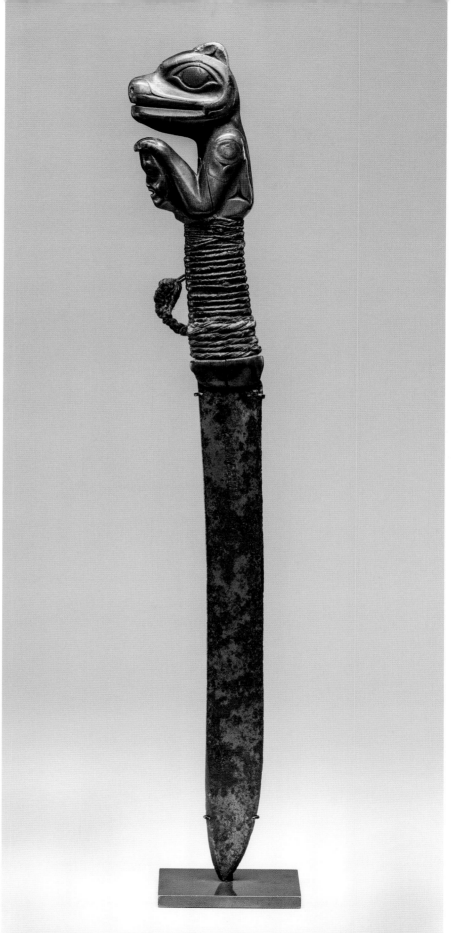

20.
Club, 1820–40

Nuu-chah-nulth or Makah, Central
Coast, British Columbia
Whalebone
33 ¼ × 3 × ½ in. (84.5 × 7.6 × 1.3 cm)
Diker no. 832

Clubs were an important accoutrement for warriors of the Northwest Coast. In general, warfare was staged to redress a perceived wrong, avenge a murder, or acquire slaves or resources.[1] Among some of the Northwest Coast groups, weapons such as clubs or daggers might become family or clan heirlooms, their illustrious histories recounted in public ceremonies. Clubs were fashioned from stone, wood, and/or whale jawbones. Whalebone clubs have been found in archaeological sites on the central and northern coast; at the Ozette site near Neah Bay, Washington (dated 300–500 BP); and near present-day Prince Rupert, British Columbia (dated 2,000 BP).[2] Makah and Nuu-chah-nulth clubs have long, flat blades, often incised with geometric patterns, and pommels shaped like bird heads. An example from farther north, at an ancient Tsimshian village site, has a similar blunt, rounded blade, but the pommel is adorned with a human-like face instead of the head of a bird.

The club in the Diker Collection is something of a mystery in terms of its configuration, origin, and date. Unlike other clubs from the West Coast, this piece has elaborate plastic elements, from the scallop shapes on its edges to the sequence of creatures, which may represent the outlines of whales (note the round bodies and tails) and two birds' heads. Semicircles are incised on the sides of the blade. The club's rather long length and short handle suggest that it may have been used as a ceremonial club or weapon. Its iconography suggests a West Coast origin, Makah or Nuu-chah-nulth: both peoples were great whalers until around 1920, and often combined the imagery of a thunderbird, serpent, and whale. In

Nuu-chah-nulth cosmology, Thunderbird was the supreme whaler, able to lift the leviathan creatures from the sea with its talons, or to dispatch them using the Lightning Serpent as a harpoon. It may be that this enigmatic example was given its unusual form by an innovative artist or based on the particular owner's vision; alternatively, it could have been made for the tourist market.

1. Another type of stylized combat provided a framework within which combatants might be honored and hostages returned. See Bill Holm, *The Box of Daylight: Northwest Coast Indian Art* (Seattle: Seattle Art Museum / University of Washington Press, 1983), 97.

2. Roy L. Carlson, ed., *Indian Art Traditions of the Northwest Coast* (Burnaby, BC: Archaeology Press, Simon Fraser University, 1983).

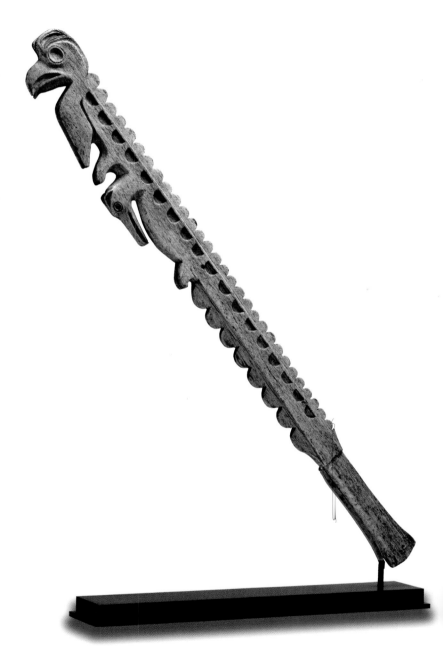

21.
Bowl, 1750–1800

Tlingit, Alaska
Wood, shell, pigment
11 ¹³⁄₁₆ × 12 ⅝ in. (30 × 32.1 cm)
Diker no. 703

22.
Bowl, ca. 1790

Tlingit, Alaska
Wood, shell
7 ⅛ × 11 ⅜ in. (18.1 × 28.9 cm)
Diker no. 544

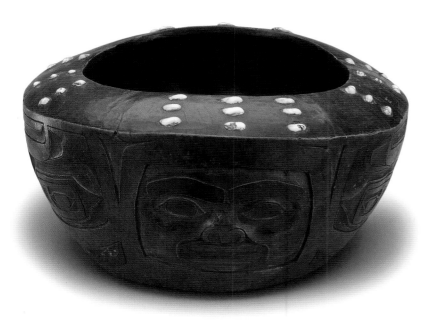

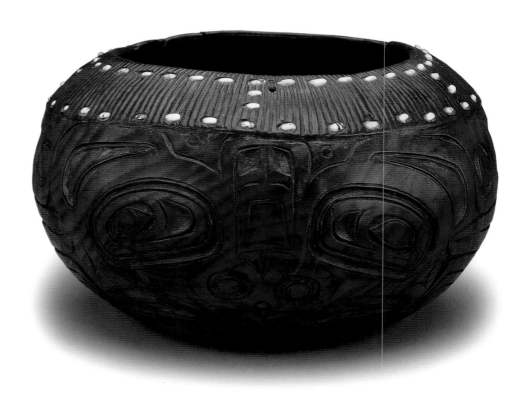

23.
Grease dish, ca. 1750

Tsimishian, British Columbia
Wood
4 ¾ × 7 ½ × 3 in. (12.1 × 19.1 × 7.6 cm)
Diker no. 786

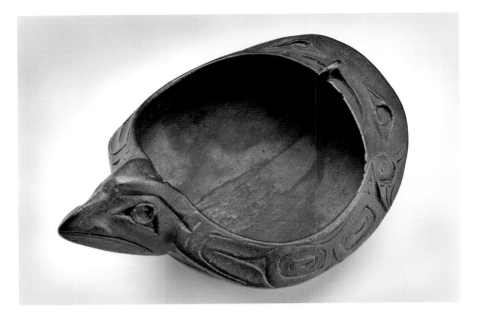

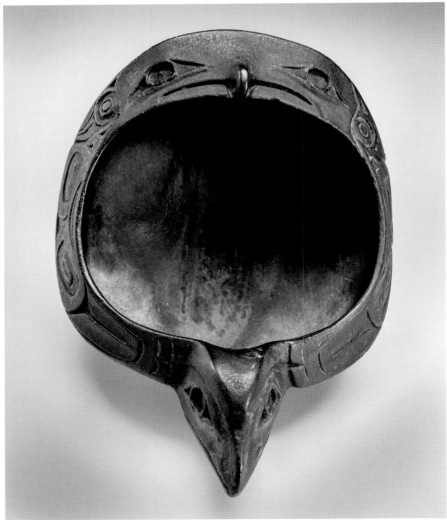

24.
Grease dish, ca. 1830

Haida, British Columbia
Alder
3 × 10 × 2¾ in. (7.6 × 25.4 × 7 cm)
Diker no. 644

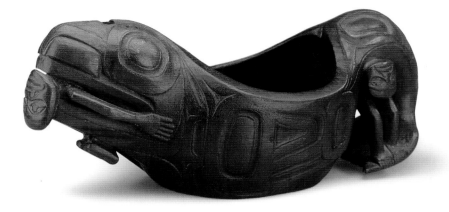

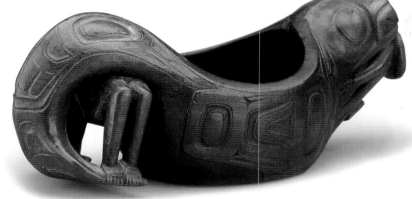

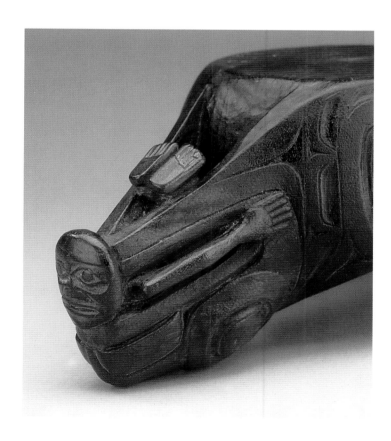

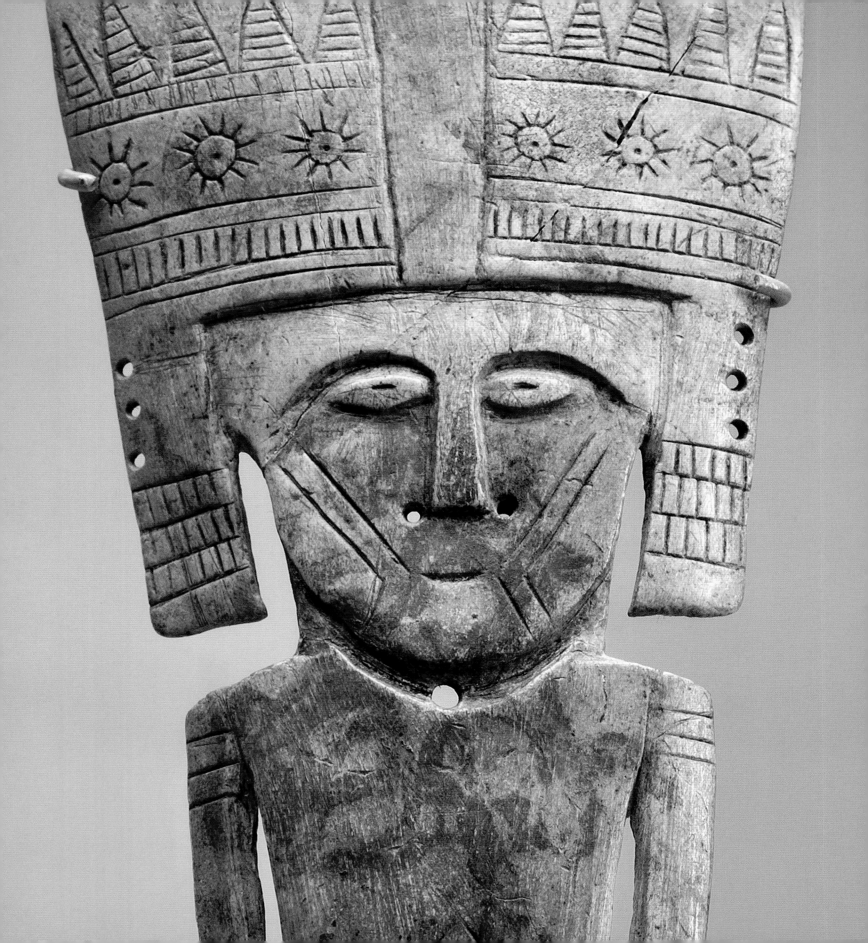

Salish Sculpture of the Southern Northwest Coast

Barbara Brotherton

Native Nations (or First Nations, as they are called in Canada) of the southern Northwest Coast live along the Salish Sea, on the landmasses defined by the Strait of Georgia, the Juan de Fuca Strait, and Puget Sound. This area, encompassing present-day southern British Columbia and coastal Washington State, includes the regions surrounding the cities of Seattle, Victoria, and Vancouver. While treaties in Washington and Oregon in the 1850s established reservations, Native Nations in British Columbia were moved to reserves without conceding their territories via treaties.[1] Outsiders, arriving in ships sailing from England, Spain, France, and Russia, first contacted local Nations in the late eighteenth century, launching the maritime fur trade. By the 1820s, land-based fur companies had established settlements and forts; they were followed by administrators (Indian agents), missionaries, and entrepreneurs. Today, Northwest Coast Natives mostly live on reservations and reserves on their traditional territories, or in proximity to them.

Peoples living along the Columbia River were also affected by fur traders, missionaries, and other outsiders looking for land and opportunities. Early pressures on Salish and Chinook tribes to renounce their languages and lifeways, coupled with the theft and destruction of their traditional arts, resulted in a serious loss of material culture. Anthropologists sent in the late nineteenth and early twentieth centuries by East Coast museums to "salvage" the remnants of these "vanishing cultures" lamented the dearth of pieces available in Salish regions. Infectious diseases, disenfranchisement from traditional lands, and the removal of children to boarding schools all conspired to disrupt communities' customs in favor of assimilation into Euro-American society. Missionaries destroyed and suppressed visual arts created in the service of ceremonies, and heirlooms that remained in Native possession were guarded by families and ceremonial practitioners, making it difficult to secure them for museum collections. The fine works in the Diker Collection from the southern Northwest Coast (cats. 25–28) are stunning and rare examples of the elemental and powerful nature of Salish and Chinook carving traditions.

Artists of the southern Northwest Coast engraved images of humans, animals, and supernatural beings on rattles, combs, clubs, bowls, and spindle whorls, employing a distinctive approach

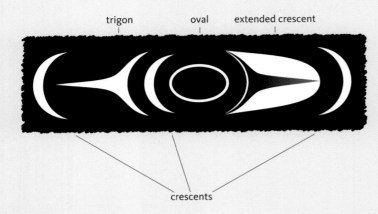

trigon oval extended crescent

crescents

Fig. 18. Coast Salish design elements.
Drawing by Qwalsius Shaun
Peterson. © Shaun Peterson

to positive and negative forms that is related to, but different from, the sculptural and two-dimensional styles of the northern Northwest Coast. According to Qwalsius Shaun Peterson, a contemporary Tulalip-Puyallup artist, the art of the south differs from that of more northerly tribes in that the negative elements, rather than the positive ones, are the foundation of the design (fig. 18).[2] While an imposed grid-like structure is used to organize the lines and shapes that make up humans, animals, and supernatural beings in designs from the north, it is the engraved, *negative* elements positioned between the positive elements on the surface of the object that dictate the composition in designs from the south. For example, in the design carved on a southern spindle whorl (fig. 19), the shape of the compact figure, whose open mouth doubles as the aperture for the spindle, is articulated by the cutout, negative area surrounding it. Signature design elements such as crescents, U-shapes, three-pointed shapes, and slits further describe the anatomy of the man and of the animals that flank him. Repetition of geometric elements suggests a circular movement, creating what Peterson calls "rotational symmetry." The particular proportioning of positive and negative elements, visible in many other nineteenth-century Salish and Chinook works, harkens back to the earliest extant carvings from the region.

While the arts traditions of the north responded to the need for assertive visibility in the context of public display (i.e., the crest system), it has been suggested by anthropologist Wayne Suttles and others, and confirmed by contemporary Native peoples, that much of the material culture from the southern Northwest Coast was intended for private use by ritualists during moments of transition, such as puberty, marriage, illness, and death.[3] The nature of the imagery and its identification were purposely left ambiguous, to be interpreted only by the ritualist or by the family whose supernatural powers, inherited from ancestors, were depicted on the art and activated by the ritualist. In this manner, the object and the way its form was articulated served as both a conduit and a barrier, providing access to the spirit world, in accordance with the needs of the ritualist, and also functioning as a buffer to protect the living. One shaman's guardian figure (cat. 26) is pared down to essentials, the sensitive modeling of the figure suggesting a human without disclosing its identity. Wood figures perched on a handle, such as this one is, were used by Northwest Coast Salish shamans in their doctoring practices to help anchor the powerful exchange between the healer and his spirit allies. This figurine conforms to a planar style that is characteristic of the region; its flat, oval face, with narrow eyes and plank nose, is stepped back at the brow and cheeks. A similar approach is seen in a figure from the lower Columbia River that has less modeled and more stylized anatomy. Incised geometric elements define both its woven apron and its distinctive Wishram headdress with ear flaps, as do facial, arm, and leg markings (cat. 25). This abbreviated style is also apparent in the faces and incised patterns on a sheep-horn bowl (cat. 28) and in the compact birds perched on an elegant ladle handle (cat. 27). Naturalism and stylization of life forms are both aspects of this style and might occur together in a single object.

Fig. 19. Spindle whorl, before 1912. Coast Salish, Chehalis. Wood, 8 ⅜ × 8 × ¾ in. (23.1 × 20.3 × 1.9 cm). Royal British Columbia Museum, British Columbia Archives, 2454

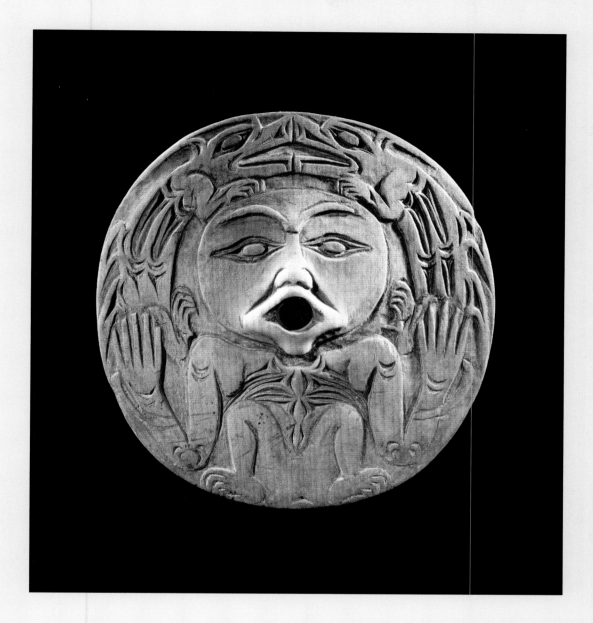

The inherited traditions of art production, and the ceremonies and feasts they served, were severely affected after 1850 when government officials and missionaries enacted measures to eradicate all forms of Native values, providing visual references to family origins, histories, and relationships to the supernatural world. The task for artists today is to find ways to exercise their personal creativity and experiences in contemporary times while defining their relationships to tradition.

25.
Figure (Pendant?), 3rd–13th century

Ancestral Columbia River people,
Columbia River Valley, Washington
State or Oregon
Antler
10 ⅛ × 3 × ¼ in. (25.7 × 7.6 × .64 cm)
Diker no. 529

26.
Guardian figure staff, 1820–50

Coast Salish, Chehalis,
Washington State
Wood, deer hooves, pigment,
vegetal fiber
25 × 4 × 3 in. (63.5 × 10.2 × 7.6 cm)
Diker no. 758

27.
Ladle, ca. 1850

Chinook, Washington State
or Oregon
Wood, pigment
3 × 8¼ in. (7.6 ×15.2 cm)
Diker no. 514

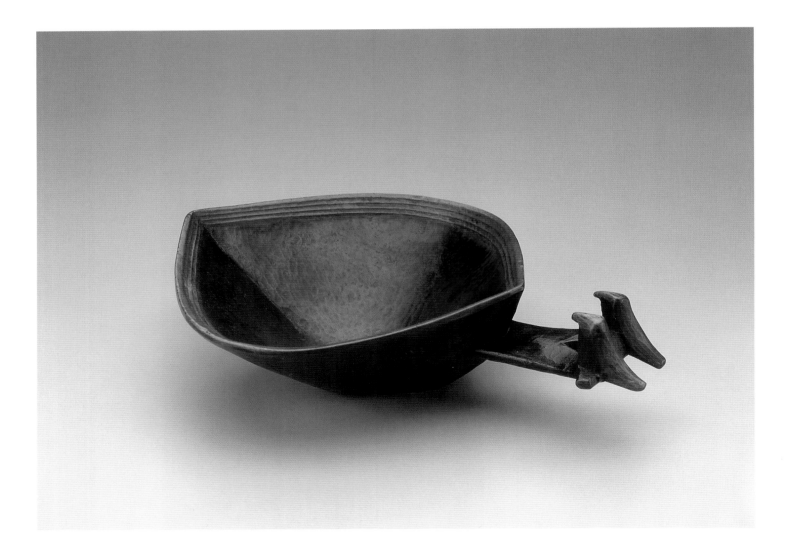

28.

Bowl, ca. 1840

Wasco/Wishram, Washington State
or Oregon
Bighorn sheep horn, nails
14 × 18½ in. (35.6 × 47 cm)
Diker no. 569

The Wasco and Wishram peoples who originally settled the southern and northern shores of the lower Columbia River were affected severely by the influx of traders to the forts built in the years after the Lewis and Clark expedition (1805–6) opened the area to non-Natives. Fatal diseases and the arrival of newcomers and their goods devastated the population and destroyed traditional ways of life. After the treaties of the 1850s, survivors were forced to move to reservations in Washington and Oregon.

Despite these tribulations, some weavers continued to make root bags from Indian hemp and corn husk, and carvers created decorated bowls and ladles from mountain sheep horn for ceremonies. Images of skeletal humans, birds, quadruped animals, and geometric patterns are seen in both weaving and carving, and appear to relate to a prehistoric style of the region. Located on a major waterway where other tribes came to fish and trade, the art of this region shows stylistic affinities with that of neighboring Northwest Coast Salish peoples, especially in the use of incised geometric elements to create positive designs. The curly horns of mountain sheep, obtained from Plateau peoples to the east, were steamed until they became pliable and then shaped into bowls and ladles. In an ingenious technique for making bowls, the horn was cut in such a way that when it was opened up after steaming, it took the basic shape of a container with high ends and shorter sides, as seen here. This vessel is incised with interlocking triangles, a common motif in horn and wooden bowls whose rhythmic sequences suggest gently flowing water. Five enigmatic faces etched into the horn are related to much older figurines found in archaeological sites along the mid-Columbia River (also called the Strong River), and also to the ancestral Columbia River antler figure in the Diker Collection (cat. 25). Feasting was a time to give thanks for the abundance of food and to enact family ceremonies; implements such as this bowl played an important part.

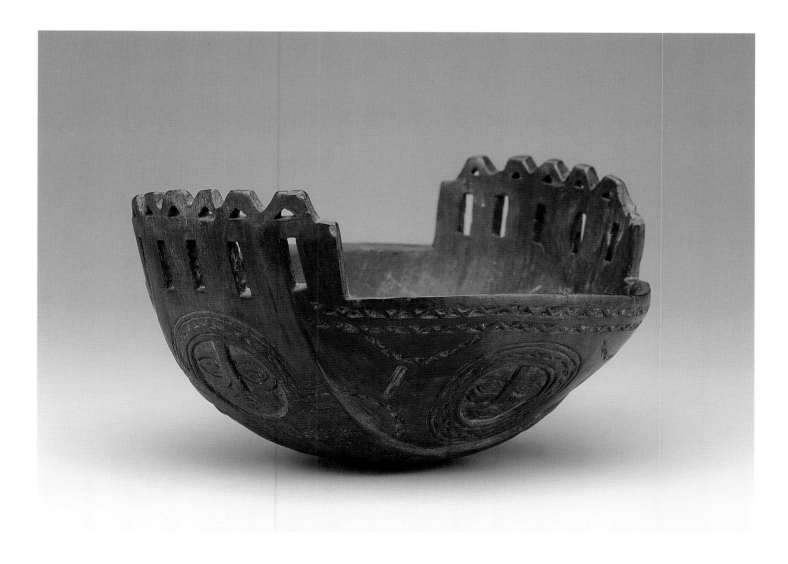

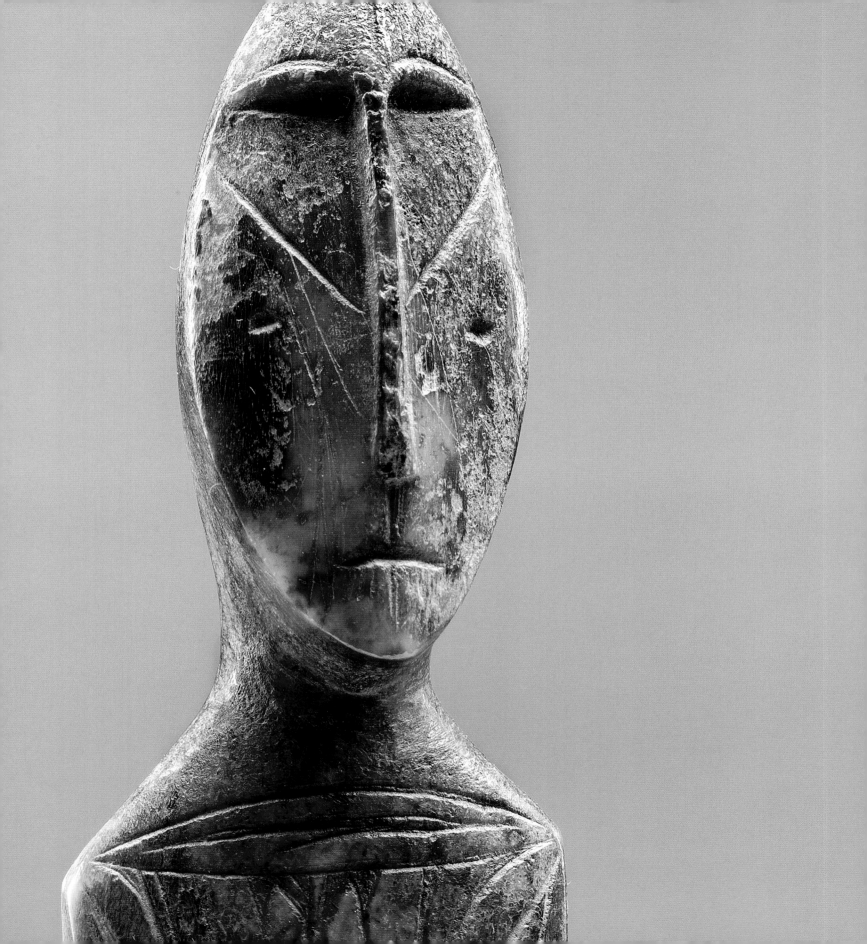

Ancient Ivories from the Bering Strait Region

David W. Penney

Fig. 20. A fur-clad Eskimo family shares domestic chores while sitting on a log, 1917. Photo courtesy National Geographic Creative. Photo by George King

In the 1930s, archaeologists began to study in earnest a number of ancient village sites located on St. Lawrence Island and the small chain of Punuk Islands that extend from it. More than 125 miles from the Alaskan mainland, these islands lie in the northern Bering Sea, close to the Bering Strait, which separates Alaska from Russia. The sites revealed that the islands had been occupied for more than two millennia by small communities of ancestral Eskimo drawn there by the area's seabird hatcheries and walrus. The current residents, the descendants of these ancient communities, had developed the practice of harvesting fossil walrus ivory washed out of old village sites by the sea, which they used for curio carving (figs. 20, 21). The sites yielded abundant ivory artifacts stained dark brown from exposure to the graphite-rich earth, their surfaces engraved with intricate designs.

Archaeological excavations in the vicinity of the Eskimo community at Gambell, on the western tip of St. Lawrence Island, established a stratigraphic sequence of artifact styles from these old sites, and archaeologists named the cultural tradition that had inhabited them "Old Bering Sea." Some of the earliest objects from Gambell resemble others harvested by Eskimo ivory collectors from a remote site on one of the Punuk Islands. Archaeologist Otto Geist accompanied Eskimo to the Punuk Island site in 1931 and purchased the collection of artifacts found there for the University of Alaska Museum. Froelich Rainey, who excavated the site in 1934, named it Okvik, the Eskimo term for a location where walrus are hauled out of the water.[1]

Many of the sites on St. Lawrence Island and the Punuk Islands evidence several episodes of habitation. A great deal of archaeological interpretation is concerned with linking stylistic changes in artifacts with datable historical periods. Archaeologists observed subtle differences in styles of engraving among the Old Bering Sea artifacts, and initially they interpreted these variations as corresponding to different periods of manufacture. The style of engraving characteristic of the Okvik site seemed to be the earliest of the Old Bering Sea styles, which range in date from 500 BCE to as late as the seventh century CE, when a slightly different pattern of artifact styles begins to dominate the archaeological record in that region, evidencing shifts in lifeways. Archaeologists called this newly discovered culture

Fig. 21. Anavik at Banks Peninsula, Bathurst Inlet, Northwest Territories (Nunavut). Photo by Rudolph Martin Anderson, May 18, 1916. Canadian Museum of Civilization, 39026

pattern "Punuk." More recent interpretation, however, construes differences in Old Bering Sea and Okvik engraving styles as primarily regional rather than chronological. Differences in these styles may have signaled ethnic identities among three closely related yet distinctive regional traditions scattered about the Bering Strait region: Okvik, which seems to have roots in Southwest Alaska; Old Bering Sea, which expanded out from the Siberian coast; and Ipiutak, which is named for a large village site in northwestern Alaska. The Old Bering Sea and Okvik cultures depended largely on walrus hunting, while Ipiutak peoples also looked inland for caribou and other terrestrial resources.[2]

Many of the Okvik and Old Bering Sea artifacts are components of large harpoons designed for hunting walrus: the distinctive toggle head that swivels sideways after it penetrates the animal, ensuring that an attached line holds fast; a socket that holds the toggle head in place; a heavy foreshaft designed so that the socket and toggle head detach after striking the quarry; and a counterweight, which would have been attached to the rear of the harpoon to balance the heavy foreshaft and toggle head at the striking end so that the weapon would fly straight when thrown. Harpoon parts were customarily engraved with elaborate, curvilinear patterns and designs that suggest animal forms and fragments. The same manner of engraving was also used to decorate bucket handles, boat fittings, human figurines, and other types of walrus-ivory artifacts.

The designs can be interpreted in a number of different ways. As mentioned earlier, stylistic variations may signal ethnic identity: the archaeological record suggests that several distinct community groups were interspersed throughout the Bering Strait region, sharing or contending for the same resources. The designs may also convey spiritual beliefs: the images of animals and their abstracted forms, often one merging into another, were intended to assist hunters by fostering good relations with helpful spiritual beings. The carved heads and toothy jaws of fearsome predators such as the polar bear forge links between human hunters and the prowess of their carnivorous competitors. The designs are applied with great precision and skill; given the laborious and unforgiving process of engraving with stone or iron burins on ivory, they indicate that these objects were accorded high regard and imbued with strong cultural values. Not only did such artifacts make life on an island in the Bering Strait region possible, but archaeologists have discovered that many of them were also intended to accompany their owners to the next world.

Archaeological excavations sponsored by museums and universities provide most of our knowledge of these objects and the cultures that produced them, but many Old Bering Sea and Okvik artifacts continued to be harvested by resident Eskimo. With the rise of the American Indian art market in the 1980s, digging on St. Lawrence Island increased dramatically, and several dealers regularly visited the island in search of masterpieces. Most modern collections today were created during this recent period of activity, and some observers fear that many of the archaeological sites of St. Lawrence Island have been stripped of artifacts and largely destroyed.

29.
Female figure, 2nd–5th century

Okvik, Bering Strait region, Alaska
Walrus ivory
6 × 2 × 2 in. (15.2 × 5.1 × 5.1 cm)
Diker no. 730

This exceptionally large, carved walrus-ivory figurine features the elongated head — coming to a point above the brow — characteristic of the Okvik style. Archaeologists disagree about the significance of such figurines: some point to ivory carvings of human figures made by Eskimo of the late nineteenth century, which, when dressed in miniature clothing, functioned as playthings for children. Okvik figurines, however, were almost invariably interred in high-status burials, along with hunting equipment and other ritual items, suggesting that they served a different purpose. Many of the Okvik figurines seem to be female, with breasts and genitalia indicated through sculptural or engraved designs. The designs on some, like this one, seem to emphasize the womb: here a pattern of rays converge on a circle at the lower abdomen. Taken together, these considerations support the notion that Okvik figurines functioned as ritual objects controlled by the community members with whom they were buried. Their female identities, with their distinct reproductive attributes, relate to the fertility and increase of either game animals or the community itself.

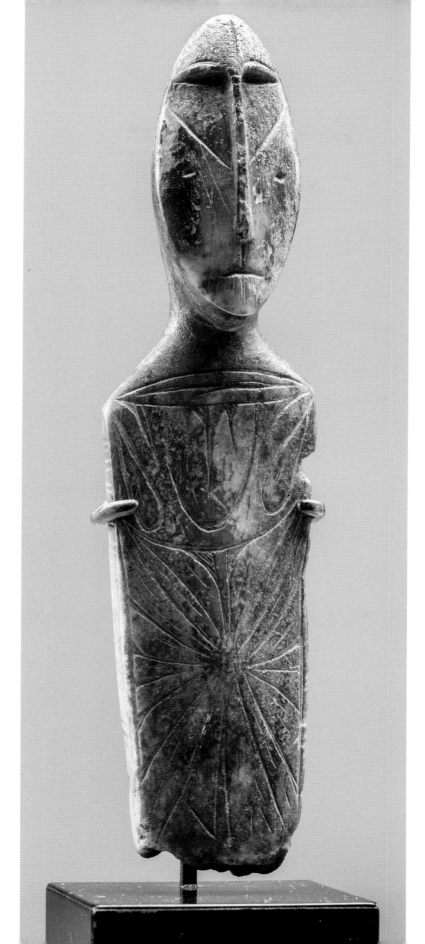

30.
Snow goggles, 5th–10th century

Ipiutak, Alaska
Wood, walrus ivory
1½ × 4¾ × 1 in. (3.8 × 12.1 × 2.5 cm)
Diker no. 774

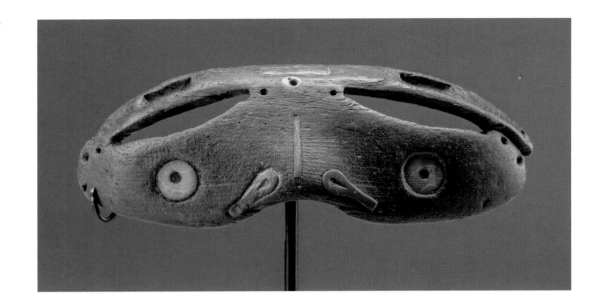

31.
Zoomorphic toggle, 2nd–5th century

Okvik, Bering Strait region, Alaska
Walrus ivory
2½ × 5¼ × 1½ in. (6.4 × 13.3 × 3.8 cm)
Diker no. 567

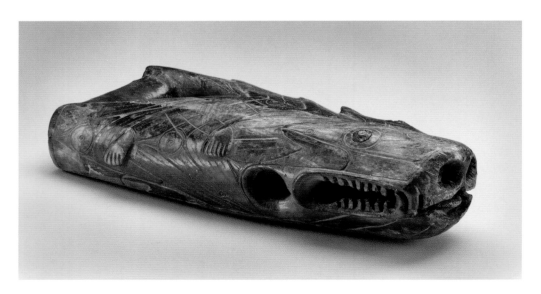
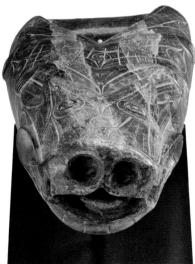

32.

Harpoon counterweight (Winged object), 5th–9th century

Old Bering Sea III culture, Bering Strait region, Alaska
Walrus ivory
2 × 7 ½ × ½ in. (5.1 × 19.1 × 1.3 cm)
Diker no. 731

The so-called winged object is one of the most elaborate artistic productions of the long-lived Old Bering Sea and Okvik traditions of the Bering Strait region. This example, carved with the flowing curvilinear patterns of the Old Bering Sea III style, has often been singled out in exhibitions for its extraordinary beauty. Its graceful shape belies its utilitarian function:

attached to the base of a harpoon, it served as a counterweight and stabilizer. While the shaft of the harpoon was fashioned of wood, counterweights and several other component parts were typically carved of walrus ivory and engraved with elaborate designs. These parts included the toggle head, with its stone blade; the narrow socket piece that helped the toggle head penetrate the thick hide of the prey; and the foreshaft hafted to the harpoon itself, which held the toggle head and socket in place at the striking end of the harpoon. The counterweight at the rear of the harpoon was designed to provide a stable base for the hook of an *atlatl*, or throwing board, a device that

extended the throwing arc of the arm and increased the harpoon's range and velocity. The harpoon is a marvel of hunting technology, and the engraving of its component parts was likely intended to enhance its efficacy through spiritual means.

Harpoons of this kind were clearly elite objects in the Old Bering Sea cultures. They have been recovered, for the most part, from high-status graves in large and long-frequented burial grounds. Many were passed from one generation to the next before interment. In some cases, harpoon parts were worn and broken from long use before being interred. The control of these harpoons by select individuals suggests that those who owned them possessed special

status and powers, analogous perhaps to those of the whaling captains or *umiak* of the more recent Eskimo. We may surmise that these ancient hunters created and used special equipment and spiritual objects in their hunting, as the *umiak* did when they led whaling parties. (For Old Bering Sea peoples, the objects of the hunt were not whale but walrus.) The engraving on this counterweight may have been accomplished with the help of iron burins imported from the Sea of Japan. The Old Bering Sea engraving style, with its webs of curvilinear lines and fragmentary animal forms, undoubtedly relates to the decorative arts traditions of the Scythian-Siberian mainland.

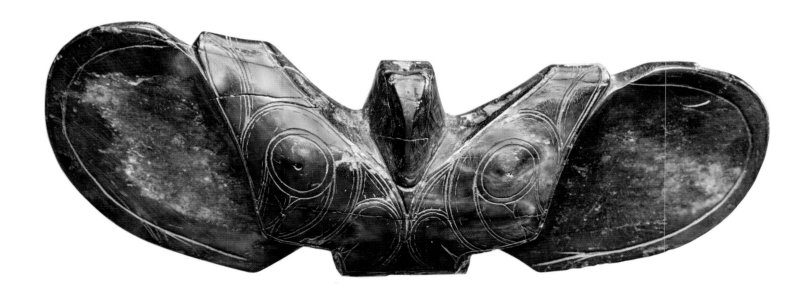

33.
Decorated plaque, 5th–9th century

Old Bering Sea culture, St. Lawrence
Island, Alaska
Walrus ivory
2 × 10 ¼ × ½ in. (5.1 × 26 × 1.3 cm)
Diker no. 833

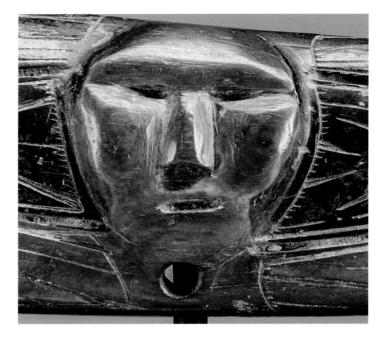

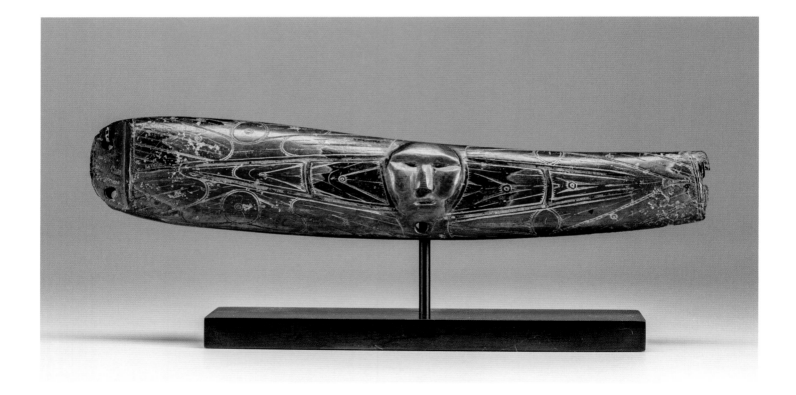

34.

Tammy Garcia (Santa Clara, b. 1969) and Preston Singletary (Tlingit, b. 1963)
Tlingit, Alaska

Ivory Pipe, 2010

Blown and etched glass
5 × 24 × 2 ¼ in. (12.7 × 61 × 5.7 cm)
Diker no. 825

Contemporary artists Tammy Garcia and Preston Singletary collaborated to create this sculpture inspired by a traditional Alaskan Arctic tobacco pipe made from a walrus tusk. The white glass simulates the color of ivory, while the black design that animates the work's surface was inspired by the ivory engraving on ancient Arctic artifacts. Instead of using typical Arctic designs, however, Tammy Garcia substituted patterns customarily found on the ancient Southwest pottery of her homeland.

This work is included here as a reminder that living artists of indigenous ancestry continue to seek inspiration from and connection to an ancestral past. The smoking pipe form of this sculpture, however, stems from a nineteenth-century category of object made by Inupiat Eskimo, the modern-day descendant of ancient Bering Sea cultures.

Inupiat artists carved ivory to make objects not only for their own use but also for sale to visitors brought to their territories by commercial whaling and sealing, and, in even greater numbers, by the Alaskan gold rush. The Singletary and Garcia creation is a tribute to those many, often forgotten artists who continued the tradition of carving walrus ivory into the modern era.

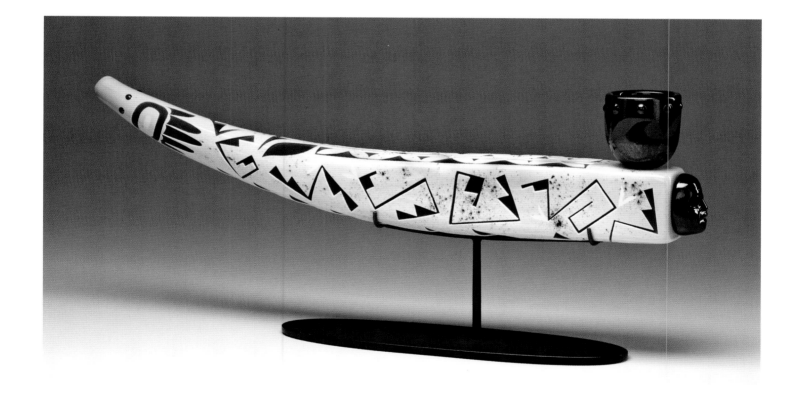

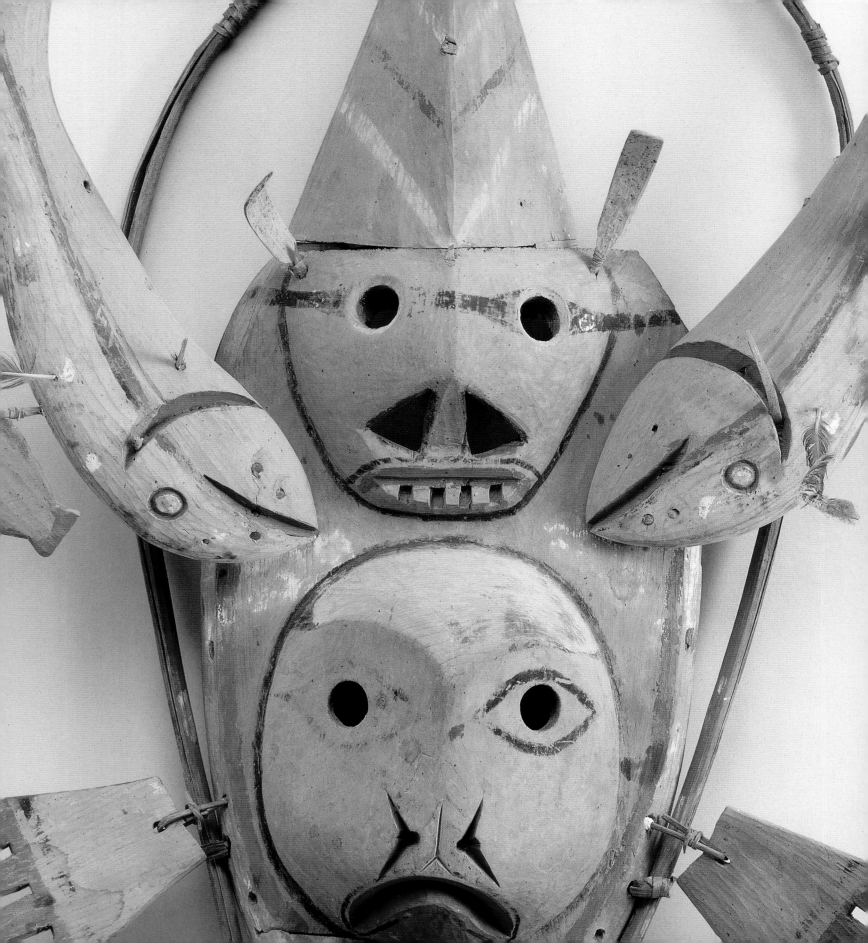

Yup'ik and Alutiiq Masks from the Alaskan Arctic

Janet Catherine Berlo

A Yup'ik saying, "ella-gguq allamek yuituq" (the world contains no others, only persons), encapsulates the belief, essential among many Northern peoples, that there are varieties of personhood — human people, nonhuman people (animals), and other-than-human people. This last category encompasses the mysterious and influential beings that may manifest themselves in visions or be carved in masks as combinations of species of animals or as human-animal hybrids. Many of the Alaskan masks in the Diker Collection represent this third category of other-than-human people.[1]

Arctic peoples of coastal Alaska include the Inupiat of the far north; the Yup'ik of western Alaska; the Alutiiq (southwest of the Yup'ik, in the region encompassing Kodiak and Afognak Islands, as well as Prince William Sound and Cook Inlet); and the Aleut (or Unangan), of the Aleutian Islands.[2] Eskimoan peoples of Alaska identify themselves more specifically as Inupiat, Yup'ik, Unangan, Alutiiq, or some regional variation of these terms. Many live above the tree line, and have used the materials harvested from sea and land animals for their art — including their spectacular masks — since antiquity.

The Yup'ik, whose villages are scattered between two great rivers — the Kuskokwim and the Yukon — have long used spruce and cottonwood driftwood that floats downriver in the summer, materials they see as gifts from the water. From this wood, along with local willow roots, withes, and feathers of the numerous species of birds that migrate to Alaska in the summer, they have crafted objects that have brought them acclaim as unusually creative mask-makers, celebrated by early ethnographic collectors, twentieth-century Surrealist artists, and modern collectors and museum curators (cats. 37, 38, 39).

Throughout these regions, people have been making and wearing masks for centuries, though missionaries, starting in the nineteenth century, tried to forbid such practices. This greatly reduced the use of such masks, though in recent decades, both mask-making and the ceremonial and social dances in which they figure so prominently have made a dramatic comeback. As in many other mask traditions, the masks of Arctic Alaska come alive in the context of dance, gesture, song, and drumming. Some represent the other-than-human spirits encountered by shamans; others depict

Fig. 22. Iraluq (Yup'ik, dates unknown). *Messenger Feast*, 1924. Pencil on paper, 10 × 8 in. (25.4 × 20.3 cm). © The National Museum of Denmark, Ethnographic Collections

animal spirits in the broader sense. As Dorothy Jean Ray has described, for the Yup'ik, masks of this kind do not represent single animals. Rather, they symbolize a "vital force representing a chain or continuum of all the individual spirits of that genus which had lived, were living, or were to live. Therefore, when a human face or representative part of it such as a mouth or an eye was placed on a seal spirit mask, it did not represent an individual seal, but an abstraction of the entire genus of the seal's spirit."[3]

The winter ceremonial season opens with celebrations of thanks to ensure success in hunting by memorializing all of the game animals killed in the previous year. As Ray points out, however, propitiating game animals is not the only reason for community performance: "The various long winter festivals, although aimed primarily at fusing the spiritual world with the earthly one, were in many cases . . . occasions of great importance to the solidarity of intertribal relations, and all entertainment was prepared with that in mind."[4] To this end, winter festivals were opportunities for lavish gift giving and displays of generosity. In some communities, this tradition continues today.

To house these events, Native peoples of coastal Alaska built large structures, some of which could accommodate the entire populations of one or two villages, for the dancing, singing contests, and storytelling that occupied long Arctic winter nights. An image drawn in 1924 by a Yup'ik man known only as Iraluq depicts how masks are used in these semisubterranean dance halls (fig. 22). We see the room from a tilted perspective, as if we are looking simultaneously through the door (at the bottom of the image) and through the roof. On either side of the door, seven figures, depicted from the back, perch on a seating platform. One holds aloft the characteristic drum seen all across the Arctic: a hand drum with a bentwood rim and a taut drumhead of walrus stomach. Drummers strike the rim rather than the membrane with a wooden beater. This steady, resonant, percussive rhythm is the sound of joyous celebration — the heartbeat of the village. Some drums used in dances have a huge circumference; the small size of the drum drawn by Iraluq suggests that it belonged to a shaman. Yup'ik elder Wassilie Berlin describes this kind of drum as a "apqara'arcuutet" (device for asking), used in conjunction with songs that summon the shaman's spirit helper.[5] In the center of the drawing, a masked dancer gesticulates, his legs bent close to the floor. Behind him, three unmasked women dance with feathered wands and two smaller masked figures echo the central dancer's movements.[6]

The complexities of a shaman's personal vision are exemplified in one mask in the Diker Collection (cat. 37). Shaped like the kayak of a sea-mammal hunter, its central image is the face of a seal, flanked by salmon. The four-fingered hands affixed to the lower half of the mask are a common element in Yup'ik masks. The lack of thumbs allows the helping spirit to let the animals slip through his hands and be caught by the human hunter instead.

Masks of the Alutiiq people, too, are worn in elaborate dances, although these masks typically have fewer parts. The Chugach mask from Prince William Sound (cat. 35) is carved in a fierce and simplified style. Red and blue pigments ornament the stern face. A long triangle

of red marks the high forehead, tiny slit eyes, nose, and large mouth with everted lips. A more fugitive blue once covered the sides of the forehead and cheeks. One willow rod is bound closely to the face. A pair of spirit masks from farther west — either Kodiak Island or Afognak Island, near the start of the Alaskan Peninsula — have similarly streamlined but expressive features (cat. 36).

Outsiders have long been fascinated by these masks, principally because of their arresting visual presence and the glimpse they give of the cultures that produced them. By charting their circulation in time and space, and documenting the ways in which new meanings are formed, or old meanings transformed, we can enrich our understanding of these masterworks. Aboriginal objects have circulated in many contexts: as gifts given on the occasion of village-to-village social dancing and feasting, in systems of long-distance trade and exchange, and as part of the colonial practice of acquiring works made by distant "others." In charting specific cultural biographies, it is important to distinguish among these various practices, and to differentiate carefully among the various forms of colonial collecting.

Notably, individual Yup'ik makers and owners of masks have generally discarded them after a festival. Preferring to create and dance with new masks the next season, they were often willing to sell or trade used ones. (This situation differs from that of many other regions of indigenous North America, where masks have long been collectively owned, ritually stored, and seldom willingly given up.) Because of this practice of discarding masks, significant numbers of Yup'ik masks came to be owned by museums around the world. Russian Orthodox priests began proselytizing in the Aleutian Islands before 1800, and various other Christian denominations, including Methodist, Catholic, and Moravian, came in the nineteenth century. These missionaries sometimes collected the masks that they forbade their converts to wear.[7] Beginning in 1877, explorer Edward Nelson had a scientific field station in St. Michael, a Yup'ik village on the Yukon River. He traveled across Arctic Alaska, collecting items and documenting Yup'ik culture for the United States National Museum (the forerunner of the Smithsonian's National Museum of Natural History). Called "the man who buys good-for-nothing things," Nelson traded useful items such as needles and thread, cloth, tobacco, and knives for masks and other indigenous cultural objects.[8]

The beginning of the twentieth century saw the arrival of teachers in the north, some of whom became collectors as well. Ralph Kelsay Sullivan and Anna Davis Sullivan were hired by the U.S. Department of the Interior to teach in Yup'ik communities from 1914 to 1920. During the two years they spent in Hooper Bay (1916–18), they attended dances and bought masks (cat. 38) and other objects.[9]

In the early twentieth century, museums often exchanged collection objects. Some from the Smithsonian made their way into the Museum of the American Indian in New York City, founded by wealthy businessman George Heye and opened to the public in 1922. (Today, Heye's museum is a part of the Smithsonian's National Museum of the American Indian.) For decades after opening his museum, Heye regularly de-accessioned objects. Parisian gallery

Fig. 23. Eskimo medicine man exorcising evil spirits from sick boy, Nushugak, Alaska. Photo by John Thwaites, 1924. Alaska State Library, John E. Thwaites Collection, J. E. Thwaites, P18–497

owner Charles Ratton recalled that he acquired Yup'ik masks in the early 1930s from Heye in exchange for ancient Peruvian gold.[10] During the 1940s, Surrealist artists who had frequented Ratton's gallery immigrated to New York and found Heye's storerooms contained many more of the masks they had come to know in Paris.[11] Many of these have since entered private collections, including two illustrated here (cats. 37, 39). Today, Yup'ik elders and artists use museum collections for the repatriation of knowledge, without seeking the return of the objects themselves. In contrast, Alutiiq people have successfully sought the repatriation of particular masks thought to have come from cave burials.[12] Most importantly, all across twenty-first century Alaska, Native artists use these ancestral works of art as inspiration for art-making in a host of media, new as well as old.

35.
Mask, 19th century

Chugach, Alaska
Wood, pigment, vegetal fiber
17 × 8 ½ × 5 in. (43.2 × 21.6 × 12.7 cm)
Diker no. 749

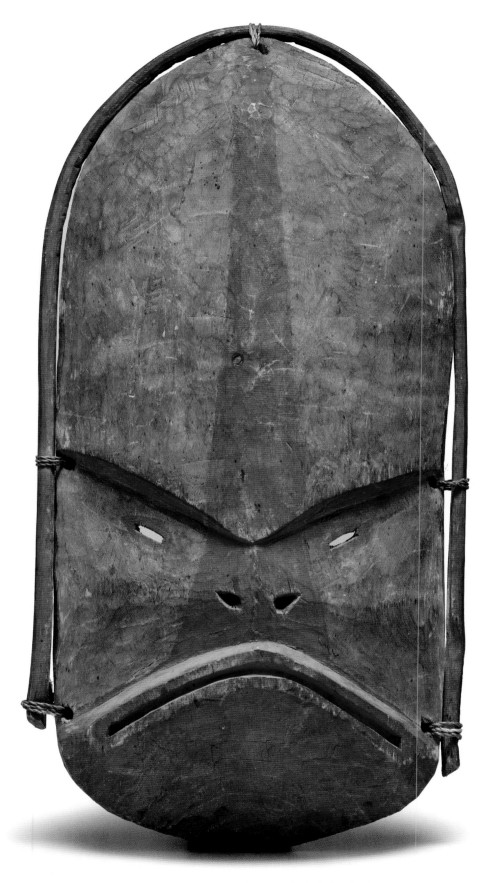

36.
Two masks, ca. 1870

Alutiiq, Kodiak, or Afognak, Alaska
Wood, pigment
Each mask: 16 ¹⁵⁄₁₆ × 9 ¹³⁄₁₆ × 7 ¹⁄₁₆ in.
(43 × 25 × 18 cm)
Diker no. 711

A pair of masks represents dangerous spirits known as *íyak* in the Koniag language of Kodiak Island. Such spirits usually belong to evil people who seek to influence the human world after their deaths. The two masks were carved with lips pursed in slightly different gestures. In Alutiiq tradition, spirits communicate through whistling; these sounds were interpreted by shamans, who could control the spirits' actions and use them as helpers in their work. The word *íyak* also means "one who is hidden," thus reminding people of the shaman's ability to reveal that which is ordinarily invisible to most people.[1] The pointed heads and pronounced nostrils of these masks are typical features of *íyak*. The relatively simplified forms of the carvings, as well as of the Chugach mask (cat. 35), reflect the Alutiiq tradition of visual abstraction, which seems minimal compared to the more complex constructions of the nearby Yup'ik region (cats. 37–39).

As art historian Judith Ostrowitz has pointed out, the modernist appreciation for such masks, starting in the early twentieth century, rested solely on the recognition of aesthetic value in objects created by cultures far from the European tradition: "Visual acuity was all that was required, not the specialized knowledge and group memberships of Native peoples or any familiarity with the voluminous texts that had been produced by turn-of-the-century anthropologists."[2] Today we seek to merge aesthetic and anthropological understanding, as well as contemporary Native insights, in order to fully appreciate both the depth of meaning and the artistic mastery in these objects.

1. Aron Crowell, Amy Steffian, and Gordon Pullar, eds., *Looking Both Ways: Heritage and Identity of the Alutiiq People* (Fairbanks: University of Alaska Press, 2001), 196, 208.

2. Judith Ostrowitz, "'Full of Blood, Thunder, and Springy Abandon': History, Text, and the Appreciation of Native American Art," in Ralph T. Coe, J. C. H. King, and Judith Ostrowitz, *The Responsive Eye: Ralph T. Coe and the Collecting of American Indian Art* (New York: Metropolitan Museum of Art / Yale University Press, 2003), 52.

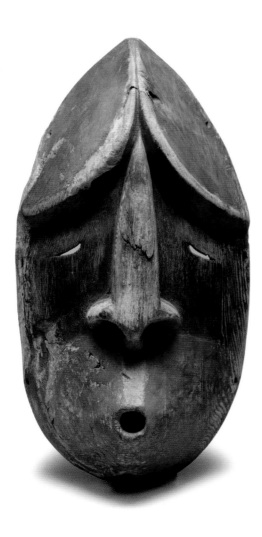

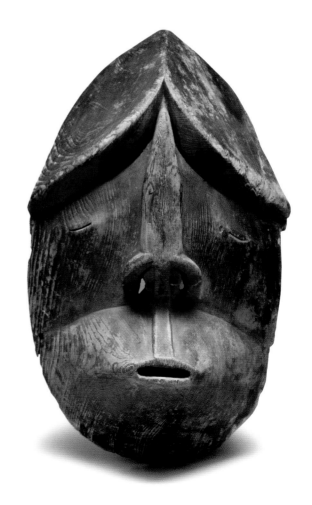

37.
Mask, 1916–18

Yup'ik, Alaska
Wood, pigment, feathers, vegetal
fiber, sinew, ferrous nails
33 ⅞ × 23 ½ × 8 in. (86 × 59.7 × 20.3 cm)
Diker no. 527

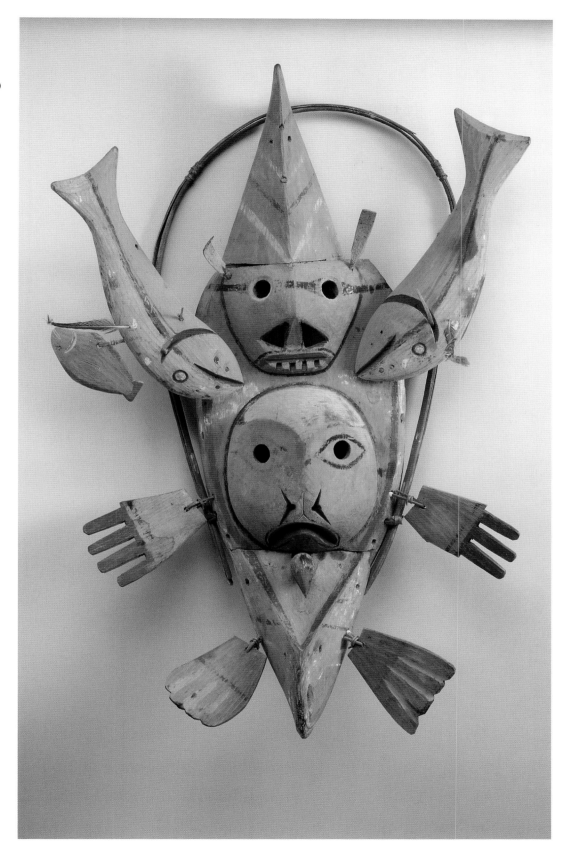

38.

Mask, 1916–18

Yup'ik, Hooper Bay, Alaska
Wood, pigment, vegetal fiber
20 ½ × 14 × 8 in. (52.1 × 35.6 × 20.3 cm)
Diker no. 788

This powerful spirit mask draws together creatures of air, sea, and land, all suspended in a willow hoop. In the center is a spirit face, with a seal and fish to the right and a loon to the left. Particularly surprising are the fingers of an oversize human hand, with fingernails demarcated boldly in white paint, grasping the fish that curves down the right side of the mask. In fact, these fingers do not connect to a hand: the back of the mask is uncarved. A dancer would have held the object flush against his face by clasping its rectangular wooden grip between his teeth. Such masks are deliberately frontal, for in the Arctic, masked dancers generally perform on a platform, facing their audience, with drummers and singers behind them.

We will probably never know the stories, songs, dances, and shamanic visions that went along with this arresting mask; it exists today, as Tlingit scholar Nora Marks Dauenhauer has remarked about the masks of her own culture, "like a movie without a soundtrack,"[1] giving us just a tantalizing visual glimpse of one of the world's great masking traditions. This is true of most objects that we experience in museums, outside of their contextual matrix, be it the eleventh-century Bayeux Tapestry, meant to hang in a cathedral; a painted Greek icon; or the countless masterworks made by Native North Americans and collected by outsiders fascinated by the cultures these objects represent.

1. Nora Marks Dauenhauer, "Tlingit At.óow: Traditions and Concepts," in *The Spirit Within: John H. Hauberg Collection from the Northwest Coast Native Art*, ed. Steven C. Brown (New York: Rizzoli; Seattle: Seattle Art Museum, 1995), 21.

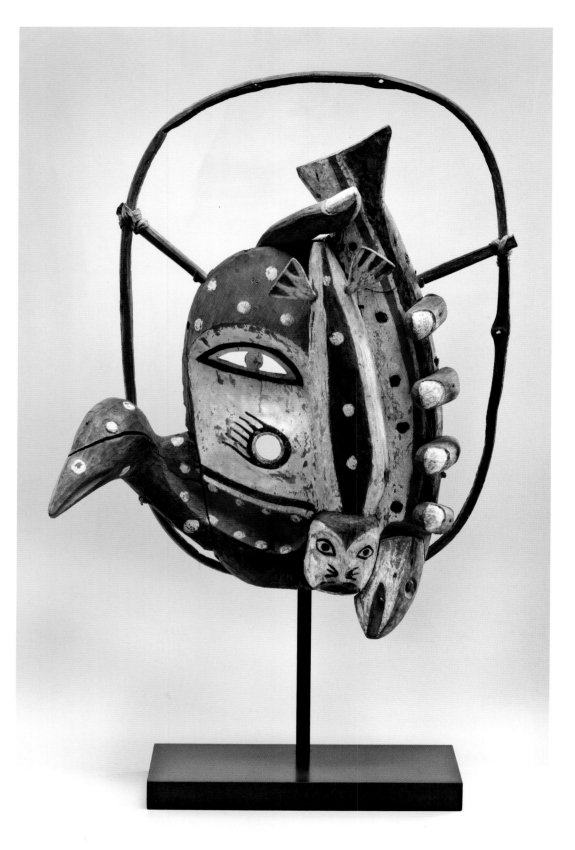

39.
Dance ornament, ca. 1900

Yup'ik, Alaska
Wood, pigment, feathers
10 ½ × 36 ⅛ × 28 in.
(26.7 × 91.8 × 71.1 cm)
Diker no. 526

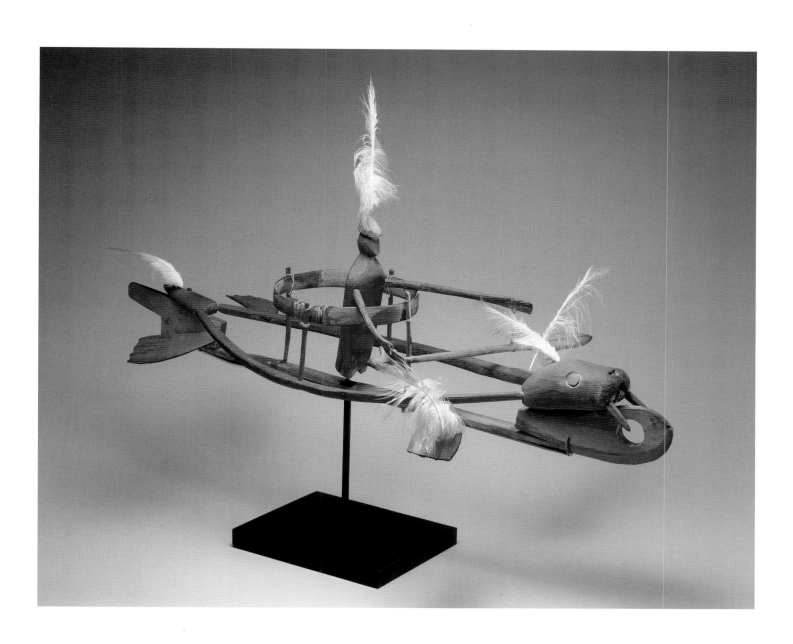

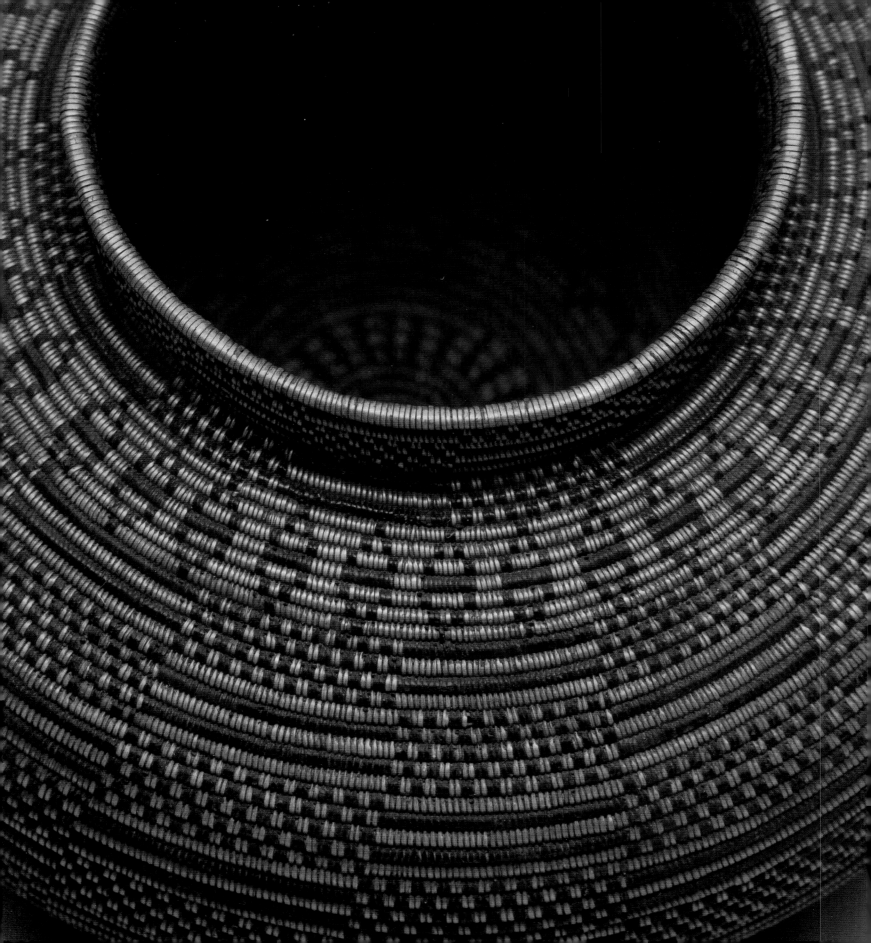

Western Baskets

Bruce Bernstein

Although Native American baskets may look simple, they are in fact technically sophisticated, extremely difficult to produce, and often sumptuous to behold. Like a sculpture, a basket poses challenges in three dimensions. There are no templates or models to guide the weaver — only the forms and decorative motifs in her mind, both of which are often typically associated with her family. Traditionally, baskets were the companions to indigenous lives: meals were prepared and cooked in them (fig. 24), worldly goods were stored in them, babies were carried in them, and they were given as gifts to mark an individual's entrance into and exit from this world.

Though women wove most baskets, men made some of the coarser and larger whole-shoot twined baskets, including fishing traps, and woodpecker and quail traps. Basketmaking was a family art form, the techniques of which were passed down from elders to their younger relatives. The practice was governed by a set of cultural rules, and while deviation could and did occur, adherence to these parameters was startlingly consistent. Weaving traditions continue to be strong and manifest; they are apparent, for example, in the choice to adapt traditional gift-basket forms to baskets intended for market, because those forms are most associated with the exchange or reciprocity inherent in the purchase of a basket.

The size of a basket is a calculus of the numbers of warp required to increase or decrease its girth. A change in color represents a change in sewing strand or weft. But weaving can begin only after the arduous tasks of harvesting and preparing basket materials, which take up fully half, if not more, of the total time needed to make a basket.

Understanding structure and technique is, of course, distinct from understanding creativity. Technical skill — the complicated process of coordinating materials, weave, shape, and design — is only part of a weaver's competence. Too often, when people think about Native American baskets, they assume that the weavers who make them are hemmed in by traditional rules that govern their production. But tradition is better understood as a set of values that guide the weaver's work rather than a static list of rules to be followed.

Baskets are often named or identified in terms of their "function" — for example, a winnowing tray, a cooking basket, or a gift jar. This terminology, however, can obscure the singular

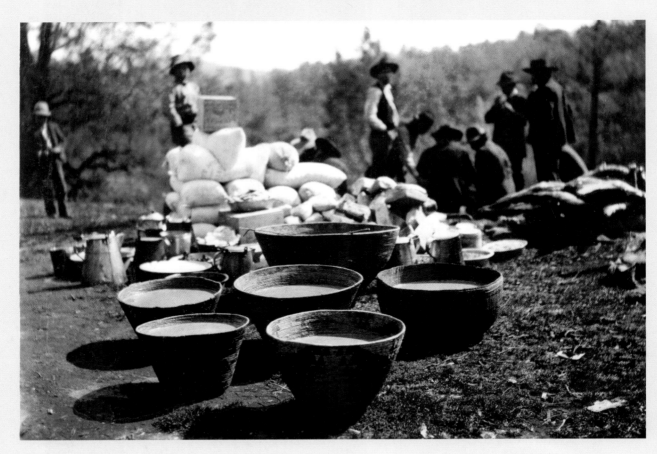

Fig. 24. Feast baskets filled with acorn mush at a Konkow-Maidu gathering, 1903. Foreman Ranch near Bidwell (Butte County), California. © The Field Museum of Natural History (Chicago), CSA 9525. Photo by John W. Hudson

melding of functionality and beauty that is a defining characteristic of Native baskets. In Anglo-American society the term "basket" implies something simple and even primitive, but great baskets like the ones illustrated here are sophisticated art objects that disprove these naïve notions. Consider for a moment the fact that there is no functional reason to decorate a basket with designs. Decoration adds labor — each design must be planned and executed — and requires that new and different weaving materials be harvested and prepared. From a functional perspective, an undecorated or plain basket would work just as well as a basket enhanced with decorative motifs, such as mountains, birds, and plants. But design and function in Native American baskets are inseparable, and herein lies the key to a deep appreciation of their aesthetics.

Baskets come from the landscape — plants are used in their construction and also serve as the inspiration for their designs — and thus, basketmaking may be seen as akin to constructing allegorical landscapes. Moreover, the foods and other goods stored in baskets come from the landscape as well. The transposition of "landscape" into the act of making a basket may be best understood as an eternal and continuous acknowledgment by Native American culture of the content and value of the natural world.

The art of baskets is expressed through a combination of materials, technique, and finished form. Although Western observers

Fig. 25. Three Tlingit weavers, Sitka, Alaska. The use of spruce root and plain twining are the iconic markers of Tlingit weaving. Alaska State Library, William A. Kelly Photograph Collection, P427–65

may know little about a basket beyond their generalized ideas about baskets and Native Americans, even the uninformed can appreciate its beauty by looking closely at the many intricacies apparent in the weaving process. Understanding how the finished basket seamlessly combines aesthetic beauty, technical skill, and cultural values enhances our appreciation of it.

Basketry was just one of many aspects of Native life that changed with the arrival of Europeans in North America. Although their use in everyday aboriginal life began to decline rapidly by the close of the nineteenth century, baskets became among the most sought-after art forms in America in a burgeoning market for hand-crafted objects in the late nineteenth and early twentieth centuries.

The art basket (fig. 25), described in popular literature of the early twentieth century as a "trinket basket" or "curio basket," was made primarily for the non-Native market and contributed to a new economic strategy. Individual weavers responded to the demands of the market with innovations, often modifying traditional forms, expanding their use of decorative motifs, and refining traditional techniques to superfine levels. In addition to accommodating the tastes of buyers, weavers may also have been exploring the limits of their own abilities and imaginations.

Adaptations for non-Native buyers are best seen as part of the long evolution of basket art. While all groups made certain modifications for the marketplace, some also created whole new styles. Smaller stitch size — meaning a greater number of stitches per square inch — became a gauge of quality. In addition, designs became more pictorial and detailed, as weavers learned to more graphically depict their homes and homeland for potential buyers. Since baskets are so intrinsically difficult to make, they were rarely reduced to the crass, mass-produced tourist commodities that some other Native art forms were. Even the most workaday weavers continued to produce objects distinguished by an adherence to cultural ideals of design and materials.

Among the hundreds of talented Native American weavers, a few women truly excelled at making extraordinary masterpieces. These visionary basketmakers challenged themselves to create virtuoso artworks distinguished by exacting attention to the harvesting and preparation of materials, experimentation with shapes and designs, and the perfection of weaving techniques. Unfortunately, we know very little about most of them. One of the strengths of the Dikers' collection of baskets is that it includes many works by known artists.

40.
Basket jar, ca. 1790

Chumash, Southern California
Juncus stems, sumac shoots
6 ⅛ × 8 ⅜ in. (15.6 × 21.3 cm)
Diker no. 363

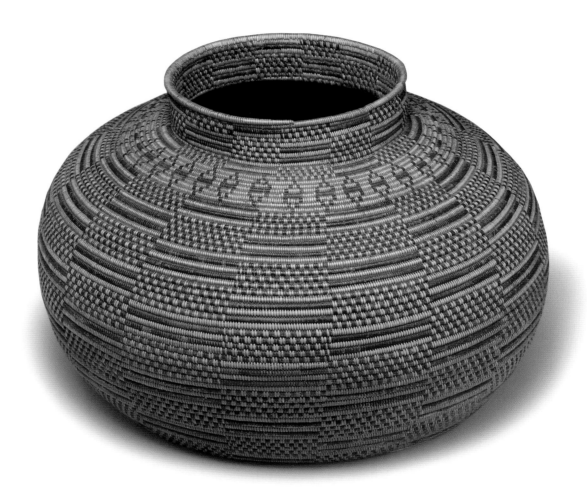

41.

Bottleneck gift basket, ca. 1880

Tubatulabal, Southern California[1]
Yucca root, devil's-claw seedpods,
sumac shoots, quail topknot feathers,
worsted wool
5¾ × 9¼ in. (14.6 × 23.5 cm)
Diker no. 362

The pleasing appearance of this basket is due to its exceptional detail, and the weaver's virtuosic skill in handling the diverse plant materials she wove together. Harvesting and preparing materials is arduous work, and there are no shortcuts or alternatives. Typically, more than half of a weaver's time is devoted to this stage of the process. Plants must be cut at the proper time of the year in order for them to be uniform in strength and color. The preparation of the freshly picked splints and roots is also vital to achieving rich, consistent tones. Details such as the source of water, the type of bowl in which the materials are soaked, and a clean work area are critical to producing stunning baskets. Once prepared, the materials are stored for a year or more to cure properly.

The different plants and variety of plant parts (roots, branches, and seedpods) create additional challenges for the weaver. Each plant reacts differently to water, swelling or shrinking while curing, according to its individual properties. This basket is woven on a three-rod foundation, sewn predominantly with red-brown yucca root, and embellished with designs of white sumac and black devil's-claw. Its "shoulder" is decorated with red wool and quail topknot feathers. The weaver used yucca root as the primary background color and sumac for accents — the reverse of what is typical in terms of materials. Yucca root is usually found in limited quantities on baskets because it is relatively scarce and difficult to harvest, while sumac is abundant throughout the Sierra Nevada foothills. The weaver would have to make a long trek to the east side of the Sierra Nevada to harvest yucca root, or would obtain it through trading.

The use of negative space in the design scheme is another exceptional feature of this basket. The scattered, seemingly disorderly placement of the designs — indicating a lack of concession to the non-Indian market — supports the attribution of a relatively early date.

1. For further information on Southern California Native basketry, see Bruce Bernstein, "Panamint Shoshone Basketry: A Definition of Style," *American Indian Art Magazine* 4, no. 4 (Fall 1979): 69–74; and Bruce Bernstein, *The Language of Native American Baskets: From the Weaver's View* (Washington, DC: Smithsonian Institution, National Museum of the American Indian, 2003).

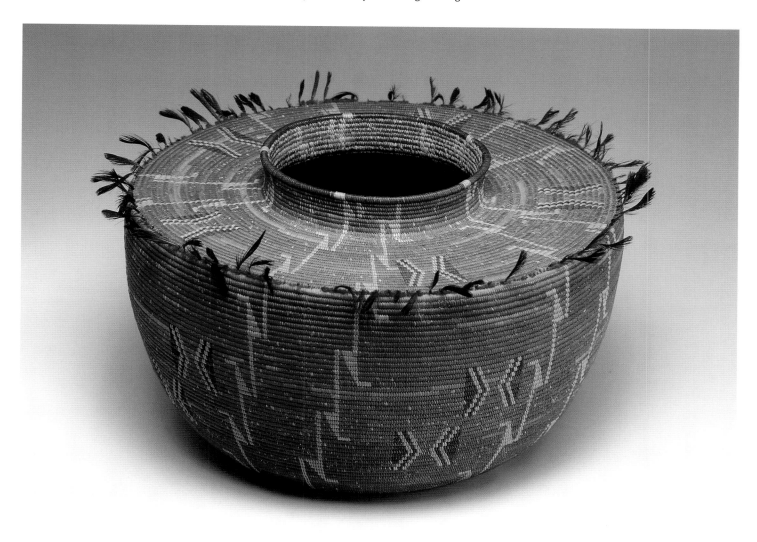

42.
Basket jar, ca. 1880

Tubatulabal, Southern California
Sedge root, bracken fern root, yucca
root, sumac shoots
5 ⅜ × 8 ⅝ in. (13.7 × 21.9 cm)
Diker no. 357

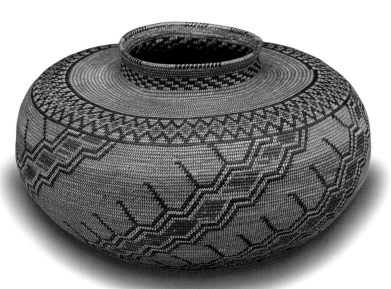

43.
Basket jar, ca. 1885

Chemehuevi, Southern California,
Arizona, or Nevada
Willow, devil's-claw
12 ¼ × 15 ½ in. (31.1 × 39.4 cm)
Diker no. 412

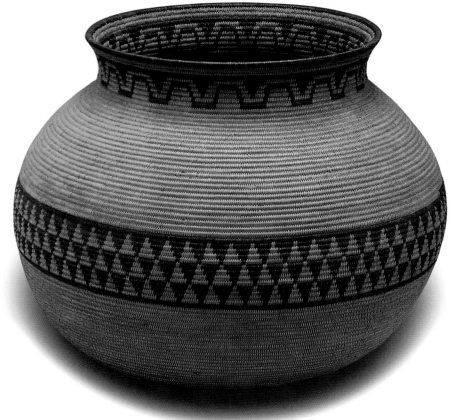

44.
**Louisa Keyser (also known as
Datsolalee, Washoe, ca. 1831–1925)**
Carson City, Nevada

Basket bowl, 1907

Willow shoots, redbud shoots,
bracken fern root
12 ½ × 16 ⅝ in. (31.8 × 42.2 cm)
Diker no. 326

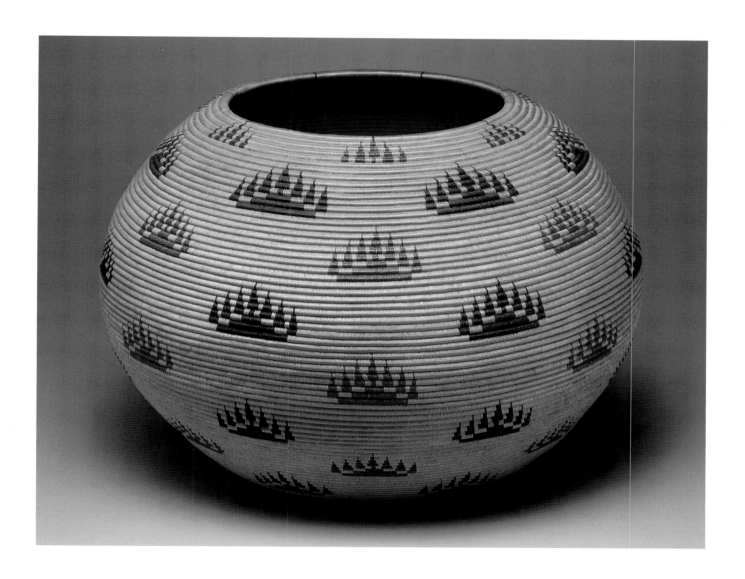

45.
Lizzy Toby Peters
(Washoe, 1865/70–?)
Nevada

Basket bowl, ca. 1904

Willow shoots, redbud shoots,
bracken fern root
7 ⅛ × 11 ¼ in. (18.1 × 28.6 cm)
Diker no. 359

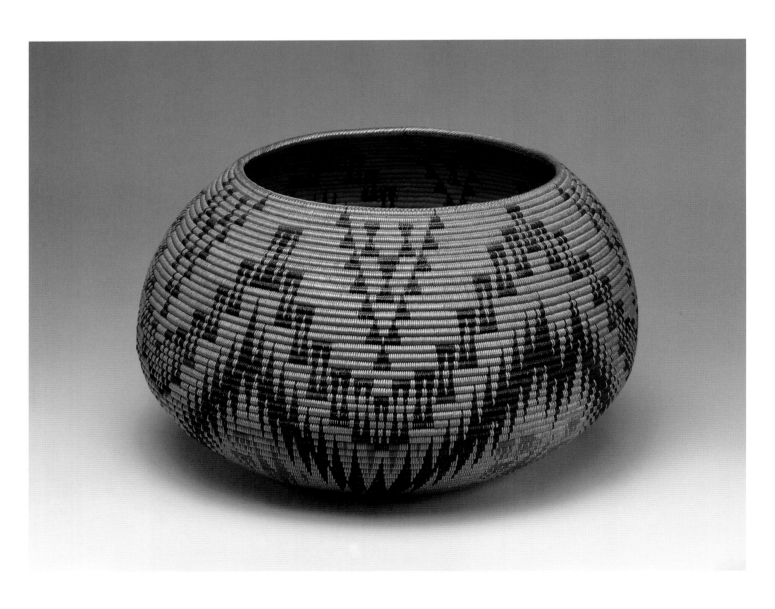

46.
**Lucy Telles (Miwok Paiute,
1885–1955)**
Yosemite, California

Basket bowl, ca. 1912

Sedge root, redbud shoots, bracken
fern root
5 × 9 ⅞ in. (12.7 × 25.1 cm)
Diker no. 356

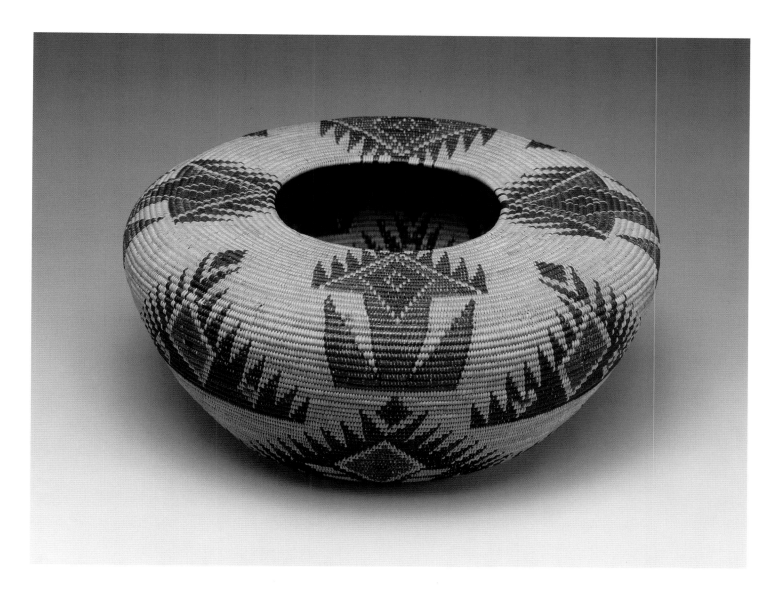

47.
Carrie Bethel (Mono Lake Paiute, 1898–1974)
Yosemite, California

Large basket storage jar, 1929

Sedge root, redbud shoots, bracken fern root, willow shoots
9½ × 20½ in. (24.1 × 52.1 cm)
Diker no. 706

Carrie Bethel[1] was born in Lee Vining, a tiny town on the east side of California's Sierra Nevada range. This storage jar was her first large-scale work (fig. 26), and it likely took her three years to complete. In 1929, she entered it in the Yosemite National Park Indian Field Days competition, a local annual celebration of Native cultures, and won the best basket prize of $50. It was purchased from Bethel that same year for $180, a terrific sum at a time when most newly made baskets sold in the $25 range.

Bethel never worked as a full-time artist; she was employed as a domestic and as a seasonal laborer in the San Joaquin Valley. The original collector of this basket noted that Bethel "does most of her weaving in the winter when she is snowed in."[2] She made hundreds of baskets during her lifetime, including beaded versions in a style that was just becoming popular, but produced only five large-scale baskets such as this one.

In the 1920s and 1930s, Bethel helped pioneer a new genre for the Indian Field Days. The new "fancy basket" style was distinguished by innovative polychrome design iconography and smaller stitch size. Bethel's work consistently demonstrates technical mastery anchored in an ancient weaving heritage. Although individual artistic expression and experimentation certainly contributed to fueling the development of the new style, it is also apparent that Bethel tailored her work to appeal to non-Indian patrons.

Creating a basket on this scale is an enormous challenge: harvesting and preparing the amount of material needed; weaving a piece with the requisite structural integrity; and maintaining the stability of the three-rod foundation, as well as the strength of properly prepared redbud and sedge. Along with the other originators of the fancy basket style, Bethel pioneered the use of sedge root in place of split-willow branches for the background or brown tone that shows on a finished basket. Sedge has more tensile strength and can be split into finer sewing strands. Bethel sometimes planned her design idea on a piece of paper. During the weaving process, however, the complex geometry, organizing, and spacing was all done in her head.

1. For further information about Carrie Bethel, see Craig Bates and Martha J. Lee, *Tradition and Innovation: A Basket History of the Yosemite–Mono Lake Area* (Yosemite National Park: Yosemite Association, 1990), 91–112, 136–38; and Brian Bibby, "Native American Art of the Yosemite Region," in *Yosemite: Art of an American Icon*, ed. Amy Scott (Berkeley: University of California Press, 2006), 91–114.

2. Aurelia McLain, original handwritten collector notes. McLain was a businesswoman, artist, and musician who moved with her husband in 1920 to Lone Pine, California, where they purchased a drug store. By the time of her death in 1969, her basket collection included more than four hundred pieces. McLain bought this basket directly from Bethel in 1929, and the Dikers bought it in turn from McLain's descendants through an intermediary.

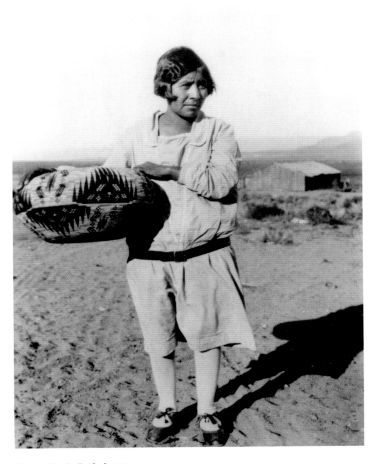

Fig. 26. Carrie Bethel, 1929. Bethel holds her first large-scale basket near her home in Lee Vining, California. Photo by Aurelia McLain. Courtesy of Yosemite National Park Research Library, YRL-18,746

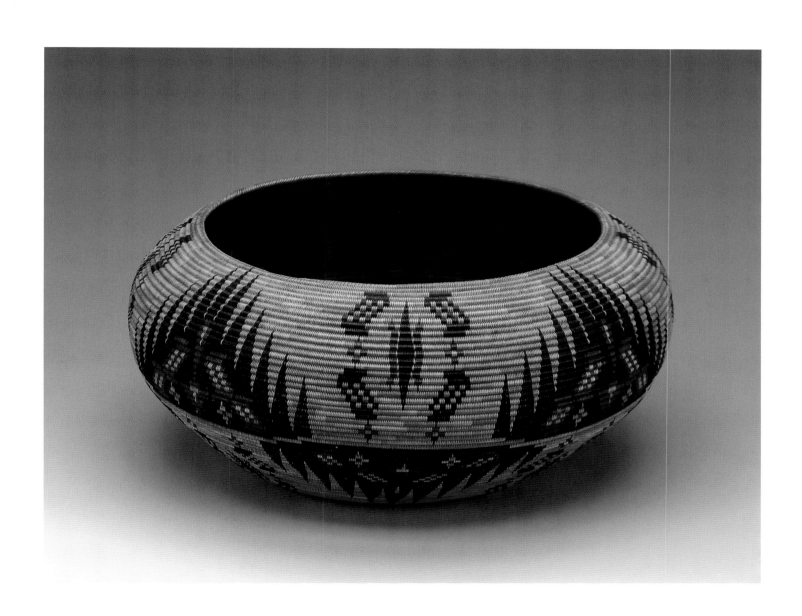

48.
Elizabeth Conrad Hickox
(Karuk, 1872–1947)
Somes Bar, California

"Fancy" lidded basket, 1917–26

Conifer root, maidenhair fern stems,
porcupine quills, hazel shoots
7 ⅛ × 8 ¼ in. (18.1 × 21 cm)
Diker no. 445

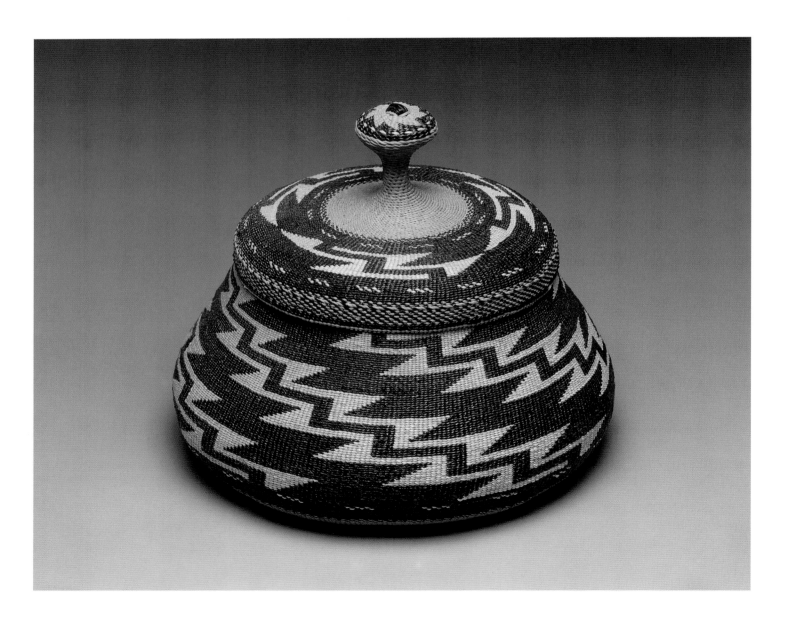

49.

Amanda Wilson (Michoopda Maidu, 1861–1946)

Rancho Arroyo Chico, California

Acorn-sifting tray, ca. 1910

Sedge root, briar root, willow shoots
15½ in. (39.4 cm) diam.
Diker no. 518

Unlike weavers who were known for creating new styles for the art basket market, Amanda Wilson[1] respected the boundaries of traditional basketmaking, never deviating from the proper and highly prescribed Maidu canon. The three-rod foundation and flat shape of this tray indicate that it was made to sift acorn meal. The mountain quail plume design points to the landscape that Wilson and her fellow Maidu had experienced for millennia. This tray is very similar to the acorn-sifting tray that Wilson herself used during her lifetime, which is now in a private collection. Along with the pattern, the use of rich brown sedge root and the black roots of the briar suggest that she learned and practiced her art in her home village of Rancho Chico or Bahapki,[2] near present-day Chico, California.

Wilson and her first husband, Holai Lafonso, were the respective heads of the women's and men's religious societies in their village. When Lafonso died in 1906, Wilson burned all of the village's religious paraphernalia, signaling an end to the practice of traditional religion at Chico, although practitioners continued in other villages. Along with her second husband, she became a devout member of the local Presbyterian Church. Wilson would serve as consultant to numerous linguists and anthropologists throughout her life, contributing to critical scholarly works on her people.

Wilson's work was treasured during her lifetime, and many pieces still remain in family hands. Only about two dozen works can be definitely attributed to Amanda Wilson, and very few pieces have made their way into museum collections.

1. Craig Bates and Brian Bibby, "Amanda Wilson: Maidu Weaver," *American Indian Art Magazine* 9, no. 3 (Summer 1984): 38–43, 69.

2. The Native name for the village translates to "unsifted," so called because Indians from several different villages and neighboring tribes resided there as part of the Rancho Arroyo Chico workforce.

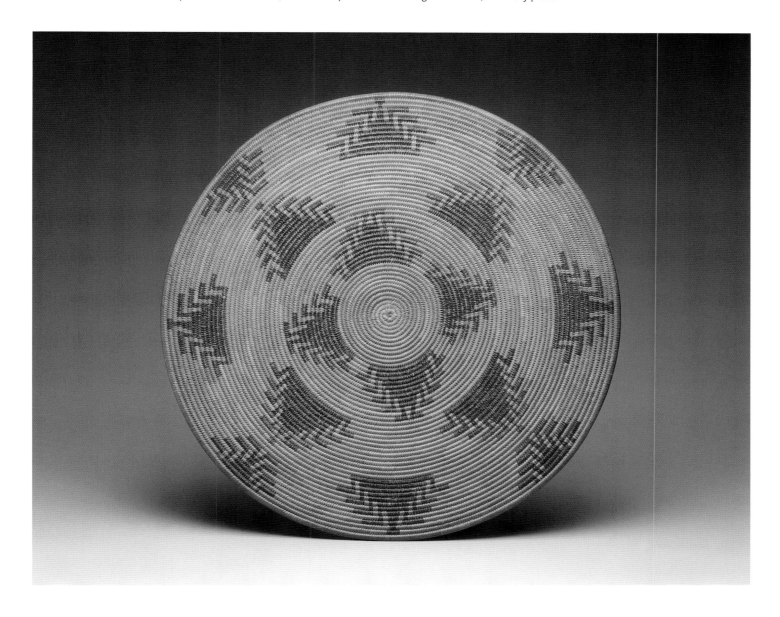

50.

Storage basket and lid, 1850–60

Mohegan, Connecticut
Black ash, pigment
12 × 17 × 17 in. (30.5 × 43.2 × 43.2 cm)
Diker no. 841

This eastern basket, made of black ash splints, is woven in a simple lattice. The technique of weaving baskets with trimmed splints of black ash was practiced throughout the northeastern region of North America, as far west as the Great Lakes. Although it was customary for Mohegan basketmakers to apply decoration to basket surfaces with stamps, here the maker used a brush to create the design scheme of stemmed plants with clusters of leaves.

Mohegan women made baskets of different functional and decorative types for sale, much like their counterparts from California. The addition of painted floral decoration enhanced this basket's attractiveness and hence its marketability.

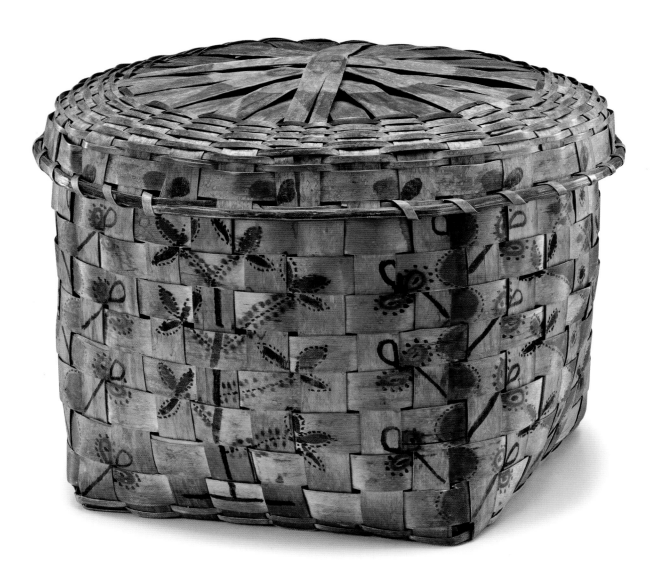

51.
Basket, ca. 1910

Tlingit, Alaska
Spruce root, grass
13 ⅝ × 15 ⅞ in. (34.7 × 40.2 cm)
Diker no. 406

52.
Basket bowl, ca. 1900

Tlingit, Alaska
Spruce root, dyed and undyed
beach or rye grass
8 ⅞ × 11 in. (22.5 × 27.9 cm)
Diker no. 845

This basket's compelling presence is a result of its authentic and direct portrayal of Tlingit people as they saw themselves in the nineteenth century: world citizens and worldly. The imagery reflects Tlingit and Euro-American cultures or a combination of the two, as well as the new wealth that fishing and trading had brought to some Tlingit communities during the late eighteenth and nineteenth centuries. Paradoxically, contact with the outside world also brought decimation from disease, governmental policies, and warfare. The basket is rife with cultural meanings and values, seen in the fine preparation of the spruce root weaving material, the use of archetypal plain twine weaving, and the choice of motifs, including houses, wolves, killer whales, and what appears to be a nighttime sky filled with stars.

The introduction of metal tools and the influx of tourists to Tlingit territory helped elevate basketry to new, higher levels. This weaver has used some store-purchased dyes to add color, and she chose to weave a heroic story into the basket. While we will never know the exact meanings of the story, the wolf depicted here is often considered a symbol of unity. It is also the crest of one of the Tlingit clans, whose members feel a deep kinship to wolves since these creatures also live and hunt in family groups.

In one legend, a great wolf with supernatural powers transforms himself into a killer whale so that he can hunt in the sea. It is believed that this is why killer whales have white markings and hunt in packs in the water, as wolves do on land. In another oral tradition of the Wasgo, or Sea Wolf, a great hunter brings abundant bounty to his mother-in-law's village. His greatest and last hunt yields three killer whales.

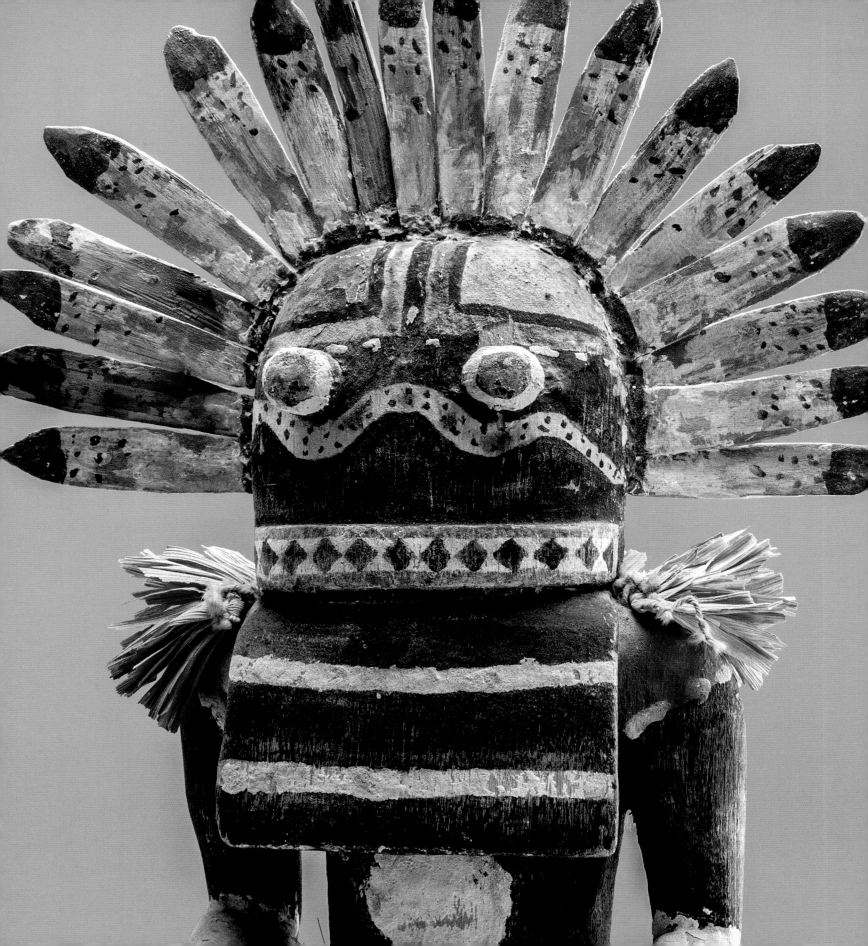

Katsina Dolls of the Hopi and Zuni Pueblos

Susan Secakuku

As a person born and raised on the Hopi reservation and who currently lives there, I have come to understand that, for Hopi people, the Katsina is believed to be a spiritual being that has superhuman abilities and offers spiritual aid to help us achieve a happier life. Hopi people know Katsinam (the plural of *Katsina* in the Hopi language) to be a positive source of assistance that we can call on to achieve more than would be possible on our own. They assist in many different ways: Katsinam serve as messengers of our prayers, taking our most sincere requests back to the spirit world to be answered. They can also control weather patterns, bringing wind, sun, and (most important) moisture in the form of rain or snow. They bless and offer seeds to the people, ensuring that germination will take place after planting. They dance to poetic, illustrative songs about the abundance of life in the world, which, sung in the Hopi language, serve as expressions of prayer. Katsinam also offer healing or medicine for physical ailments, and can alleviate stressful or anxiety-laden situations.

The Hopi world view includes knowledge and acceptance of spiritual counterparts to our everyday world. Hopi culture recognizes that we need redirection, guidance, and discipline, and that spiritual purification of our actions, carried out in religious ceremonies, is necessary to help us achieve happiness and a good life. While Katsinam offer us spiritual help, we as people must conduct ourselves accordingly, with the daily practice of positive thoughts, by being productive in making a living as farmers in a dry environment, and by assisting one another in any way possible. Katsinam are one aspect of Hopi religious practice, one way in which we maintain our spiritual connection. The goal of a Hopi is relatively simple — to achieve a long, happy life without sickness — and Katsinam help us along this path.

Hopi children who have shown exceptional kindness and generosity receive special items as gifts. Boys typically are given miniature bows and arrows and rattles, which help to prepare them for their roles as hunters, dancers, and singers. Girls receive beautiful baskets, plaques, or dancing sticks, which guide them toward their futures as basketmakers and dancers (fig. 27). The most prized gift, however, is a *tihu*, or Katsina doll, which is given only to young girls. The dolls are miniature versions of the Katsinam, but not exact replicas, as the Hopi believe one can never truly replicate a spiritual being.

Fig. 27. *Walpi maidens—Hopi*, 1906.
Photo by Edward S. Curtis. National
Museum of the American Indian,
Smithsonian Institution (P13696)

When they are young, Hopi girls who receive Katsina dolls play with them as any child would. The dolls are also used to encourage girls to prepare for motherhood. As girls get older and play with the Katsina dolls less and less, the objects are hung by a string on the wall or from a ceiling beam as decorative elements. (Although the dolls given in a traditional Hopi manner do not have bases, those carved for sale do, allowing them to be freestanding on a shelf.) The dolls remain in the home as the personal property of the woman to whom they were given, serving as personal mementos and documentation of a sort: the age of the girl when she received the doll, the ceremony at which she received it, and what she might have learned from playing with it. Women generally do not hand down their dolls to their own daughters.

Although Katsina dolls continue to be given as gifts to young Hopi girls and remain a vibrant aspect of Hopi life, their popularity has grown far beyond the community. Acquired as art pieces by museums and collectors worldwide, they are perhaps appreciated by non-Hopi people as much for their diversity as for the fact that they serve as reminders of a beautiful and unique Hopi expression. The art world has categorized Katsina doll carvings into two styles: traditional and contemporary. Traditional Katsina dolls are fairly abstract in nature, showing relatively little detail and not proportionate to the human form. Contemporary styles are much more detailed, with intricate parts carved rather than painted on. They also imply movement or action, and their proportions closely resemble those of the human form.

In Hopi culture, all knowledge and information — but particularly religious knowledge — is given and received in limited and careful ways. The Katsina is fundamentally a religious practice, and as such, the sharing and understanding of its meaning is intended only for those engaged with it. This has become the basis of conflict for some Hopi people as they witness the buying and selling of objects related to Katsina culture outside the Hopi world. A conservative Hopi outlook would limit all non-Hopi use of our culture, including that found in the art world. More contemporary views accept and promote, at the very least, the making of Katsina dolls for sale for a number of reasons: the sale of these objects has been going on for close to one hundred years; the dolls make a valuable contribution to the art world; and the sales provide income for some of our community members. These opposing attitudes continue to coexist today, in the small, complex world of Hopi, where we are desperate to maintain practices and values that are so different from the larger American community, of which we are also a part.

53.

Hiilili Katsina, 1910–30

Zuni, New Mexico
Cottonwood, cotton fabric, yarn,
hide, leather, feathers, hair, paper,
metal, shell, nails, cotton thread,
grass, pigment
18 × 6½ × 3 in. (45.7 × 16.5 × 7.6 cm)
Diker no. 280

Hiilili is a member of the whipper
family of Hopi Katsinam. There are
many diverse kinds of whippers,
whose charge it is to serve as either
guards of other chief Katsinam or
disciplinarians of the people. Hiilili
normally carries a cluster of yucca
leaves tied together. These long,
strong fibers act as a whip, sending
the message that people should not
get too close. Whippers are energetic
and always on the move, showing no
signs of weariness. They are also
quick to react to any situation.
Nonetheless, they are considered a
positive influence in Hopi life
because they help to keep people on
a good path.

All Hopi Katsina dolls are made
from the root of the cottonwood
tree, which is porous, light, and easy
to manipulate. In older, traditional
forms of Katsina dolls, all elements of
the piece are usually carved into the
wood and then painted to convey the
look of clothing, feathers, bells, and
other accoutrements. In the early
twentieth century, the style of Hopi
carving began to change. By the
1950s, carvers were routinely adding
non-carved materials, including
cloth, animal hair, and bird feathers,
to their carved dolls. This particular
piece contains a large variety of such
elements, which is characteristic of
the Zuni style of Katsina doll carving.
This doll may have been made by a
Zuni carver, or was perhaps carved by
a Hopi person who had been
influenced by that style.

54.
Qötsa Nata'aska Katsina, 1910–30

Hopi, Arizona
Cottonwood, cloth, hide, metal,
pigment
18 ½ × 6 × 10 in. (47 × 15.2 × 25.4 cm)
Diker no. 831

Nata'aska serves as an uncle of the
ogre family of Katsinam who visit the
Hopi villages in late winter. The role
of this Katsina family is to purify the
Hopi people: to discipline and
cleanse them of recent bad behavior,
as well as to remind them to abide by
the responsibilities of Hopi life.
Primarily a meat eater, this Katsina
carries a large saw to cut up bones.
The Hopi regard members of the
ogre family of Katsinam as very
sacred in nature because of their
ability to take life. As a result,
cultural protocol within the Hopi
community would normally prohibit
the carving of this Katsina into a *tihu*.
The interest of non-Hopi collectors in
Katsina dolls as art objects, however,
has had a strong impact on these
protocols. Collectors looking to
acquire a large variety of Katsina
dolls create a market for dolls that
may be outside of Hopi cultural
norms. The creation of this piece is a
direct result of the outside market
and collectors' interest in Hopi
Katsina doll carvings.

55.
Hania Katsina, 1910–30

Hopi, Arizona
Wood, cotton, wool, feathers, metal
cones, hide, pigment
16 × 3¾ × 4 in. (40.6 × 9.5 × 10.2 cm)
Diker no. 317

56.
**Situlilu (Rattlesnake) Katsina,
1910–30**

Zuni, New Mexico
Cottonwood, pine, gesso, pigment,
dyed horsehair, cornhusk, cotton
cord
14½ × 7 × 2¾ in. (36.8 × 17.8 × 7 cm)
Diker no. 835

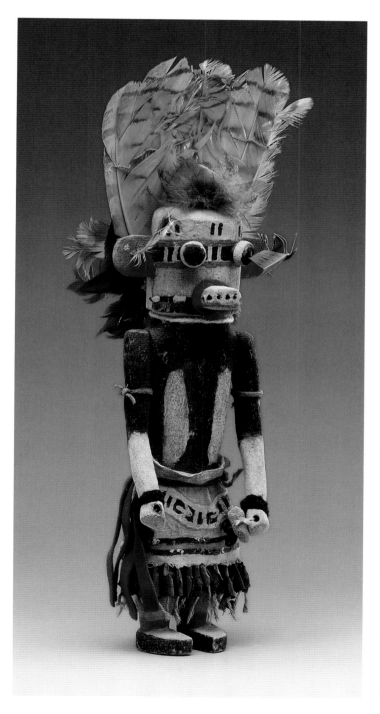

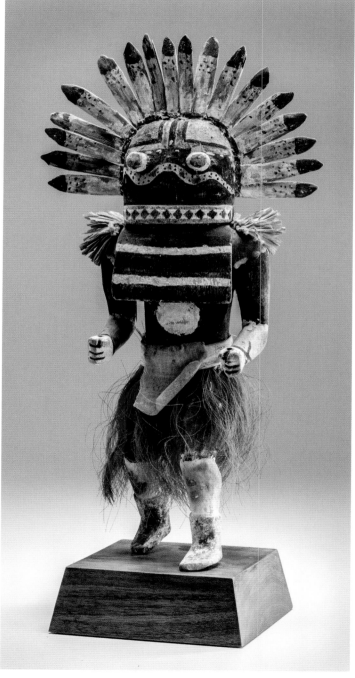

Southwestern Pottery

Bruce Bernstein

Pottery has been a constant for Pueblo people for two millennia: always present, forever evolving to reflect the historical and cultural circumstances of their lives, adapting to and adopting cultures and history, both independently and synergistically. The technical principles underlying this highly malleable substance are remarkable for their inherent simplicity: clay-rich earths are formed into shapes and irreversibly transformed into water-resistant objects by high heat. These principles of forming and firing, coupled with considerable variation in the raw materials used for ceramics, open almost unlimited possibilities in the hands of potters.

Pottery incorporates myriad ideas, from ancient iconography to new tools and materials, but one of its core purposes is to accurately present the values and principles of Pueblo cosmology through the melding of beauty and function. The choice of materials, manufacturing techniques, and shape are all dictated by cultural practice — what we might characterize as "tradition." In addition, potters include designs that are derived from the landscape and from the universe of items the pot will hold; in this way the pot is sympathetic and empathetic to the foodstuffs and liquids it contains, serving as a prayer for the continuation of nurture, growth, and water. Because of the association with Mother Earth and the creation of life in the forming of pots made of clay, pottery was traditionally part of the female world (fig. 28); men helped only with digging the clay or firing. Today, however, being male is not a hindrance to becoming a potter.

At each historic turning point in Puebloan history, pottery changed to reflect new ideas and the passing of old ones. Such was the case when Puebloan ancestors abandoned the cities of Chaco Canyon, located in northern New Mexico, in the twelfth century. Black-and-white pottery traditions that had thrived for more than half a millennium virtually disappeared until they were revived in the nineteenth century. The late fourteenth-century introduction of glaze wares was a purely indigenous invention, but the making of such pottery was discontinued when Spanish settlers were banished from New Mexico during the Pueblo Revolt in 1680. As the Spanish returned over the next half century, Pueblo people incorporated new crops into their farming, and also suffered new injustices. Both of these developments — along with many others — can be read in their pottery, from jars and bowls that featured new designs and

Fig. 28. Women carrying water back to their homes from the community well in Santa Clara Pueblo, 1910. The pots are filled, as evidenced by the dipper showing above the rim.

iconography to the eventual diminishment of pottery in favor of manufactured goods at the turn of the twentieth century.

Nonetheless, Pueblo pottery is remarkably consistent. While designs change according to fashion, the techniques for making the pottery remain steadfast. The process begins with the hard, time-consuming work of gathering clay from pits that have been used for generations. Once it is collected, the clay is dried and then soaked to remove impurities. Finally, it is sieved to remove stones, roots, and other foreign matter. Once the clay is ready, a temper is added to reduce shrinkage and cracking during drying and firing. A variety of tempers have been used at different Pueblos and during different periods in Pueblo history, the most common being crushed rock, sand, and crushed potsherds. Some clay naturally contains a sufficient amount of mica so that it needs no further temper.

Potters tell us that clay is alive, part of Mother Earth, and from it they form life. Potters speak to it, pray to it, revere it. Once the clay is prepared and ready to be used, it embodies both newborn and ancient life. The fertility is palpable in the heated and humid room, where the potter's hands prepare to give birth to new vessels. Coated with rich, earthy textures, soft and sensuous, they begin their work.

Pueblo pots are made by the coil and scrape method, in which no potter's wheel is used. The potter's fingers skillfully pinch together successive coils or ropes of clay to construct the walls of the vessel, each successive coil built on the previous one. Coil junctures are smoothed and scraped with a curved tool such as a shaped piece of gourd or a pottery shard; potters have adapted many implements for this purpose, including Popsicle sticks, hairbrush handles, can lids, and kitchen knives. Potters today generally smooth their pots with sandpaper, a material that most consider an improvement over the volcanic ash or tufa stones used in the past.

Once the pot is smoothed and then dried, it is decorated in a variety of ways. Some potters impress the wet clay to create their designs, while others carve them when the clay has dried to the hardness of leather. In some villages, slip, a watery clay mixture, is

applied as a milky-white base on which to paint designs. In other villages, a different type of slip is used to create a soft, deep, resinous shine that serves as the pot's finish. This slip is applied in ten or even twenty coats, each while there is a touch of dampness in the previous coat. While the final layer of slip is still slightly damp, the pot is polished using a smooth river stone. Once the potter begins to apply the slip, she cannot stop working until the polishing is completed.

Most pots are painted or decorated. Potters usually use black and red paint on white slipped pots (cats. 58, 59). Although polished black pottery is painted as well, potters use a material that is more akin to slip than paint. The jar made by Maria and Julian Martinez in 1918–19 (cat. 64) was one of the first to use this type of slip. Today many potters combine mineral and organic (vegetal) paints or mix them with commercial paint powders. Black vegetal paint is made from the Rocky Mountain bee plant, boiled down into a solid cake form, and then reconstituted with water when needed. Traditional paintbrushes are made from yucca leaves, but some potters prefer store-bought sable brushes.

Firing pottery is the true test of a potter's abilities. Firing outdoors in an open fire, as potters have done for centuries, adds an exponential level of complexity because of the vicissitudes of combining weather, fuel, and fire. One of the main variables is the type of fuel used — cottonwood bark; juniper, pine, or cedarwood; coal; sheep, horse, or cow manure — each of which burns at a different rate and temperature.

Pots are usually fired in the early morning. A potter might preheat the pots in the kitchen oven or near a fire that also serves to warm the ground where an outdoor kiln will be built. Kindling is stacked on the ground, and metal grates or other devices are placed on top of the fuel to keep the pots out of the fire. (Large pottery shards were used for this purpose in the past.) The fire is lit and allowed to burn down. The pots are then placed on the grate, and the fuel — most commonly cottonwood bark or manure — is stacked, along with more wood, around the pottery, and ignited. To make black ware, the potter smothers the fire with crushed dung, sometimes mixed with straw, which creates a lot of smoke, reduces the oxygen, and produces black, carbonized surfaces on the pottery. Firing is a delicate process; any imperfections or air bubbles in the clay may cause the pot to explode, possibly shattering or damaging other pots as well. While they are still warm, the pots are removed from the fire and wiped off.

The Diker Collection includes historical and contemporary pottery all made in the time-honored traditions described above. When Nancy Youngblood (cat. 65) fires her pots (fig. 29), she is doing what her female ancestors have done for centuries, using the same technologies and types of materials. Although Youngblood incorporates specially made metal components in her firing, her pottery is exposed to the same fire that has always been the final challenge of making Pueblo pottery. Her prayers are for her pottery, and for all those who have gone before and will come after her.

Fig. 29. Nancy Youngblood firing pottery, 2013. Today's potters use a variety of metal boxes and cages to protect their work from falling embers, which might mar their work. Wood and manure are used as fuel.

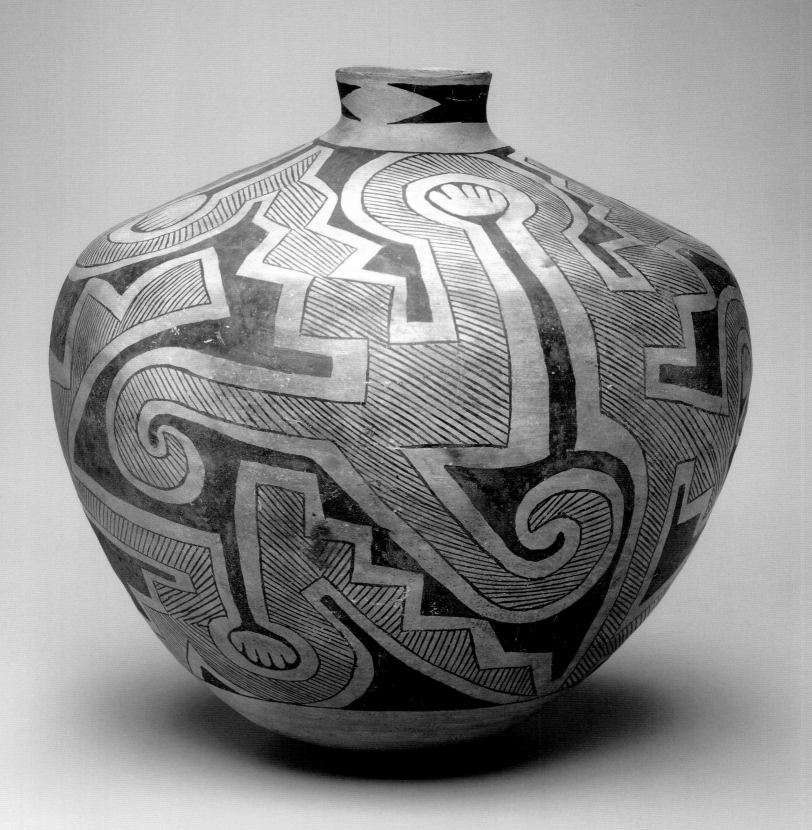

57.
Water jar, ca. 1150

Ancestral Pueblo, New Mexico
Clay, slip
15⅛ × 15⅞ in. (38.4 × 40.3 cm)
Diker no. 313

58.
Water jar, ca. 1750

Pueblo of Acoma, New Mexico
Clay, slip
10½ × 11½ in. (26.7 × 29.2 cm)
Diker no. 310

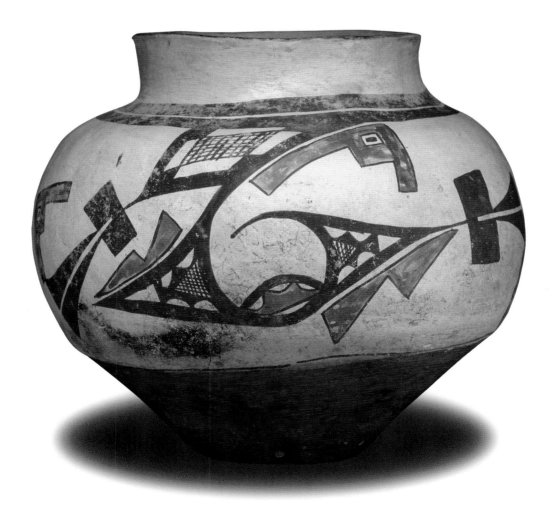

59.
Storage jar, ca. 1760

Tewa or Powhoge, New Mexico
Clay, slip
19 × 16 ⅝ in. (48.3 × 42.2 cm)
Diker no. 307

In the eighteenth century, vast social changes brought on by a declining Pueblo population due to smallpox epidemics, Spanish colonization, and unrelenting raids by Apachean, Ute, Navajo, and Comanche Indians would begin to have a dramatic impact on pottery making. Moreover, by the close of the century, the development of wheat agriculture and new trading patterns would result in new Tewa pottery forms — most notably, large round-bottomed storage jars. By 1800, a new orthodoxy of Pueblo pottery use and aesthetics had taken hold.[1]

The profound changes in pottery included the abandonment of traditional designs and forms. Some suggest that this was primarily the result of pottery being made for non-Pueblo as much as Pueblo consumption. But designs may also have been forgotten or dropped from use because of population loss, the diminishment of arable land, and lack of access to water and resources due to increasing pressure from the Spanish colonial government and expanding settlement. The standardization of shape and size during this period probably correlates with the pottery's use as a measuring device and a storage container for wheat produced for trade or barter. Finally, animal manure began to be used as a firing fuel, supplementing wood, at this time. The use of manure points to several significant changes in the Pueblo world: the introduction of domesticated cattle, sheep, and horses into indigenous lives; the construction of corrals to hold these animals, which altered the traditional spatial relationship between agriculture and the village; and the effects of restrictions placed on Pueblo land use by Spanish administrators, particularly those that reduced common-use areas where wood might be gathered.

The use of animal manure may have been a last resort, a way to ensure the continuation of pottery making, but requiring other changes like those to iconography.

The well-preserved state of this jar suggests that it was used in a storeroom and not moved about like smaller bowls and water jars would have been. Its style is distinguished by an upright form with a bulging mid-body, a short neck, and a red band separating the base, burnished with polished stone, from the snowy white slip of the pot's main body. The characteristically thick, opaque paint is made from the boiled leaves and stems of the Rocky Mountain bee plant.

This pot is dated to the 1760s because of its use of single framing lines, the division of the body into two design bands with a third neck band, the red rim, and the inclusion of Zuni or Acoma leaf forms — all typical of the period.

1. For further information about Pueblo pottery, see Francis Harlow, *Matte-Paint Pottery of the Tewa, Keres, and Zuni Pueblos* (Santa Fe: Museum of New Mexico, 1973); and Larry Frank and Francis Harlow, *Historic Pottery of the Pueblo Indians: 1600–1800* (Boston: New York Graphic Society, 1974).

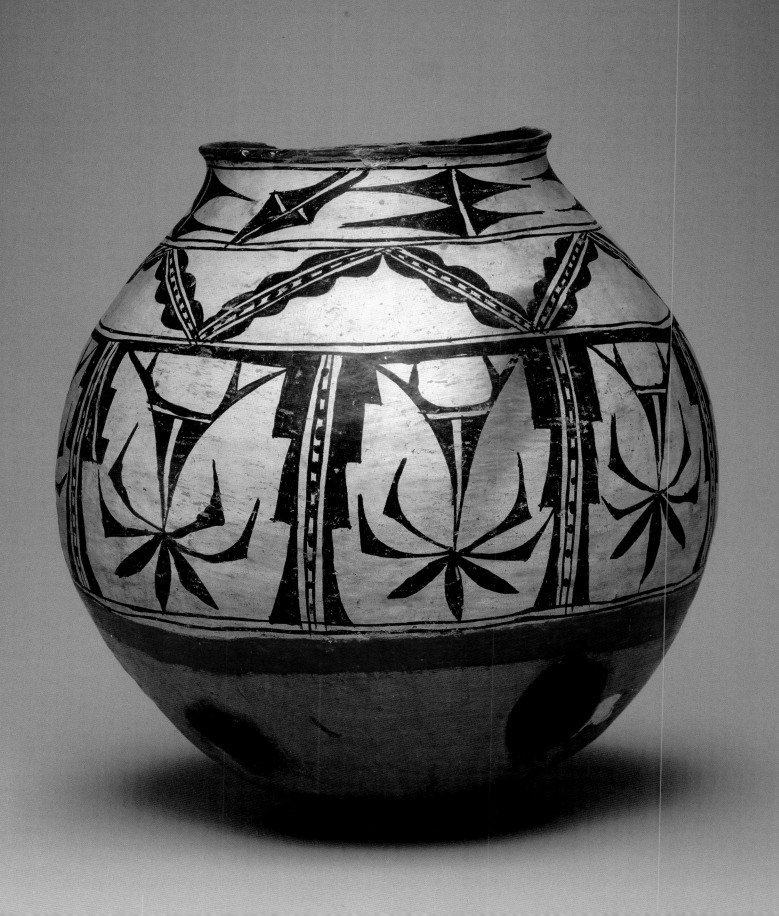

60.

Double-lobed canteen, ca. 1860

San Ildefonso Pueblo, New Mexico
Clay, slip
8 × 11½ × 4 in. (20.3 × 29.2 × 10.2 cm)
Diker no. 782

This canteen was made to mirror the duality of the Tewa universe, reflected in the construction of two chambers to hold water as well as in the iconography of earth and sky, plant life and rain, and male and female. The pot could just as easily be called a ceremonial water jar as a canteen because there is little separation between the secular and sacred in the Tewa world. The canteen is built to metaphorically represent the two worlds and the duality that Tewa find in all living things.

The potter designed the handle to make the vessel easy to lift and tilt as well as to visually unite the two bulbous forms. The round forms represent gourds, their long stems reaching up to form a single spout.

The canteen's painted decoration is replete with water imagery: clouds, mountains, birds, feathers, and green plant growth. In the New Mexico high desert, rain and moisture is life itself. Rain, of course, comes from the clouds, which form in the sky near the mountains, while feathers represent the prayers sent up to the clouds to help bring rain. Birds are potent beings, given their association with riparian areas on earth and their ability to fly toward the clouds, carrying prayers.

The designs are oriented on the double jar as they would be on an altar. At the apex of the spout and under the mouth of the canteen, there is a mobile hanging from the sky. Underneath, painted with curvilinear lines, there are clouds, plant life, birds, and cloud beings, framing the imagery of the pottery just as plants and clouds frame the world. On each end of the pot, there are birds. Careful examination of this pot reveals an intentional asymmetry, a quality often found on Tewa pottery of the time.

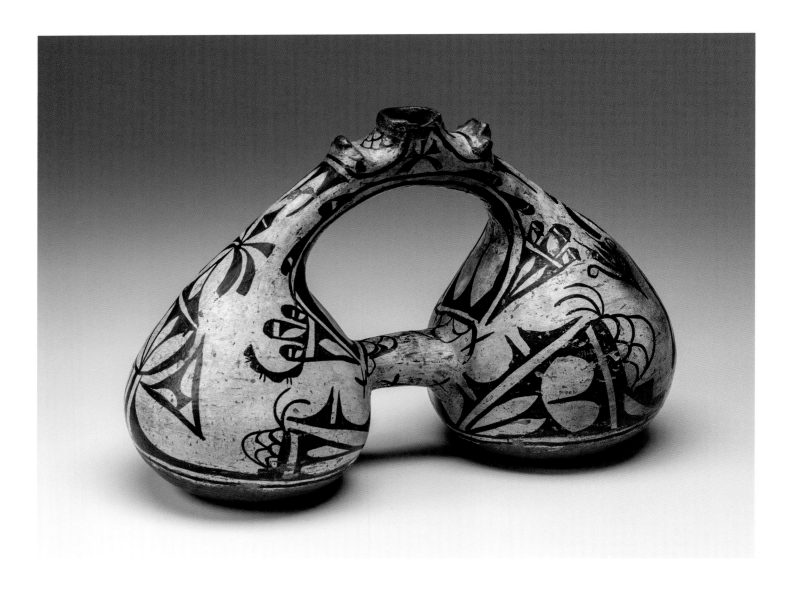

61.

Water jar, ca. 1890

Pueblo of Acoma, New Mexico
Clay, slip
9 ⅞ × 11 ¾ in. (25.1 × 29.8 cm)
Diker no. 306

This jar exemplifies Pueblo potters' long history of innovation. There is no precedent for the pictorial imagery of pumpkins, nor is any similar Acoma pot known.[1] While pictorial imagery is occasionally found on Acoma pottery after 1870, it is usually in the form of birds or a few isolated elements — nothing as graphic or as realistically rendered as here.

The beautiful rendering of the pumpkins, corn, and vines is striking, a masterpiece of realism, especially given the degree of difficulty involved in painting on a three-dimensional surface. Acoma people in the late nineteenth century had access to seed catalogues and magazines, which may have been the source of inspiration for this graphic design. Although well-meaning traders tried to influence pottery design by introducing ideas to potters that they believed would appeal to tourists, the unique and complex design on this pot suggests it was exclusively Native in choice and execution.

Equally prominent is the potter's use of the standard body layout of a repeated primary design (the pumpkins) interspersed with a divider panel (corn). The upper shoulder is separated from the body of the pot by a double framing line. The shoulder is decorated with black and white geometric forms and hatchuring, a design element based on the indigenous revival, beginning around 1820, of ancestral pottery dating from the tenth to thirteenth centuries. While we may never know the potter's identity or the origin of the unusual design, the pot's shape, its superfine thin walls, and the revival elements on its rim and shoulder indicate the piece was made between 1890 and 1910, during the height of the polychrome era of Acoma pottery production.

1. For further reading about Acoma pottery, see Rick Dillingham, *Acoma & Laguna Pottery* (Santa Fe: School of American Research Press, 1992); and Dwight Lanmon and Francis Harlow, *The Pottery of Acoma Pueblo* (Santa Fe: Museum of New Mexico Press, 2013).

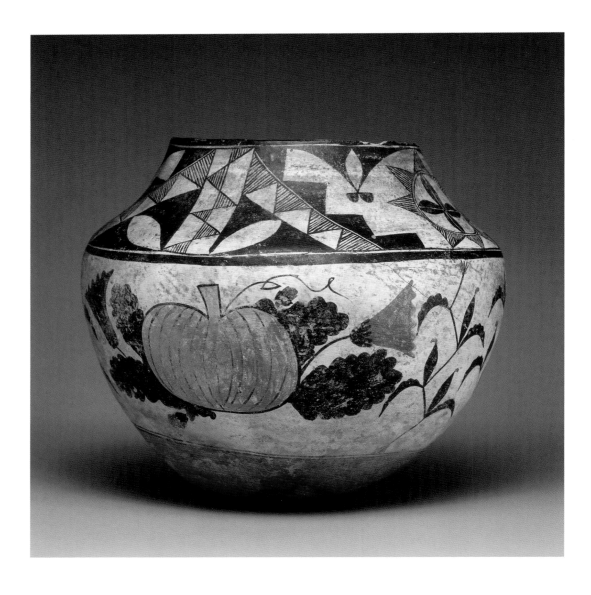

62.

Embroidered manta (dress), 1850–60

Pueblo of Acoma, New Mexico
Handspun natural yarn, twill, dyes
48 × 58 in. (121.9 × 147.3 cm)
Diker no. 790

The combination of unusual floral and more common geometric design elements made with elaborate red embroidery on this *manta*, or formal dress, parallels historically similar design combinations on pottery of the time from the same Pueblo community. The wool was spun with precision, with the brown color carded from belly wool and indigo expertly used to dye the lighter wool an exquisite and subtle blue. The use of twill weave creates an interplay of dyed and carded wool with the cochineal-dyed red embroidery. When worn under the crystalline blue New Mexico skies, the horizontal sections of the *manta* would serve as a symbolic reminder of the layers of worlds the Pueblo passed through on the surface. The similarity between the floral motifs on the *manta* and on the pottery is intentional. Flowers, vines, and leaves are associated with fertility, and a potter's use of these motifs is a visual prayer for water or fertility. Worn during a public dance, the *manta* reminds participants and audience that dances and songs are intended as prayers for rain.

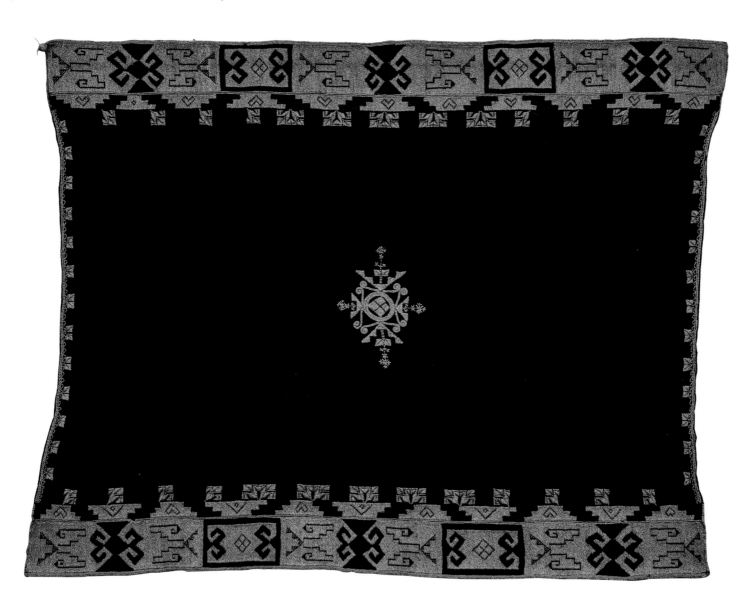

63.

Nampeyo (Hopi-Tewa, 1860–1942)
Hano Village, Hopi, Arizona

Water jar, ca. 1900

Clay, slip
12 × 13½ in. (30.5 × 34.3 cm)
Diker no. 824

Nampeyo (fig. 30) was a visionary artist, the rare individual whose work inspires excellence and change.[1] Her career was characterized by a love of experimentation, innovation, and creativity, and her pottery has influenced generations of potters up to the present day.

Like most Hopi-Tewa girls, Nampeyo began making pottery at a young age, and she excelled at all phases of the process. Her technical skills would become unsurpassed and her aesthetic sensibilities unequaled. As a Pueblo potter, Nampeyo harvested her own clay, cleaned and processed it, and used paints from organic and mineral sources. She sought out new clays and paints, painstakingly investigating their qualities to effectively mold pottery under the naturally dry conditions of Hopi, to ensure that paint would adhere to the pot's surface and that the finished piece would not pit or crack during firing.

The designs on this storage jar are a combination of contemporaneous and ancient, based on interpretations of the pottery of the Hopi people and the ancestral pottery of the Northern Arizona area. The body of the vessel includes a stylized depiction of a Katsina or "friend" figure. These beings live half the year in the clouds and the other half nearer to the Hopi villages, ensuring fertility and prosperity, particularly by fulfilling prayers for rain. Public dances include the magnificent and emotionally moving Katsinam (plural of Katsina), which have long fascinated the non-Hopi world. The figure here is drawn in a straightforward manner, with an attention to the details of body paint, jewelry, and the rattle and bow that are held in the dancer's hands. Nampeyo imaginatively introduces conventional pottery designs for the head and ears.

The jar's shape — with its squared body and broad shoulders — is a sophisticated interpretation of a storage jar from Zuni, one of the neighboring Pueblos. Hopi people in the early nineteenth century temporarily moved to Zuni because of a severe drought at Hopi, and when they returned to Hopi they brought designs and shapes borrowed from their hosts. The pot's neck decoration is a series of feather images adapted from contemporaneous pottery from other Pueblo villages.

1. Nampeyo has been broadly studied and written about from the late nineteenth century through today: Jessie Walter Fewkes, "Archaeological Expedition to Arizona in 1895," in *Seventeenth Annual Report of the Bureau of American Ethnology for the Years 1895–1896, Part 2* (Washington, DC: Government Printing Office, 1898); Edwin Wade and Lea McChesney, *America's Great Lost Expedition: The Thomas Keam Collection of Hopi Pottery from the Second Hemenway Expedition 1890–1894* (Phoenix, AZ: Heard Museum, 1980); Joseph Traugott, "Fewkes and Nampeyo: Clarifying a Myth-Understanding," in *Native American Art in the Twentieth Century: Makers, Meanings, Histories*, ed. Jackson Rushing (New York: Routledge, 1999), 7–20; Barbara Kramer, *Nampeyo and Her Pottery* (Albuquerque: University of New Mexico Press, 1999); and Edwin Wade and Allan Cooke, *Canvas of Clay: Seven Centuries of Hopi Ceramic Art* (Sedona, AZ: El Otro Lado, 2012).

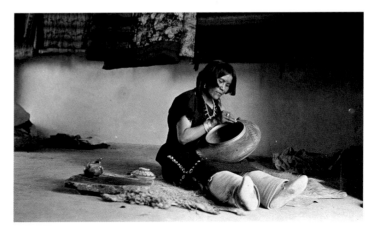

Fig. 30. Nampeyo, ca. 1910. Nampeyo is wearing her special-occasion clothes for the photographer: a woolen black *manta* and wrapped white moccasins. But she is posing in her working position, on the floor of her house with her legs straight forward. Courtesy Palace of the Governors Photo Archives (NMHM/DCA), New Mexico History Museum, Santa Fe, 021536

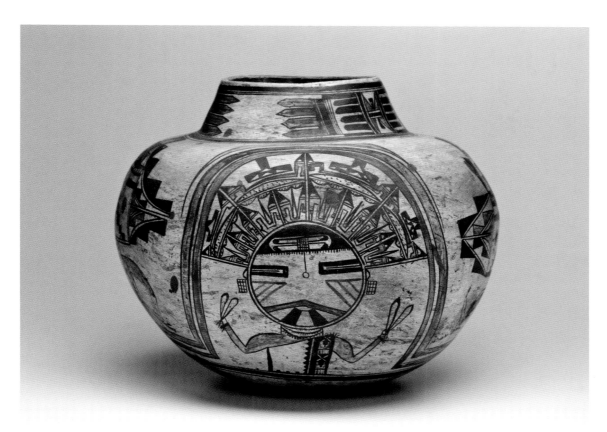

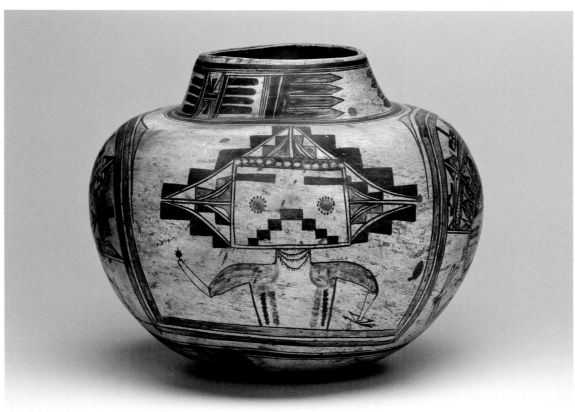

64.
Maria Martinez (San Ildefonso Pueblo, 1887–1980) and Julian Martinez (San Ildefonso Pueblo, 1879–1943)
San Ildefonso Pueblo, New Mexico

Jar, 1918–19

Clay, slip
9 ⅞ × 14 ⅝ in. (25.1 × 37.1 cm)
Diker no. 305

65.
Nancy Youngblood (Santa Clara, b. 1955)
Santa Fe, New Mexico

Melon jar, 1980s

Ceramic
4 ¾ × 11 in. (12.1 × 27.9 cm)
Diker no. 756

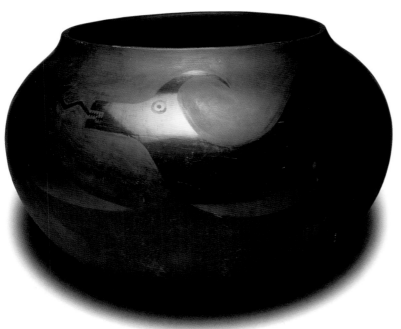

66.
Tammy Garcia (Santa Clara, b. 1969)
Santa Fe, New Mexico

Jar, ca. 1999

Ceramic
12 × 8 in. (30.5 × 20.3 cm)
Diker no. 808

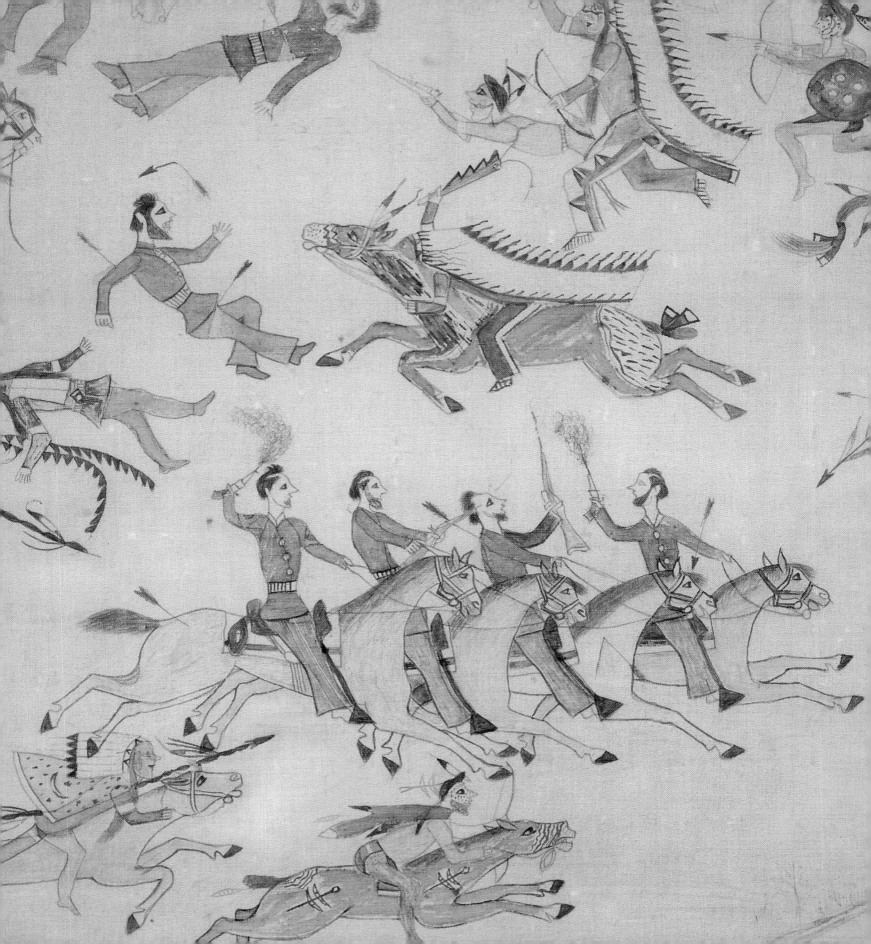

Pictographic Arts of the Plains

Janet Catherine Berlo

The peoples of the Great Plains are unique in Native North America in their keen interest in recording in pictorial format the specific events of their personal and group histories. Supplemented by oral histories, these drawings keep events of the past alive. For the most part, recording history was and continues to be a male pursuit; painted robes and shirts collected in the early nineteenth century demonstrate that men displayed their own history as warriors on their garments.[1] As the shield painted by Joseph No Two Horns (He Nupa Wanica) (cat. 67) demonstrates, men also painted images from visions and other religious experiences to add to their personal power in war-making. A group of objects from the Diker Collection illustrates diverse manifestations of Plains pictorial language.

In the 1830s, the white artists George Catlin and Karl Bodmer shared artistic materials such as paper and commercial paints with their Plains counterparts who, up to this time, had used natural pigments on animal skins. So a few early drawings on paper are known, but the greatest flowering of Plains graphic art occurred in the last three decades of the nineteenth century, when thousands of drawings on paper were made. As the availability of hides diminished (mostly due to the rapacious overhunting of buffalo as sport by white men), Native men turned to new media: small notebooks, ledgers, scrap paper, and, occasionally, drawing books, in which they recorded meaningful events using pencil, colored pencil, ink, and watercolor. United States military men sometimes gave such materials to their Indian scouts, and other materials were purchased from traders or taken from the bodies of soldiers as spoils of war. These drawings became a new way for men to record and share their experiences and war honors.

One of the earliest books of Plains drawings that can be securely dated was done by an elderly Hinono'eiteen (Arapaho) chief named Little Shield in 1867 or early 1868 (fig. 31).[2] In a truly spare, almost schematic style that recalls the robes and war shirts of a previous generation, Little Shield shows himself astride a horse, confronting a Pawnee enemy. The great economy of line — the method through which a lot of information is conveyed very simply — is characteristic of early Plains pictographic drawing. The inscription naming Little Shield and his Pawnee opponent was likely added by the drawing's non-Native collector, for Little Shield's peers would have

Fig. 31. Little Shield (Hinono'eiteen or Arapaho, dates unknown). *Little Shield Counts Coup on a Pawnee*, ca. 1867–early 1868. Pencil, colored pencil, and ink on paper, 3¾ × 6½ in. (9.5 × 16.5 cm). From the Collections of the St. Louis Mercantile Library at the University of Missouri–St. Louis. 78.034.4

recognized his enemy as a Pawnee by his hairstyle, and by the distinctive cut of his moccasins. Little Shield's own identity is made clear by the not-so-little shield that he carries in most of the drawings.

The drawing by Swift Dog exhibits greater realism in the way the figures and the implied action are drawn (cat. 68). His opponent's shirt is recognizably one of the pierced-skin war shirts worn on the Northern Plains beginning early in the nineteenth century and used for many decades thereafter (cat. 78).[3] Swift Dog makes clear that, in this very specific moment of warfare with an Apsáalooke (Crow) opponent, the Apsáalooke's two arrows have missed their mark. Swift Dog, with his long bow lance, will prevail.

An even keener interest in representing details of clothing, architecture, ceremony, and action is evident in drawings made by the Ka'igwu (Kiowa) artists of the Julian Scott ledger (cats. 73–76) and the Hinono'eiteen artists of the Henderson ledger (cat. 70), discussed in the following catalogue entries. Short Bull, a well-known Lakota, made many drawings, both during his time overseas with Buffalo Bill's Wild West show (1891–93) and in subsequent years back at the Pine Ridge Reservation.[4] This was a time when many old men were recording the brave deeds of their youth in pictures, while in earlier decades surely it was young warriors who were recording their recent heroics for all to see. By the end of the nineteenth century, many Lakota were literate, and Short Bull himself probably wrote the laconic captions above the scene of his encounter with Apsáalooke enemies whose arrows fly at horse and rider (cat. 69). The image of him being thrown from his wounded horse is remarkable for its imaginative use of perspective and foreshortening. Short Bull was also a maker of "winter counts," a singular category of Plains pictographic art. Best known among the Lakota and Ka'igwu, winter counts represent each year using a single pictograph that depicts the most memorable occurrence of its winter. These counts remind tribal historians of the notable events of prior decades, extending generations into the past.[5]

Some ledger books contain drawings done solely by one man. Art historical analysis of style combined with verification by one such artist reveals that several men might also share a book: in 1877, an Army officer wrote that his Hinono'eiteen scout had told him, "It is extremely common for intimate friends to insert in each other's books evidence of mutual esteem by drawing scenes from their past lives."[6] An original book of drawings called the Henderson ledger contains the work of at least two artists. The one designated Henderson "Artist A" depicted several visionary scenes.[7] As the genre developed, men recorded not only their military exploits but also aspects of daily life, ceremonial life, and their most profound spiritual experiences. This drawing (cat. 70) shows that among some Plains groups tipis were another canvas for the recording of visions, personal emblems, and deeds of valor. This practice persists today: the Kiowa Black Leggings Warrior Society tipi, for example, updates the imagery of a well-known nineteenth-century tipi with scenes of Ka'igwu bravery in recent wars in the Middle East.[8]

In addition to painted exteriors, some tipis of the nineteenth and early twentieth centuries incorporated decoration on inside

Fig. 32. Arthur Amiotte (Lakota, b. 1942). *The Visit*, 1995. Collage, 20 × 24 in. (50.8 × 61 cm). Buffalo Bill Center of the West, Cody, Wyoming, USA. Gift of Mrs. Cornelius Vanderbilt Whitney, 17.95

curtains called tipi liners, though these are uncommon today. Made of canvas or muslin purchased from traders, these curtains served both as insulation and as records of the tipi owners' deeds. Many such paintings are known, and those by Standing Bear are among the finest; his tipi liner *The Battle of the Little Bighorn* (cat. 71) offers a precise visual chronicle of one of the key historical events of the nineteenth century. In the first quarter of the twentieth century, making replica tipi liners for sale rather than local use was a way to recall the past, teach it to a younger generation, and earn money at the same time. One of Standing Bear's daughters, for example, recalled her father sitting at the kitchen table making such items and, as he did so, telling her the events of nineteenth-century Lakota life in which he participated.[9]

Standing Bear has also played a pivotal role in the artistic work of his great-grandson Arthur Amiotte. Amiotte's collages forge connections between old ways and new, employing the visual language of nineteenth-century Plains drawings in collages that include early twentieth-century print media and family photos.[10] In *The Visit* (fig. 32), a Lakota couple on horseback, at right, arrives to inspect the fine touring car parked by a photograph of Standing Bear and his family in front of their cabin. On the roof, figures wearing clothing of the 1890 Ghost Dance movement study the heavens. Amiotte incorporates handwritten text, using the voice of his great-grandfather to provide the point of view: "In 1919 we stand on the threshold of a new and different time. We live in a wooden house." Standing Bear's life had incorporated both the migratory freedom of his childhood, when a tipi could be pitched anywhere, and the settled existence of the reservation that a wooden cabin entails. Amiotte's work and that of other contemporary artists demonstrates that the pictorial language of nineteenth-century Plains art remains a rich aesthetic archive to be mined and transformed.

67.

Joseph No Two Horns (also known as He Nupa Wanica, Lakota, 1852–1942)
Standing Rock, North Dakota

Shield, ca. 1885

Hide, feathers, pigment, ink, sinew, cordage, wood
16 ¹⁵⁄₁₆ × 3 ³⁄₁₆ in. (43 × 8 cm)
Diker no. 691

There are few Lakota artists who were more artistically creative and productive than Joseph No Two Horns (He Nupa Wanica). He worked in virtually all mediums that were available to him, including sculpture, drawing, and painting. Most of his works are drawings of his battle exploits and horse-raiding adventures, subjects that are typical of the Plains pictographic tradition. He also created several versions of his shield, and these are considered among the most important of his works.

The Diker Collection includes one of the three He Nupa Wanica shields made of hide that are known to exist;[1] the others are made of muslin and were created for the growing market for Native-produced goods in the early 1900s. One of He Nupa Wanica's hide-based shields accompanied him during the Battle of the Little Bighorn.

Imagery inspired by visions was painted on shields to protect warriors in battle. According to tradition, it was the sacred power of the designs, not the material of the shield, that protected the warrior. He Nupa Wanica's shield features a sacred bird, probably the Thunderbird, the powerful being of the Upper World. The squiggly lines radiating from its wings represent lightning, a physical manifestation of spiritual energy. In the drawings that He Nupa Wanica made of himself, he painted similar lines on his forehead and on the legs of his battle horse. These references to his sacred vision protected him during the many battles he fought during his life.

Although thousands of Plains warriors owned shields in historic times, a relatively small number of these have survived. Capitalizing on the scarcity of these objects and the growing demand by non-Natives for Native-produced items, He Nupa Wanica created reproductions of items like the shield he used in his early years.

1. The others are in the collection at the Denver Art Museum (1932.237) and the Detroit Institute of Arts.

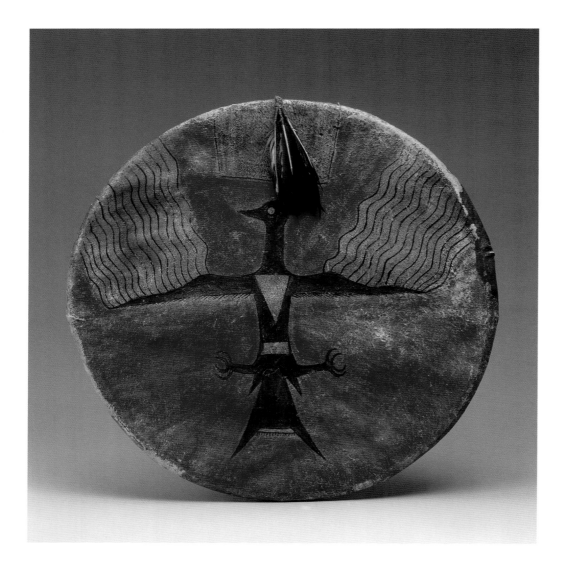

68.
Swift Dog (Lakota, ca. 1845–1925)
Standing Rock, North Dakota

No Two Horns Fights a Crow,
ca. 1890

Watercolor and ink on paper
7 ½ × 12 in. (19.1 × 30.5 cm)
Diker no. 175

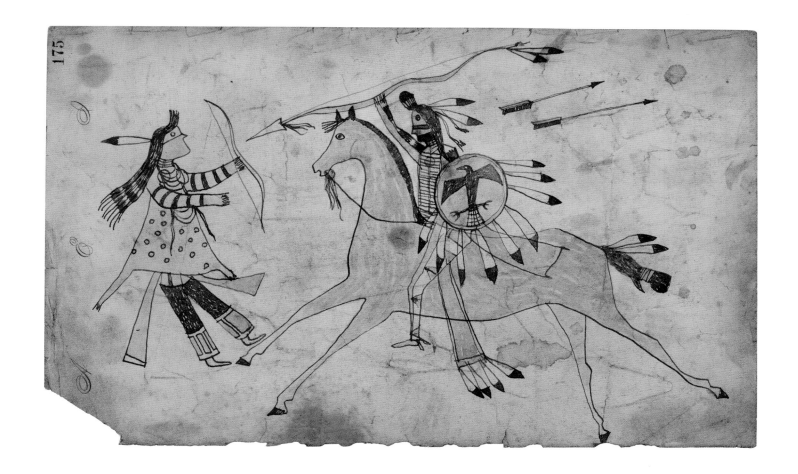

69.
Short Bull (Lakota, ca. 1845–1915)
Pine Ridge (?), South Dakota

Short Bull Falls from Wounded Horse, ca. 1890

Watercolor and ink on paper
7 × 10 in. (17.8 × 25.4 cm)
Diker no. 202

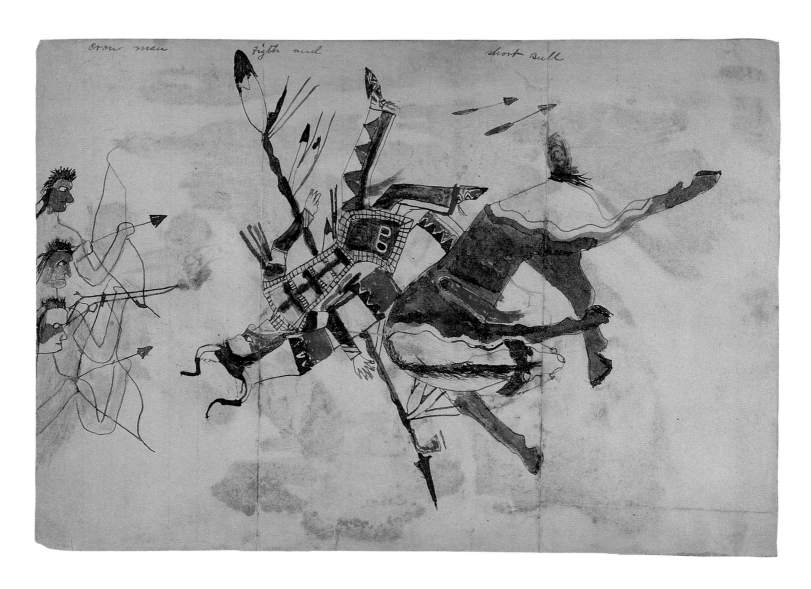

70.

Frank Henderson (Hinono'eiteen [Arapaho], 1862–1885)
Cheyenne-Arapaho Indian Reservation, Oklahoma

A Medicine Vision, 1882

Pencil, colored pencil, and ink on paper
10 ⅝ × 11 ⅞ in. (27 × 30 cm)
Diker no. 024LD

A young Hinono'eiteen (Arapaho) man named Frank Henderson presented a book of 122 drawings to Martha Underwood, who may have been his benefactress while he attended Carlisle Indian School in Pennsylvania. Some Plains holy men report having had visions even as small children. While the seventeen-year-old orphan, who left the Cheyenne and Arapaho Agency in 1879 for boarding school in the East, may have had such visions, it is unlikely that he became, at such an early age, the powerful warrior depicted here. The tipi is painted with power images, including a juvenile golden eagle (below), and an adult golden eagle in a field of eagle claws. Flanking the tipi are the horned headdress and feathered staff of a warrior of high rank. Henderson depicts the transformative moment when the protagonist's "war medicine" — the potent imagery and objects that would protect him in battle — was bestowed upon him in a vision. The visionary, supine at lower left, absorbs wavy lines of blue and red power emanating from the Medicine Being, who is astride a horse at upper right. The bird accompanying this figure incorporates aspects of different animals, as spirit figures often do: the red on its wings references the red-winged blackbird, but its body is eagle-like.

The supernatural figure also offers protective medicine in the shape of a feathered war shield, painted in red and blue with the spirit bird's head in the middle. Blue lines of power springing from the beak of the bird on the shield radiate down to the man at the bottom. The blue horse in the vision, with red hailstones on its body, has its tail tied up for war. Bullets zoom at the celestial horse and rider from all directions, yet they are unscathed; this suggests that the vision bestows the power to ride into enemy fire and emerge unharmed.[1]

1. Karen Daniels Petersen, *American Pictographic Images: Historical Works on Paper by the Plains Indians* (Santa Fe: Morning Star Gallery, 1988); and Janet Catherine Berlo, ed., *Plains Indian Drawings 1865–1935: Pages from a Visual History* (New York: Harry N. Abrams / American Federation of Arts / Drawing Center, 1996), 82. I am grateful to bird watcher Dr. Mary M. Fox for our discussions of the ornithological aspects of this drawing.

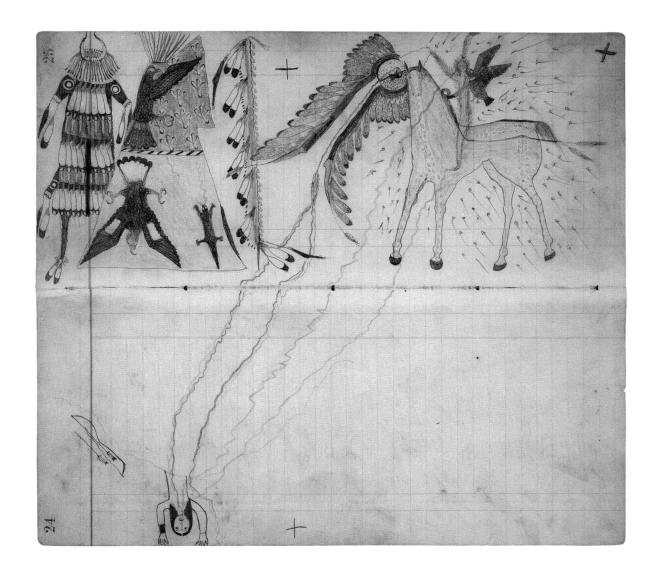

71.

Standing Bear (Lakota, 1859–1933)
Pine Ridge, South Dakota

The Battle of the Little Bighorn,
ca. 1920

Pencil, pen, and ink on muslin
36 × 105 ½ in. (91.4 × 268 cm)
Diker no. 652

A significant chronicler of Lakota life, Standing Bear fought in the Battle of the Little Bighorn (1876) as a young man; traveled with Buffalo Bill's Wild West show in Europe (1887, 1889–90); and served as a respected leader at Pine Ridge Reservation for the rest of his life. While in Europe, he met and married an Austrian woman, whom he brought back to his land allotment on the reservation. Standing Bear and Louise Rieneck raised three daughters in their log home in Manderson, South Dakota. The whole family was industrious and artistic, and somewhat more prosperous than most Lakota. In keeping with Lakota traditions of *noblesse oblige*, Standing Bear provided for the poor in the Lakota community. One of the many ways he made money was to draw and sell pictorial muslins.[1]

For most of the twentieth century, Standing Bear was best known as the illustrator of *Black Elk Speaks* (1932), a book on Lakota history and spirituality based on conversations between Lakota medicine man Black Elk and a white writer, John G. Neihardt. Standing Bear's muslins, however — which include depictions of the Battle of the Little Bighorn and of traditional Lakota camp life — are far more significant contributions to Native American art history. Standing Bear brings to life the rich texture of camp life and the ceremonial practices of the Sun Dance taking place in the days before the Lakota and their Tsitsistas/Suthai (Cheyenne) allies wiped out Custer's own battalion and many others of the Seventh Cavalry.

In this muslin, Standing Bear depicts, vividly and with great clarity, the mayhem of the Battle of the Little Bighorn. The battle began on June 25, 1876, just days before the United States was to celebrate its centennial; many across the country hoped for the continued success of General George Armstrong Custer, a "golden boy" in the struggle of the U.S. military against the Native peoples of the Great Plains. In fact, Custer's men were routed by combined Hinono'eiteen (Arapaho), Tsitsistas/Suthai, and Lakota forces, and the general himself was slain. In this drawing, Standing Bear captures

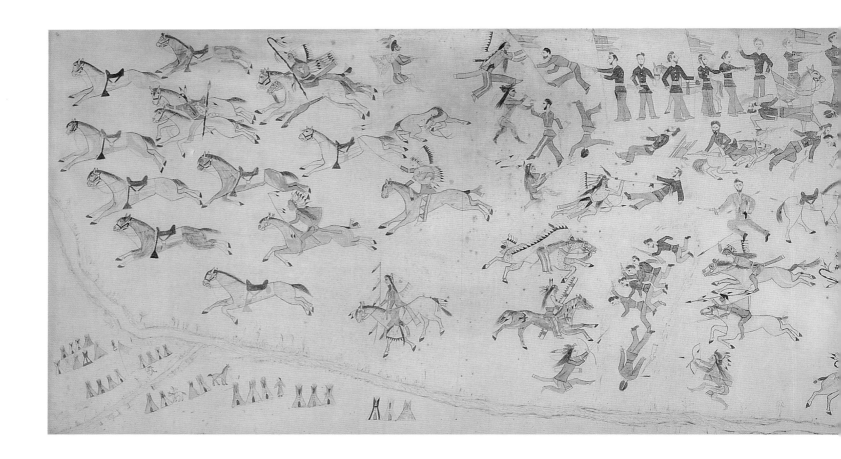

dead and dying men, wounded horses, and the bravery of the victors, individuating each of the more than five dozen people and two dozen horses through details of dress, hairstyle, or weaponry. In Standing Bear's composition, the events of the Lakota's last big victory over the U.S. military overshadow the scene of tipis at lower left. Standing Bear suggests the scale of the event, which included hundreds of combatants on both sides, by filling the muslin with as many figures as space would allow.

In the center of the composition Standing Bear presents a vignette of

five of Custer's men crouched in a ravine. Three have drawn their weapons. A sixth man is dead, his rifle resting beside him. Lakota and Tsitsistas/Suthai warriors attack from both sides, some mounted and some on foot. Each is drawn in an active pose. The horses' legs are extended as they gallop toward the enemy. One horse is painted with protective emblems of an eagle and dragonfly, while another is adorned with red hailstones. Each horse's tail is tied up or has feathers attached — a sign that the horse has been trained for battle. More than most Plains graphic artists, Standing Bear strove to

capture not only the distinctive clothing and paraphernalia of each character in the scene, but also the physiognomy of each face, whether Native or white.

1. For further biographical information on Standing Bear, see Louis Warren, "Standing Bear," in *Buffalo Bill's America* (New York: Knopf, 2005), 390–96. Other muslins by Standing Bear are in the South Dakota State Historical Society, the Philbrook Museum of Art, the Foundation for Preservation of American Indian Art and Culture, and in collections in Germany and Japan. See, for example, Peter Powell, "Sacrifice Transformed into Victory," *Visions of the People: A Pictorial History of*

Plains Indian Life, eds. Evan Maurer and Joseph D. Horse Capture (Minneapolis: Minneapolis Institute of Arts, 1992), 81–106; and Arthur Amiotte, "'I Witnessed All This': The Standing Bear Muslin at the Museum of the South Dakota State Historical Society," in *Transformation and Continuity in Lakota Culture: The Collages of Arthur Amiotte, 1988–2014* (Pierre: South Dakota State Historical Society Press, 2014).

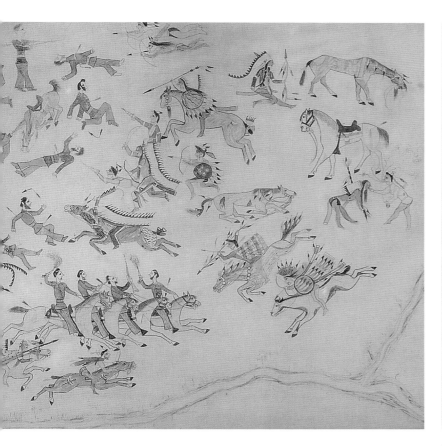

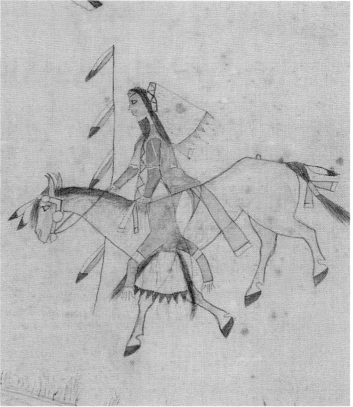

Fig. 33. Detail of cat. 71

72.
**Model tipi cover with drawings,
ca. 1890**

Lakota, Rosebud, South Dakota
Hide, pigment
38 × 66 in. (96.5 × 167.6 cm)
Diker no. 265

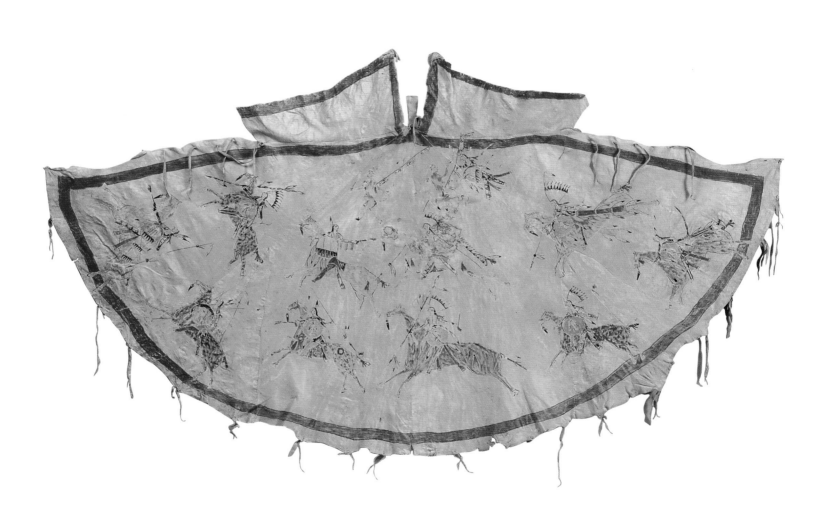

73.
Julian Scott ledger "Artist A"
Ka'igwu (Kiowa)
Kiowa and Comanche Indian
Reservation, Oklahoma

***Kiowa Vanquishing Navajo*, 1880**

Pencil, colored pencil, and ink on
paper
7 ½ × 12 in. (19.1 × 30.5 cm)
Diker no. 021LD

The artist has carefully rendered the details that identify each of the players in this battle scene. At left, a mounted Ka'igwu (Kiowa) of high rank spears an opponent. His split buffalo horn headdress and feathered spear signal that he has accrued many honors and victories in war. Both the headdress and the shield are trimmed with red trade cloth, and the horse's tail is tied up for war in the same red cloth. At right, brandishing a knife, a Navajo warrior reins in his horse and looks back at what has transpired. Though the caption identifies him as Mescalero Apache, he wears the feathered skin cap of a Navajo warrior (fig. 34). Both the figure at right and the dying man in the center wear Navajo two-part moccasin leggings with silver buttons. Ronald McCoy has convincingly argued that the middle figure's mustache and goatee identify him as "a non-Indian captive adopted into the tribe, perhaps a Mexican, or one of mixed Navajo-Spanish-Mexican blood."[1] The artist has further indicated the ethnicity of the enemies by showing their hair gathered at the napes of their necks in a *tsiiyeel*, the traditional Navajo hair bun, wrapped in red cloth or leather.

1. Ronald McCoy, *Kiowa Memories: Images from Indian Territory, 1880* (Santa Fe: Morning Star Gallery, 1987), 60.

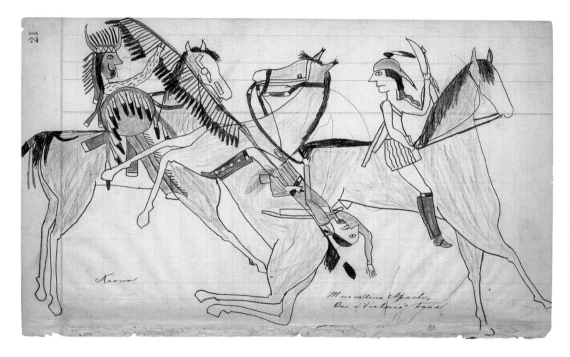

Fig. 34. Navajo hunting cap, made by Little Singer, 1903. Hide, dye, metal, sinew, feathers, 8 × 19 in. (20.3 × 48.3 cm). Brooklyn Museum 03.325.3680

74.
Julian Scott ledger "Artist A"
Ka'igwu (Kiowa)
Kiowa and Comanche Indian
Reservation, Oklahoma

Honoring Song, 1880

Pencil, colored pencil, and ink on
paper
7 ½ × 12 in. (19.1 × 30.5 cm)
Diker no. 057LD

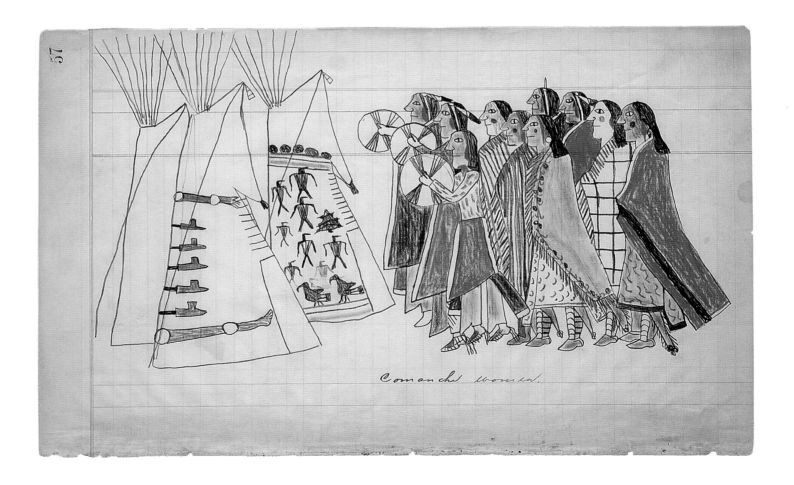

75.
Julian Scott ledger "Artist A"
Ka'igwu (Kiowa)
Kiowa and Comanche Indian
Reservation, Oklahoma

Caddos, 1880

Pencil, colored pencil, and ink on
paper
7 ½ × 12 in. (19.1 × 30.5 cm)
Diker no. 053LD

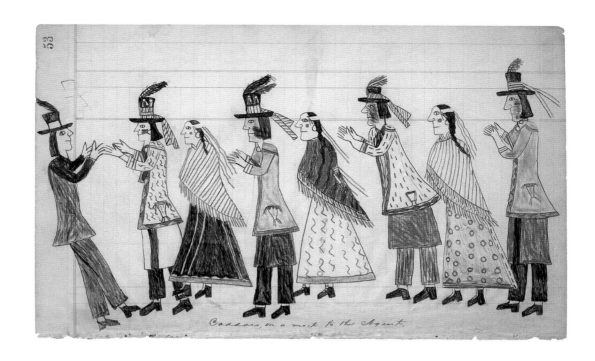

76.
Julian Scott ledger "Artist B"
Ka'igwu (Kiowa)
Kiowa and Comanche Indian
Reservation, Oklahoma

Twelve High-Ranking Kiowa Men, 1880

Pencil, colored pencil, and ink
on paper
7 ½ × 12 in. (19.1 × 30.5 cm)
Diker no. 059LD

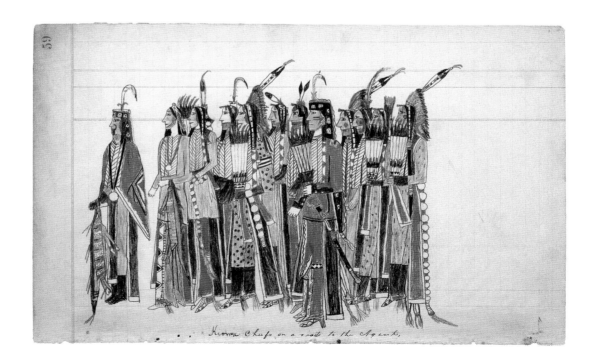

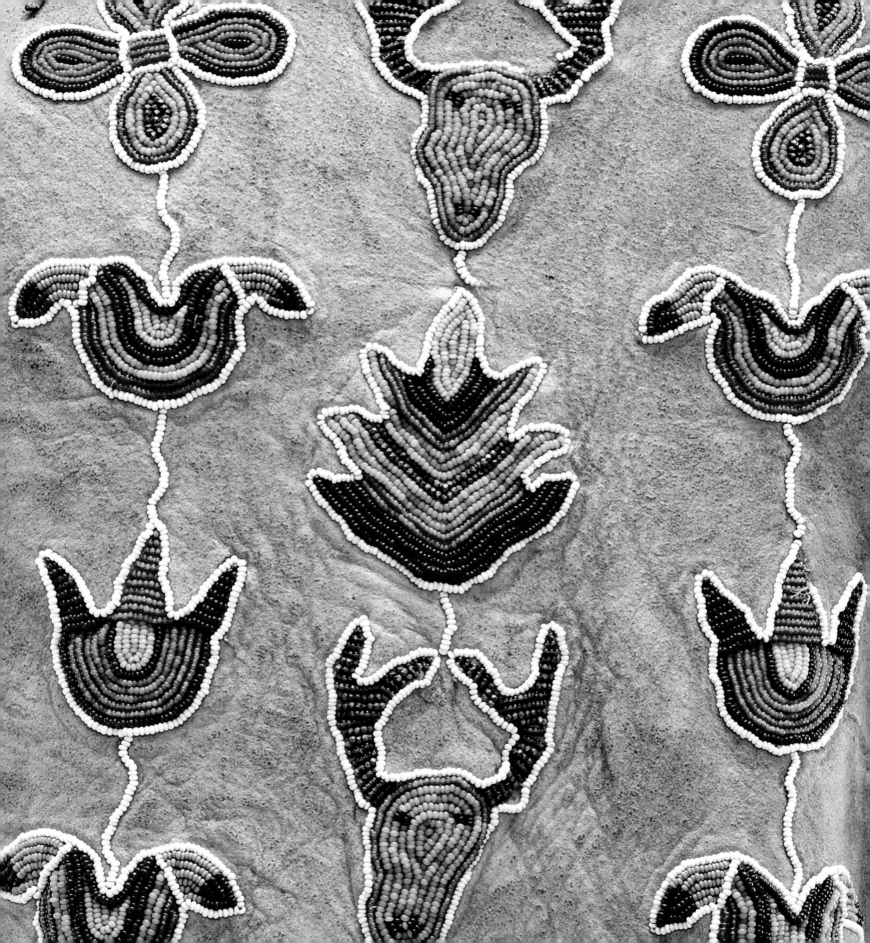

Plains Regalia
and Design

Joe D. Horse Capture

A man or woman in traditional nineteenth-century Plains regalia has become an iconic image of American Indian identity (albeit one often misrepresented or used inappropriately by the media, by non-Native artists, and, most gallingly, by sports teams). Ceremonial regalia persists today as a backbone of tradition for many Native people. Serving as a link to the ancestors, contemporary traditional outfits worn by dancers at powwows, or worn for other appropriate social occasions, continue to function as a cornerstone of Native identity. Although materials and methods of construction have changed, present-day outfits are imbued with the same ideas and philosophy as those created by Native people of centuries past.

Countless nineteenth-century explorers and artists noted the beautiful clothing and regalia worn by Plains Indian people. An Apsáalooke (Crow) once remarked that beautifully produced clothing "can make a simple man look so handsome."[1]

Today, articles of traditional dress clothing of the past have become prized by museums and collectors, celebrated in exhibitions and publications such as this one as great masterpieces of American Indian art.[2] In such contexts, shirts and dresses decorated with elaborate glass-bead or porcupine-quill designs are conventionally presented as single works, perhaps with other garments and accessories similarly isolated and exhibited close by. Even though such an approach appeals to the contemporary Western eye, these objects were intended to function together as complete ensembles of dress clothing. A full outfit would include leggings, moccasins, bags, decorated belts, hair ornaments, and other accoutrements, all conceived to join together for effect (fig. 35). Whether worn for contemporary ceremonies or on past occasions, as recorded in thousands of historic photographs (such as when delegates of Plains Nations visited Washington, DC, to negotiate matters of great importance), traditional dress clothing communicates a powerful message: "We are here and we are proud (fig. 36)."

The overall visual effect of a Plains ensemble with all its accoutrements is beautifully represented in Rhonda Holy Bear's *Maternal Journey* (cat. 77). Although miniature in scale, this piece exemplifies Native artistry of outstanding aesthetic quality. Holy Bear, a Cheyenne River Lakota, is one of the most important Plains artists working today. She specializes in the creation of historic figurines, and

her peers regard her groundbreaking work as setting the standard for this genre. Although Holy Bear is Lakota, her subjects often feature the Apsáalooke, who continue their ancestral tradition of creating great works of regalia for display at celebrations, and at the annual Crow Fair, which takes place on their reservation in south-central Montana.

Holy Bear's resplendent figures vibrantly express Apsáalooke aesthetic values. She conducts meticulous research into her subjects in order to capture the essence of the mid-nineteenth century attire (much of which is still in fashion today), striving for the greatest possible accuracy in her representation. Close study of *Maternal Journey* reveals how many individual and beautifully crafted objects come together to create the regalia of a proud Apsáalooke woman, her children, and her horses. The work includes a variety of object categories represented in the Diker Collection made by artists of the Apsáalooke and of other Plains nations as well.

The equestrian mother wears a classic Apsáalooke dress, adorned with elk incisor teeth. This style of dress, customarily made of wool after the 1880s, is a throwback to the hide dresses worn in earlier times. The green V-shaped inset visible on the chest of the red cloth resembles the shape formed by the tail of the animal hide when tailored into the old-style garment (the Wasco dress, cat. 80, is made the same way), a detail intended to honor the form and iconography of earlier hide dresses.

Elk-tooth dresses were used by many tribes on the Plains, but they are most often associated with the Apsáalooke. A single elk has two incisor teeth, which are well suited for use as ornament due to their size and glossy ivory enamel. Although there are many interpretations of the teeth's symbolic significance, the most widely accepted is their association with longevity: long after the animal's bones have returned to the earth, the incisor teeth remain. Elk-tooth dresses also show off the hunting skills of the men in a family, since many individual elk are necessary to supply enough teeth to decorate a dress. But the importance goes deeper. According to contemporary Apsáalooke artist and dressmaker Gladys Jefferson: "A long time ago, the elk-tooth dress wasn't worn every day. Back then, it was [made] to outfit your daughter-in-law or your sister-in-law. It was basically a wedding dress. As a boy grew up, he would collect elk teeth and save them for his mother and sisters to put on a dress for his wife when he married."[3]

Within this context, an Apsáalooke elk-tooth dress represents a husband's love for his wife as well as the connection between the wife and her new family: the mother- or sister-in-law customarily makes the dress for the bride. At a community level, the dress is an important symbolic link between intermarried families and serves as a visual reminder of these important connections.

The mare shown in *Maternal Journey* is also dressed in elaborate regalia, a beaded horse blanket on her back, a martingale ornament draped over her chest, and a beaded rosette for her brow. The Apsáalooke mother sits in an elaborately beaded saddle and carries some of her husband's weapons, as was her customary duty, including a lance in a beaded case. Her infant rides in a beaded baby carrier

Fig. 35. Spotted Rabbit on horseback, ca. 1900–10. Photo attributed to Fred E. Miller. National Museum of the American Indian, Smithsonian Institution (N13766)

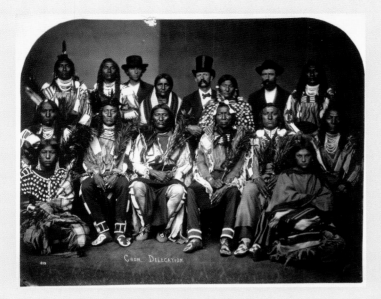

Fig. 36. Studio portrait of Apsáalooke (Crow) Delegation, 1872. Photo by Henry Ulke. National Museum of the American Indian, Smithsonian Institution (P03424)

mounted off the horse's shoulder (similar to the Kiowa and Ute baby carriers, cats. 89, 90). The horse drags a travois, a V-shaped vehicle that was used to transport a family's possessions, and a pair of painted rawhide containers are mounted in their customary position on either side of the horse's flanks (see cat. 96 for a Niitsitapi, or Blackfeet, pair). Two children, a boy and a girl, ride in back.

Like her mother, the young girl wears a classic elk-tooth dress and holds a doll that wears a similar dress — for a total of three dresses in descending scale in this single work. Mother, daughter, and doll emphasize the importance of generational continuity within Apsáalooke traditions, a message reinforced by the young foal that trots alongside his mother. The girl also wears matching glass-beaded leggings and moccasins and brass bracelets on both arms.

The boy on the travois wears a beaded shirt similar to the boy's shirt in the Diker Collection (cat. 82). It has been decorated in classic Apsáalooke fashion, with strong contrasts between the pink and blue glass beads and designs outlined in a single row of white. His breech-cloth is decorated with floral designs like those seen in the Apsáalooke jacket (cat. 83). Apsáalooke artists incorporated a distinctive style of floral imagery into many of their works after 1880 or so. The boy's blue wool leggings with a hint of beaded designs on the lower edge complement the floral work on his moccasins.

The boy holds an intriguing item in his hands. This blue-painted sculpture is known as a "horse stick," which a warrior carried to honor his fallen horse in battle. In the nineteenth century, a boy would not have owned one of these. In fact, this particular style of horse stick was made by a Hunkpapa Lakota named Joseph No Two Horns who lost his blue roan horse at the Battle of the Little Bighorn. (His shield is featured in cat. 67.) The red inverted V-shapes on the body of the object refer to the animal's fatal bullet wounds. Nevertheless, Holy Bear cleverly incorporates the miniature replica of a famous sculpture created by a Lakota as a tribute to her own people.

Today's Native American regalia continues many of the traditions of the past. Focused on the whole, contemporary outfits have incorporated new and exciting materials — just as historic Native artists incorporated wool, glass beads, and other materials into their work during the nineteenth century. The creation and preservation of regalia are expressions of contemporary Native Americans that also pay tribute to the ingenuity of those who came before.

77.
**Rhonda Holy Bear (Cheyenne River
Sioux, b. 1960)**
Lakota, North Dakota

Maternal Journey, 2010

Wood, gesso, paint, clay, cotton,
wool, metal, aluminum wire, glass
beads, brain-tanned buckskin,
rawhide, fur, hair, feathers
31 × 42 in. (78.7 × 106.7 cm)
Diker no. 816

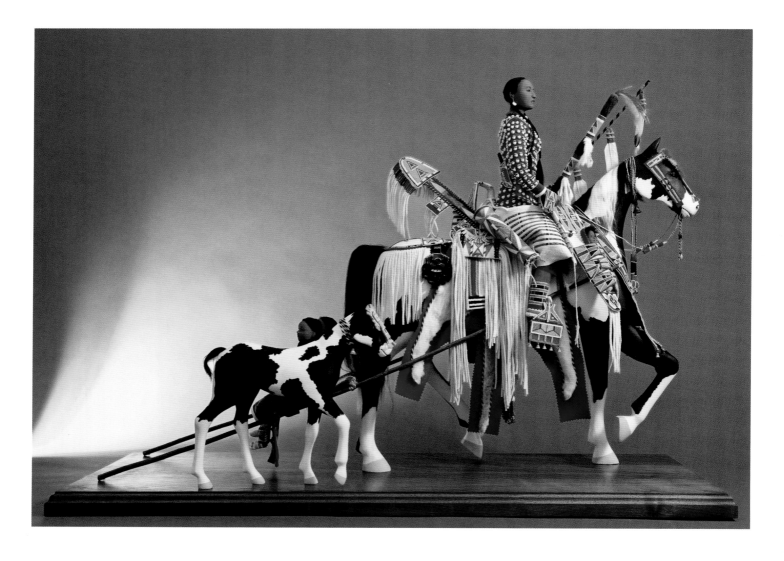

78.

Man's shirt, ca. 1875

Apsáalooke (Crow), Montana
Hide, ermine pelt and fur, glass
beads, wool, hair, feathers, cotton
fabric, cotton thread
41 × 59⅞ in.
(104.1 × 152.1 cm)
Diker no. 152

Highly decorated shirts were worn by men of high stature throughout the Plains. In historic times, men had to fulfill certain responsibilities to their people before they received the honor of wearing one of these magnificent garments. During the late 1800s and early 1900s, these restrictions were gradually lifted, and decorated shirts, like other garments, became symbols of tradition and cultural survival.

The Apsáalooke, located in today's south-central Montana, were known, and continue to be known, as one of the finest-dressed groups on the Plains. Early explorers including Prince Alexander Philipp Maximilian of Wied-Neuwied, the German ethnologist and naturalist, and the painter George Catlin recorded their impressions of the fine garments the Apsáalooke wore. Created by women and worn by men, Apsáalooke shirts are highly prized among both traditionalists and non-Native collectors today.

This shirt is a classic example of Apsáalooke artistry, created using a spot-stitch (or two-thread) appliqué technique. The main color combination of light blue accented with pink is characteristic of Apsáalooke work. The fringe that hangs from the sleeves and body of this garment is made from the pelt of the short-tailed weasel, commonly known as an ermine, a fierce animal whose fur turns white in the winter. Ermine bodies and their black-tipped tails were used as decoration on many shirts. The creator of this shirt made an unusual choice with the ermine. Instead of using the animal's hide with the black-tipped tail attached, she cut and sewed tubes of hide from the body and added black fur at the ends. This ingenious style of ermine fringe is a testament to the creativity, flexibility, and adaptation of Native arts.

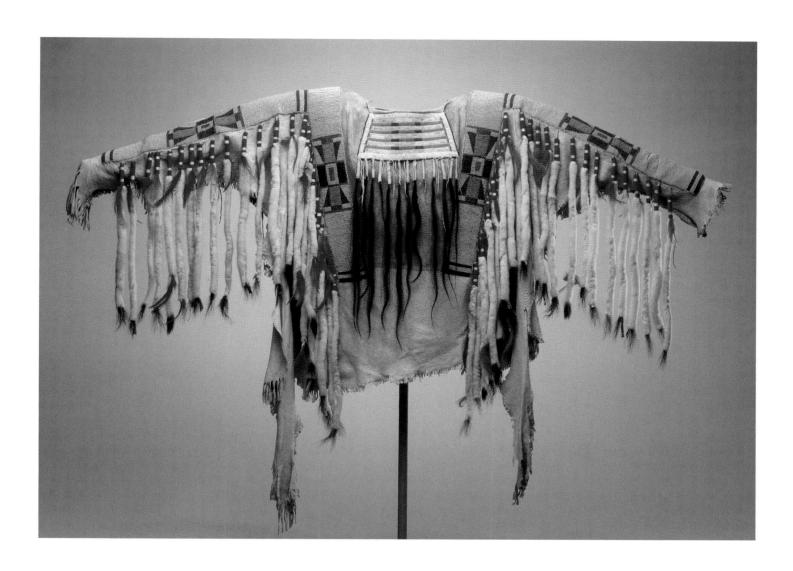

79.
Man's shirt, ca. 1850

Niimiipu (Nez Perce), Oregon or
Idaho
Hide, porcupine quills, horsehair,
wool, glass beads, pigment
32 ¹¹⁄₁₆ × 60 ⅔ in. (83.1 × 154.2 cm)
Diker no. 666

80.
Dress and belt, ca. 1870

Wasco, Oregon or Washington State
Dress: hide, glass beads, shells,
thimbles; belt: commercially tanned
leather, glass beads, metal studs and
cones
52 × 43 ½ in. (132.1 × 110.5 cm)
Diker no. 459

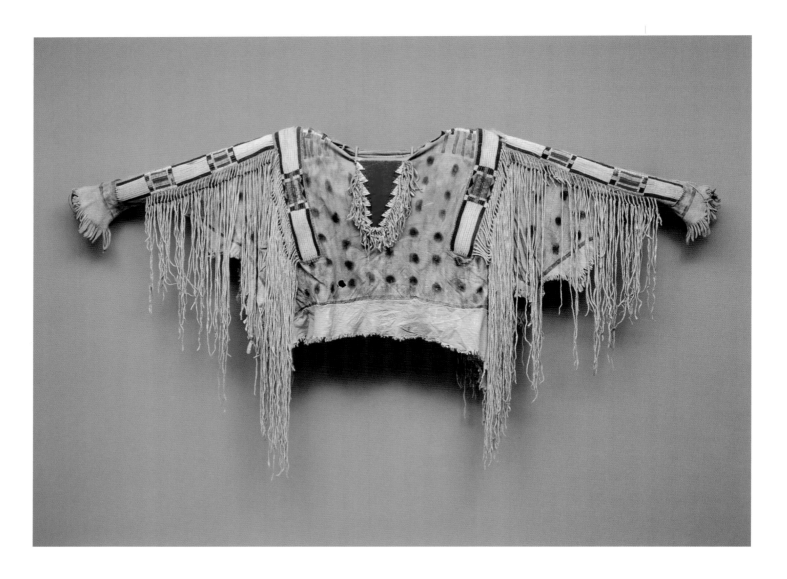

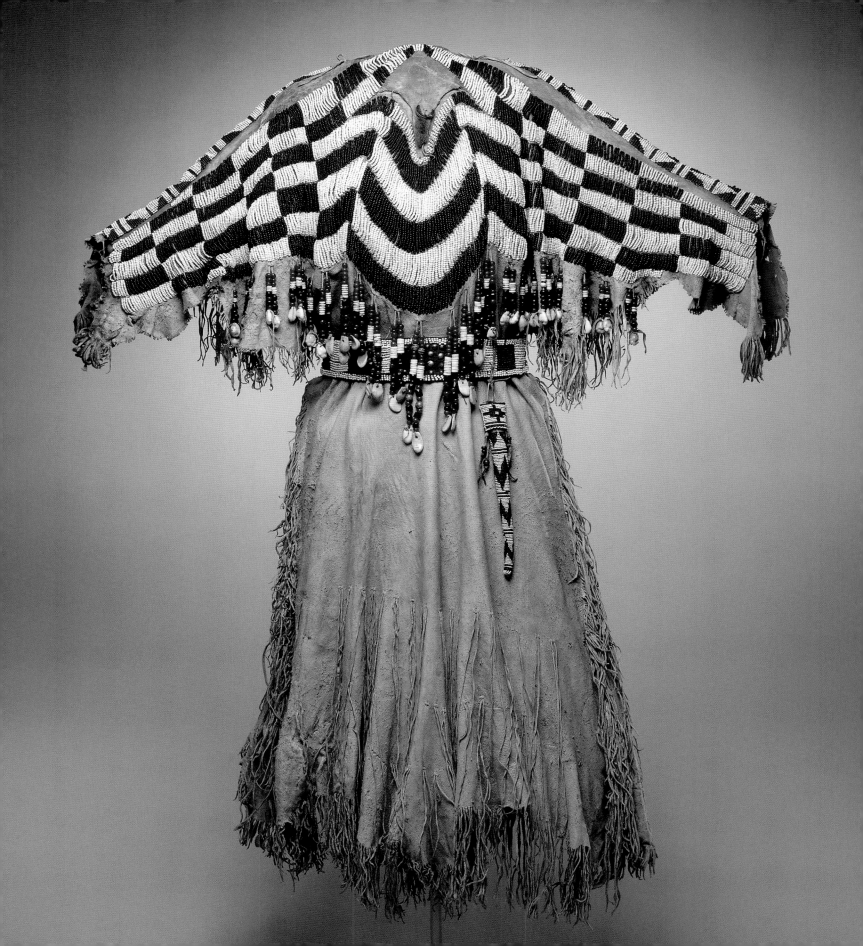

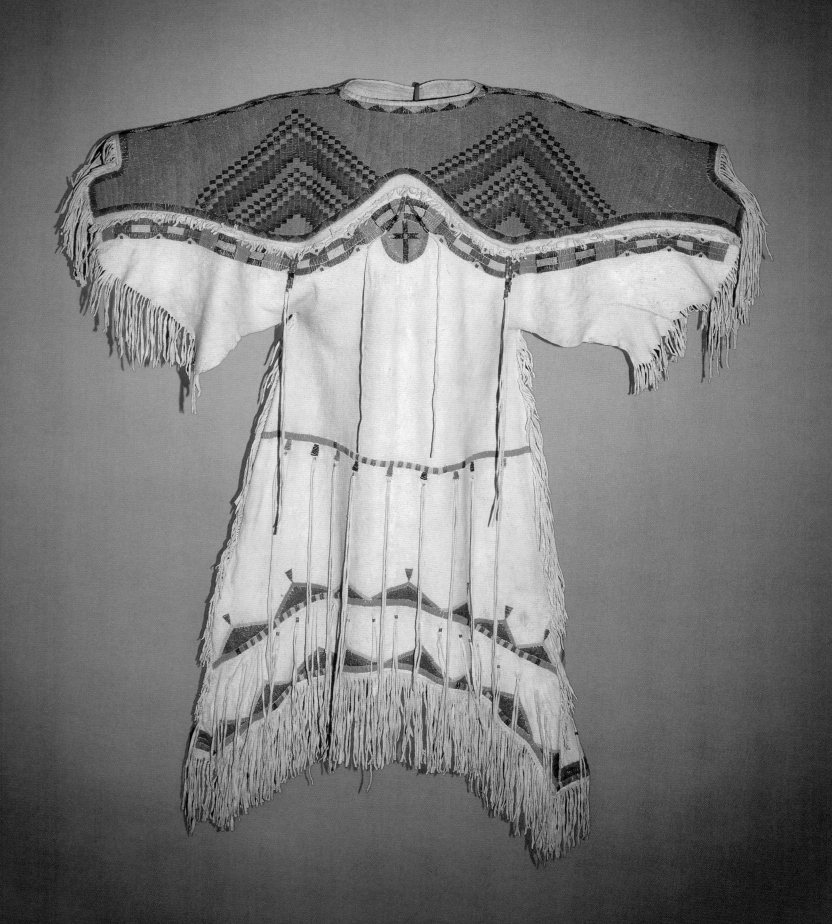

81.

Dress, ca. 1870

Lakota, North Dakota (?)
Hide, sinew, glass beads
42 × 31 in. (106.7 × 78.7 cm)
Diker no. 572

82.

Boy's shirt, ca. 1870

Apsáalooke (Crow), Montana
Hide, glass beads, cotton fabric, wool
cloth, sinew, cotton thread
21 5/16 × 31 1/2 in. (54.2 × 80 cm)
Diker no. 665

This Apsáalooke boy's shirt reflects
the rich color palette, design, and
techniques of Apsáalooke arts, and is
a great example of the tribe's artistic
legacy. Perfectly beaded, this shirt

has classic central designs that lie
on a field of blue beads. The central
diamond designs are outlined with
a single row of white beads that
separates the blue beads from the
red, a visual device found in other
Apsáalooke works in this exhibition.

With many northern Plains groups,
this type of highly decorated boy's
shirt was made for a "favorite child."[1]
According to contemporary
Apsáalooke, however, a shirt like this
one would have belonged to a boy in a

wealthy family; in fact, all the children
in such a family would have owned—
and proudly worn—the finest outfits
the Apsáalooke could produce.[2]

1. For further discussion of this topic, see
Paul Raczka, "Minipokas—Children of
Plenty," *American Indian Art Magazine*, vol.
4 (Summer 1979): 62–67.

2. Personal communication with Tim
McCleary, archaeologist for the Crow
Tribal Historic Preservation Office,
September 23, 2013.

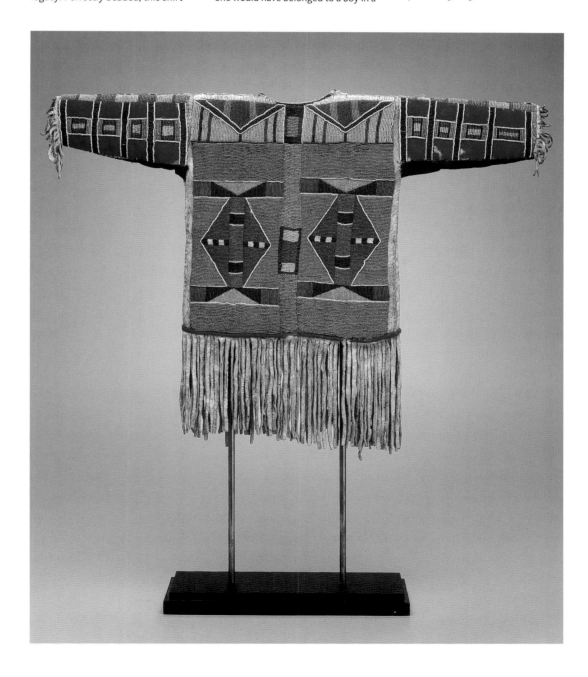

83.
Child's jacket, ca. 1880

Apsáalooke (Crow), Montana
Hide, glass beads
14 × 30 in. (35.6 × 76.2 cm)
Diker no. 846

84.
Painted robe, ca. 1875

Hinono'eiteen (Arapaho), Wyoming
or Montana
Hide, pigment
55 ⅛ × 62 in. (140 × 157 cm)
Diker no. 530

85.
Blanket strip, ca. 1830

Rų?eta, Sahnish, or Hiraacá
(Mandan, Arikara, or Hidatsa) (?),
North Dakota
Buffalo hide, glass beads, sinew
10 ¼ × 66 ¹⁵⁄₁₆ in. (26 × 170 cm)
Diker no. 707

86.
Blanket strip, ca. 1850

Niimiipu (Nez Perce), Oregon or
Idaho
Hide, glass beads, porcupine quills,
copper alloy bells, wool, sinew
5 ¹⁵⁄₁₆ × 63 in. (15.1 × 160 cm)
Diker no. 690

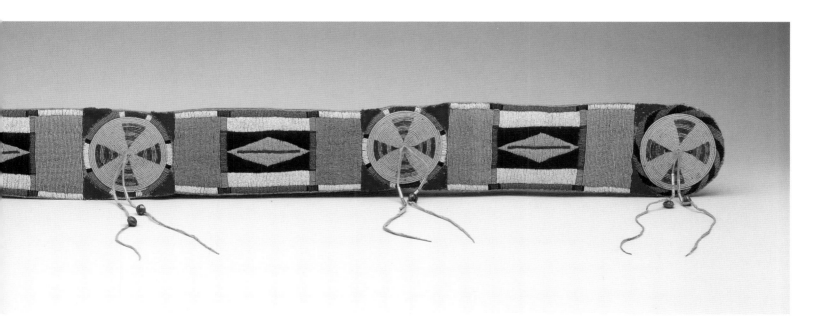

87.
Moccasins, ca. 1870

Nʉmʉnʉʉ (Comanche), Texas or
Oklahoma
Hide, glass beads, pigment
2 ¾ × 11 in. (7 × 28 cm)
Diker no. 104

88.
High-top moccasins, ca. 1890

Ka'igwu (Kiowa), Oklahoma
Hide, glass beads, pigment
13 × 7 in. (33 × 17.8 cm)
Diker no. 850

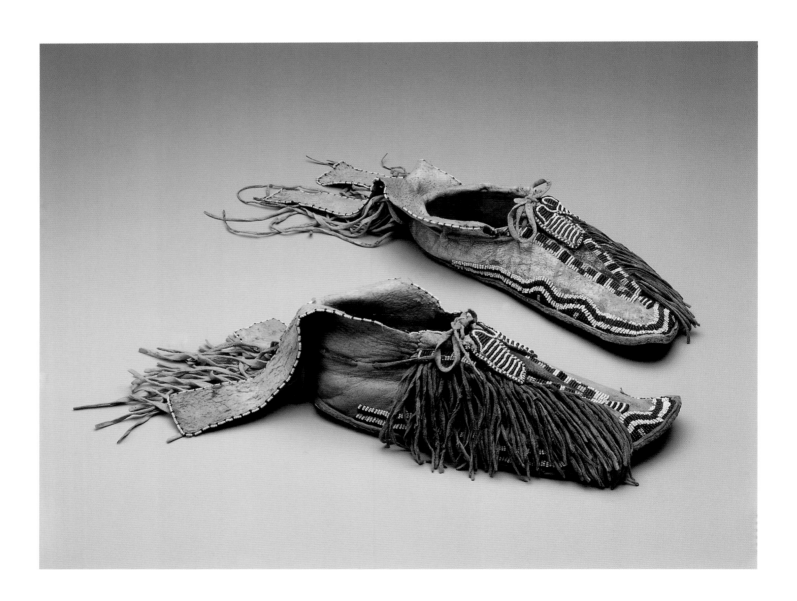

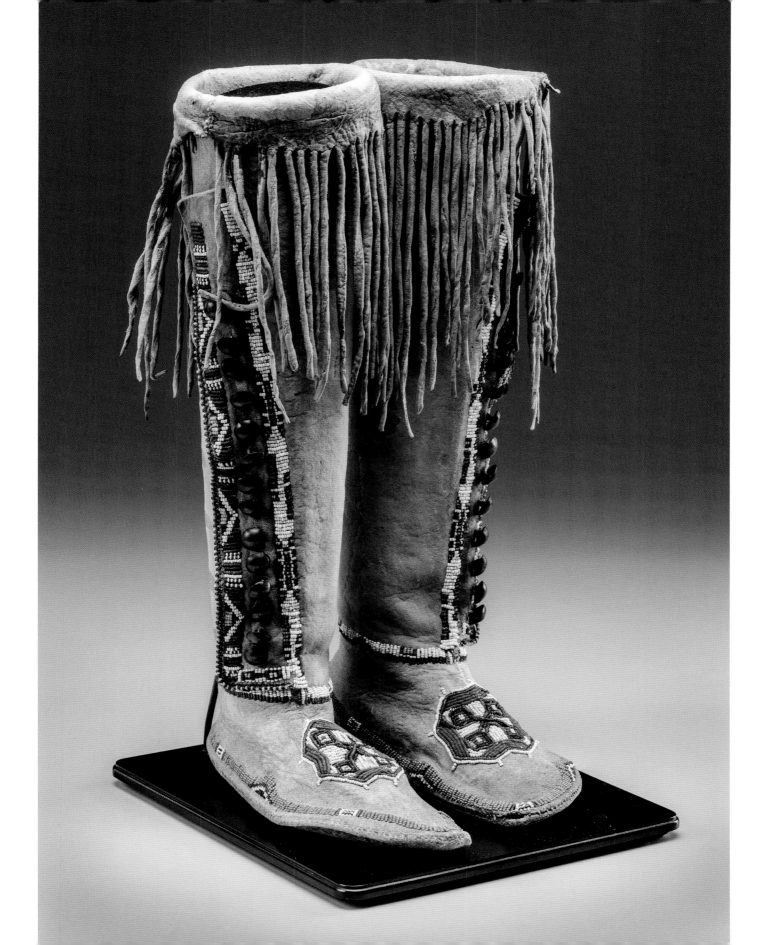

89.
Baby carrier, ca. 1880

Nʉmʉnʉʉ or Ka'igwu (Comanche or Kiowa), Oklahoma
Hide, wool, cotton fabric, wood, glass beads, copper tacks, cotton thread, pigment
40¾ × 10⅞ × 6 in.
(103.5 × 27.6 × 15.2 cm)
Diker no. 499

90.
Baby carrier, ca. 1890

Ute, Utah or Colorado
Hide, wood, glass beads, bone
40½ × 20¾ × 6¹¹⁄₁₆ in.
(102.9 × 52.7 × 17 cm)
Diker no. 417

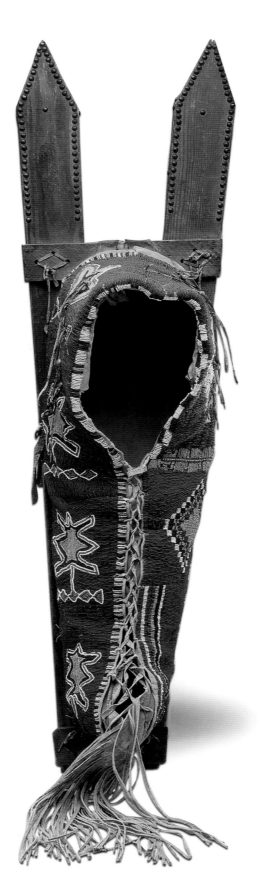

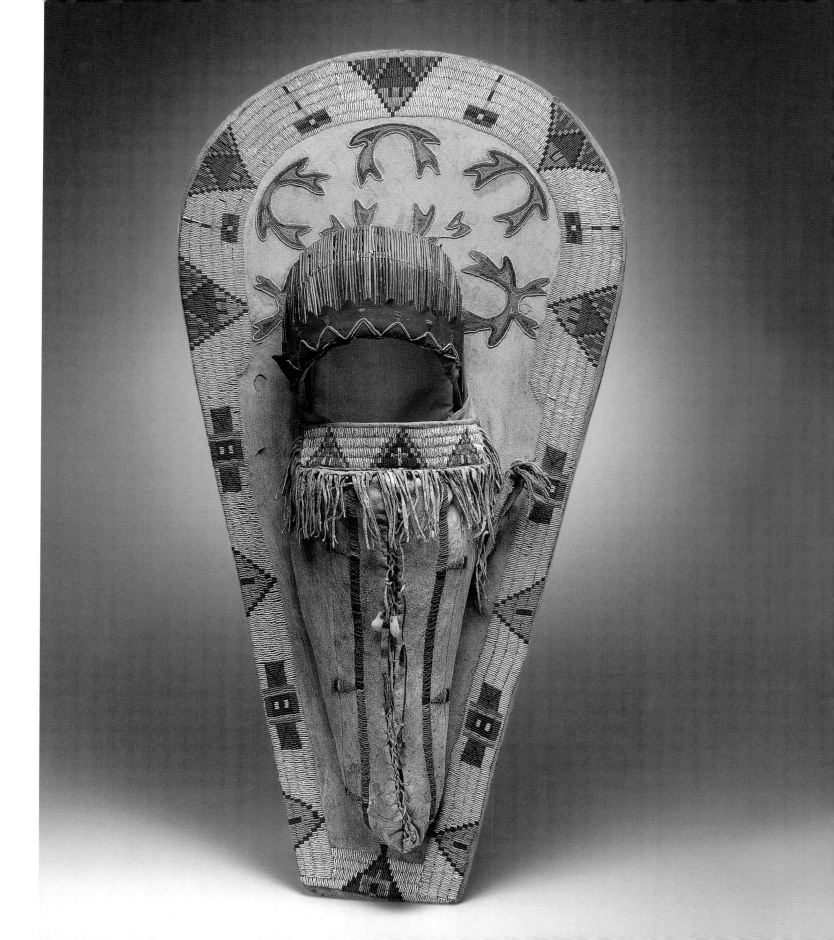

91.

Tobacco bag with pipe stem sleeve, ca. 1870

Tsitsistas/Suthai (Cheyenne),
Wyoming or Montana
Hide, glass beads, wool, tinned iron,
horsehair, sinew
Sleeve: 18⅞ × 1⅜ in. (47.9 × 3.5 cm);
bag: 14⅜ × 5¼ in. (36.5 × 13.3 cm)
Diker no. 272

A pipe and the associated accoutrements are important tools in the spiritual life of a traditional Plains Indian man. Used for prayer, a man's pipe provides a means of connecting to the spirit world. A tobacco bag would hold a pipe, a tamper, tobacco, and other personal items. Since the sacred power of the pipe comes from above, tobacco bags were usually not allowed to touch the ground; in many historic photographs, they are seen mounted on small tripods.

This Tsitsistas/Suhtai tobacco bag is a beautiful example of the elegant aesthetic of the people who created it. It features the classic Tsitsistas/Suhtai triangle design in two rows, facing each other, and twisted fringe, which is a characteristic but less common element of the tribe's artistry. An image of a bird has been beaded near the neck of the bag and this is certainly a reference to the powerful Thunderbird. The positioning of the image makes reference to the importance of the tobacco and other spiritually related contents of the bag. These items and the Thunderbird are holy. The Tsitsistas/Suhtai were known for beading imagery on their works (for another example of animal imagery on a tobacco bag, see cat. 92). Usually the pipe stem is inserted into the tobacco bag, but the creator of this work made a separate sheath to hold the stem, an interesting and unusual feature of this particular bag.

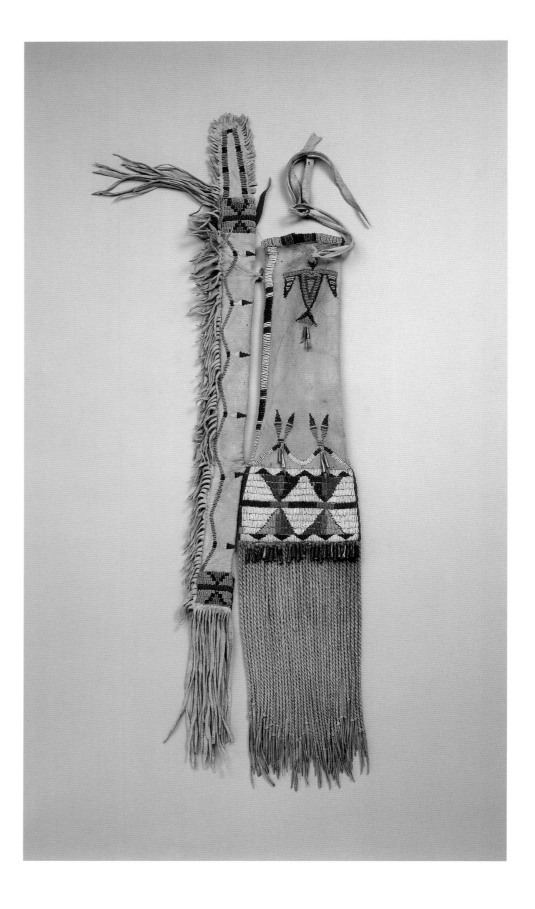

92.
Tobacco bag, ca. 1870

Tsitsistas/Suthai (Cheyenne),
Wyoming or Colorado
Hide, cotton, glass beads, horsehair,
tinned iron, sinew
16⅞ × 6¼ in. (42.9 × 15.9 cm)
Diker no. 251

93.
Tobacco bag, ca. 1880

Ute, Utah or Colorado
Hide, glass beads
31 × 5½ in. (42.9 × 15.9 cm)
Diker no. 853

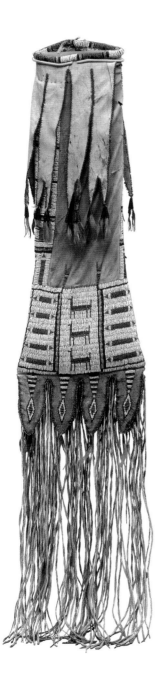

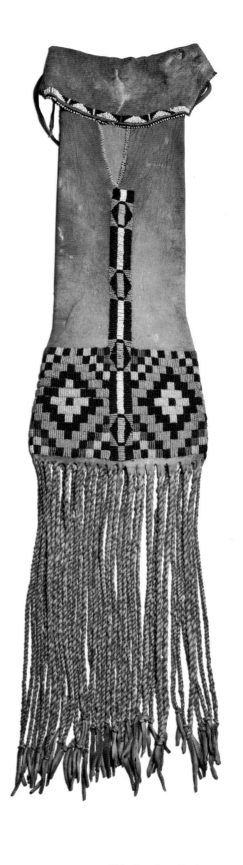

94.
Bag, ca. 1860

Wasco, Washington State
Cotton fabric, cotton thread, glass
beads, hide, copper alloy buttons
17 × 7 in. (43.7 × 17.8 cm)
Diker no. 570

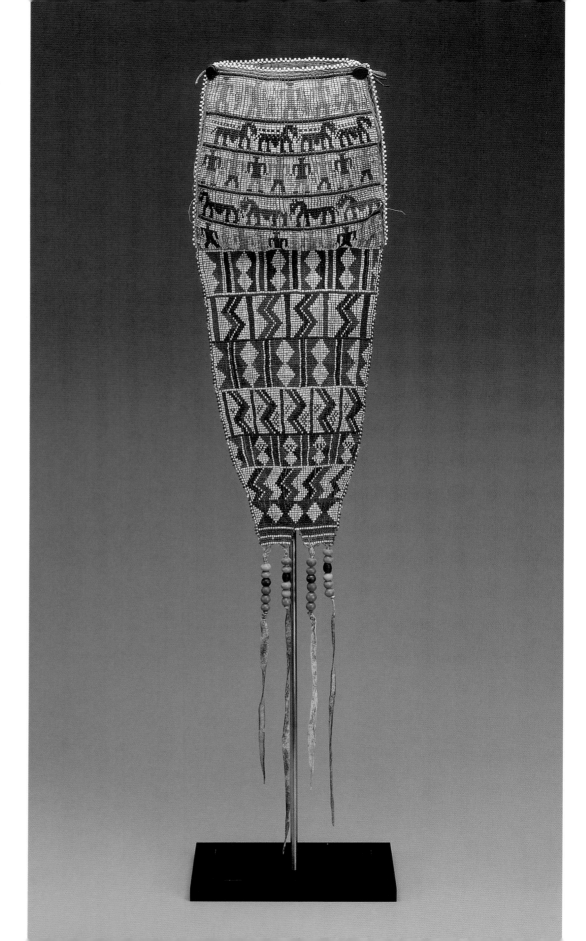

95.
Parfleche case, ca. 1850

Nʉmʉnʉʉ (Comanche), Texas
or Oklahoma
Buffalo hide, pigment
33 × 11½ in. (83.8 × 29.2 cm)
(with fringe)
Diker no. 842

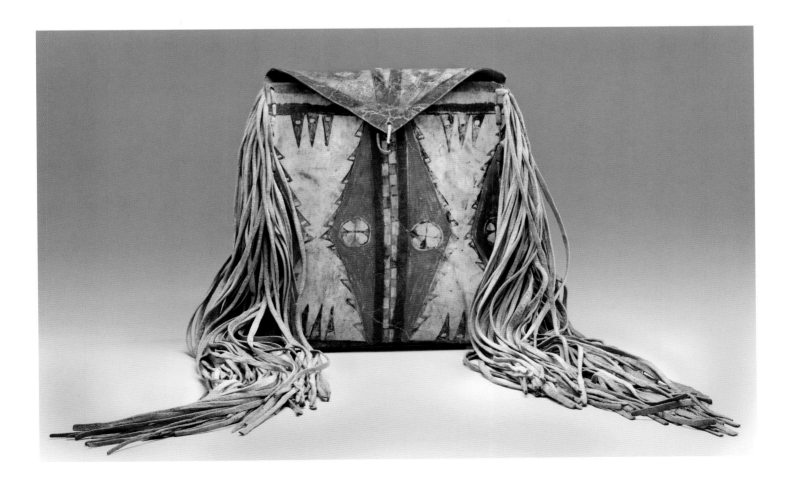

96.

Pair of parfleche cases, ca. 1870

Niitsitapi (Blackfeet), Montana
Rawhide, pigment
15 × 9 ⅞ × 1 ½ in. (38.1 × 24.8 × 3.8 cm)
and 14 ¾ × 9 ½ × 1 ½ in. (37.5 × 24.1 ×
3.8 cm)
Diker no. 269

These rawhide containers come from the Piegan Niitsitapi (Blackfeet), one of the most powerful tribal groups on the northern Plains during the

nineteenth century. Their home reservation is located in the foothills of Glacier National Park in northwest Montana. Their prowess in battle cannot be exaggerated: they dominated many tribes on the northern Plains, and nearly killed Meriwether Lewis of Lewis and Clark fame. They continued to produce traditional arts into the twentieth century, mostly due to the demand of East Coast tourists visiting Glacier National Park.

These envelope-shaped bags were created by all tribes on the Plains. They are commonly known as parfleches, a French term that translates roughly as "defend arrow," probably referring to the toughness of Native-produced rawhide, which was also used for shields. The containers were always made in pairs, most likely because they hung on both sides of a horse, and were used to store household items, clothing, and other miscellaneous objects.

Like all such bags, the main design in this Piegan pair is repeated on both sections of each object. The customary composition on such rawhide containers is abstract; this style of Piegan parfleche has both curvilinear and geometric patterning. The center black outline creates a visual balance between the painted and unpainted areas.

97.

Pair of storage bags, ca. 1880

Lakota, North Dakota or South Dakota
Hide, cotton, glass beads, cotton thread,
tin tinklers, horsehair
11 ¾ × 18 ½ × 1 ½ in. (29.8 × 47 × 3.8 cm) each
Diker no. 270

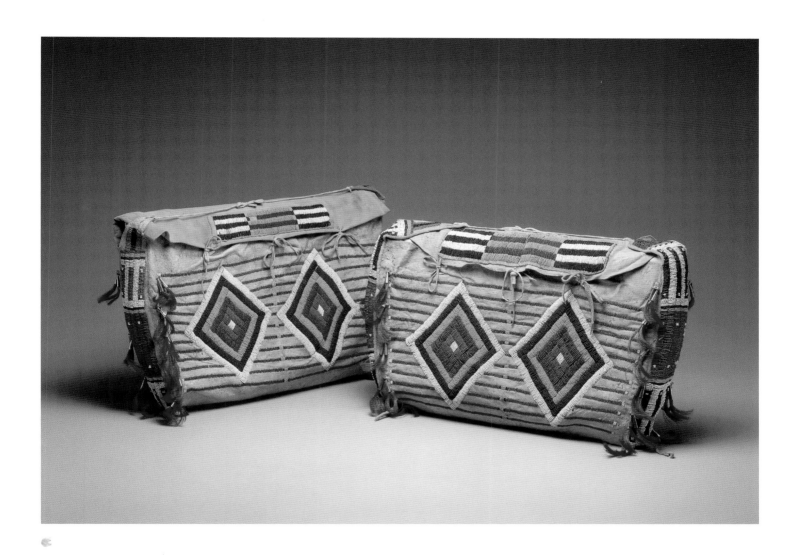

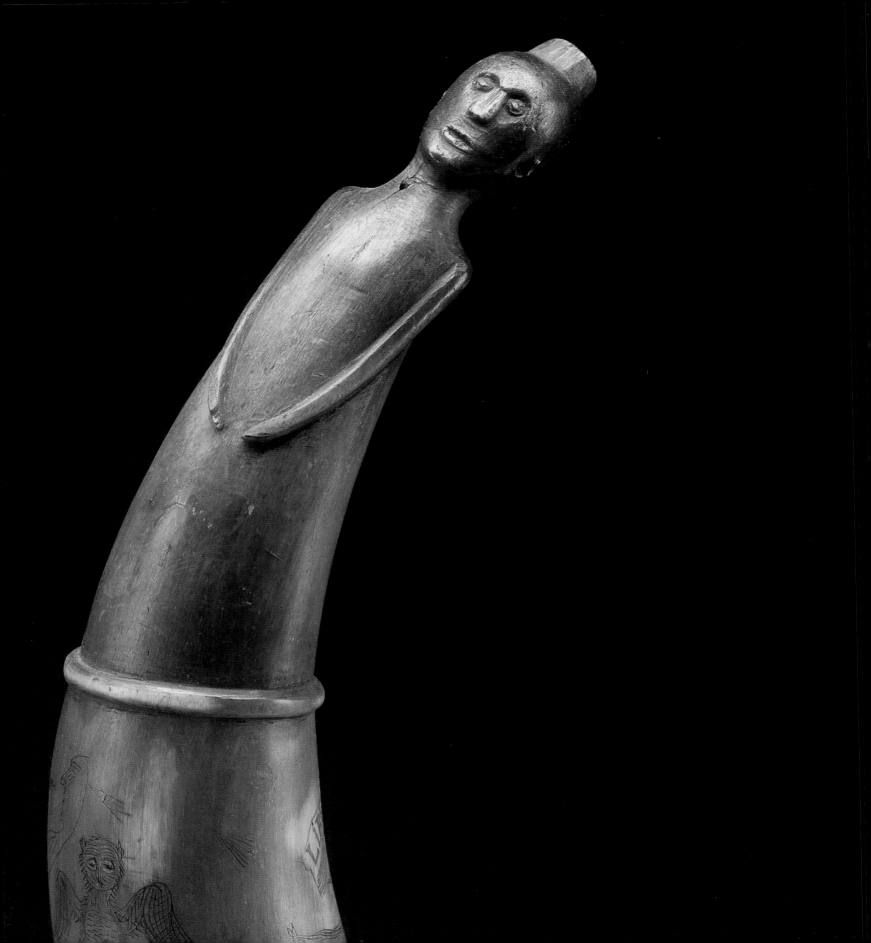

Sculptural Objects from the Eastern Woodlands

David W. Penney

Historian Michael Witgen characterizes the vast interior of eastern and central North America during the seventeenth and eighteenth centuries as the "Native New World."[1] While the European colonies that hugged the eastern coast remained very much a part of an Old World, oriented east across the Atlantic to Europe, the interior remained dominated by indigenous peoples up through the 1800s. The political, social, and cultural engagement between Native Nations and the European colonies of the Atlantic economy created this Native New World of trade, alliances, conflict, and diplomatic relations, perhaps the most transformational aspects of which lay within the realm of material culture.

Relations between Native Nations and the Atlantic world depended on the exchange of things — for the most part the pelts and skins of animals for products of European manufacture, but many other items as well. Those European participants who operated within the Atlantic economies saw these exchanges primarily as commercial transactions, otherwise known as the "fur trade." Within Native worlds, however, the exchange of objects and materials helped to manage social relationships. The Old World pursuit of economic transactions created for the Native New World obligations of kinship. Trade relations between Native Nations and the European Atlantic economies created vast networks of relations extending into the Native interior of North America far from the European colonies. The circulation of the wondrous new objects and materials from Europe fueled and sustained these networks. Copper kettles, steel blades, firearms, cloth, glass beads, silver: these goods and others transformed relations of power, spawned alliances or conflicts, and prompted shifts in the locations and seasonal movements of Native communities.

The small group of objects on the following pages were carved of wood and antler and came from the Native New World of the seventeenth and eighteenth centuries. All of them reflect in some way the material and social transformations that characterized life in that place and time. Steel blades for axes, knives, and carving implements improved many aspects of Native life, including warfare, hunting, and the fabrication of essential items. Signs of change are visible in the form and decoration of various fabricated objects. An important tool for creating these new forms was the "crooked knife" — simply put, a

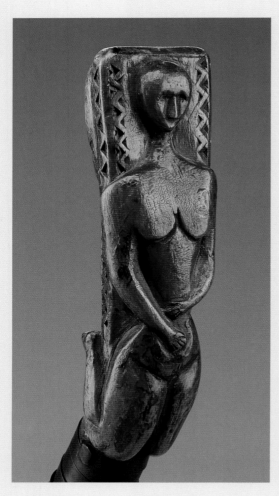

Fig. 37. Crooked knife (Mocotaugan),
ca. 1840 (cat. 103)

steel blade hafted to a handle for the purposes of carving. Named for its customary curved blade, the crooked knife was developed from a farrier's knife and improved upon the hafted beaver incisors that had served the same purpose as carving tools in the old Native world for more than four thousand years (in New York State, such tools have been recovered from archaeological contexts dating to the second millennia BCE).[2] The nude figure on the handle of an Anishinaabe crooked knife (fig. 37, cat. 103), as well as the human head carved at the end of the powder horn made of cow horn (cat. 104) and the intricate, shallow relief carved on the surfaces of the so-called "belt cup" (cat. 101), would have been impossible to create without the use of steel carving tools. A seventeenth-century Haudenosaunee comb (cat. 98) illustrates the point. The Haudenasaunee (also known as the Iroquois) and their ancestors had been making this kind of hair ornament from sections of elk or moose antler for more than fifteen hundred years.[3] Before the availability of steel tools, the carved tines of a comb were broader and fewer in number, often only four or five. The Diker comb has fourteen tines, all thin and square cut, while the crest is much thinner than its chunky counterparts of the past. The crest of the object, always adorned with symbolic carved imagery, is here cut with an elaborate framed tableau containing a pair of European figures wearing waistcoats and tricorn hats.[4]

Many of these kinds of objects were used in ceremonial and social transactions: some were gifts or presentation pieces that helped to build or reinforce social relations, while others functioned as weapons. The most significant objects for exchange and the best illustration of the point were wampum belts, or woven strips of valuable shell beads. Produced and presented to accompany oratory, they served as mnemonic records of memorized speeches and agreements. Smoking pipes with stems also played an important role during ceremonies of council and peacemaking, and many were presented to participants as gifts to memorialize such events. On the other end of the spectrum, it was customary for the victors in a battle to leave a war club at the site to communicate their identity to the enemy. Such weapons occasionally made their way into the hands of non-Native collectors; objects such as smoking pipes, carved bowls and spoons, and clubs were even more likely to enter into the feeder stream of collections. Although these objects were originally created as tangible tokens of social relations, acquisitive outsiders often sought them out as souvenirs of their relatively brief encounters in the Native New World. Soldiers, traders, and officials purchased such objects for households back home, where they often became family heirlooms. Native artisans eventually rose to the occasion by creating objects specifically for this new kind of social transaction—one with cash, not social obligation, as its reward. Each one of the objects in the entries that follow embodies some encounter and resulting transaction—and the moment that marked the beginning of the journey that brought it into this exhibition.

98.
Comb, ca. 1680

Susquehannock or Seneca,
Pennsylvania or New York State
Moose antler
4⅞ × 2½ × ¼ in. (12.4 × 6.4 × .64 cm)
Diker no. 742

The late seventeenth century saw many changes in Iroquoia, the expansive world of the Haudenosaunee Confederacy and its allies and dependents. Wealth and power flowed from newly established relations with the colonial powers established on the North American coast, the source for metal tools, cloth, and other trade goods. This intricately carved comb made from a flat section of moose antler reflects some of these transformations.

Antler hair ornaments had always been common in the Haudenosaunee world, but they proliferated after 1650 or so, especially among the Seneca, the westernmost member of the Haudenosaunee Confederacy. Other similar combs have been recovered archaeologically at Susquehannock village sites in the Susquehanna Valley of central Pennsylvania, immediately to the south of Seneca territory. Although not part of the Haudenosaunee Confederacy, the Susquehannock were closely allied. Carved with metal tools, the combs now featured many slender tines, rather than the five or six of earlier periods, and artists carved the crests with elaborate cutout designs featuring animals and human figures. Archaeologist Charles Wray has suggested that the animals, such as the heron, wolf, and bear, represent clans,[1] but clan identity is not sufficient to explain the richness of comb imagery. On some combs, animal forms suggesting supernatural beings like underwater panthers are intertwined with each other or interact with human figures.[2]

The two figures carved into the crest of this comb represent Europeans wearing jackets and tricorn hats. Beginning in the second half of the seventeenth century, many Seneca and other Iroquoian combs were carved with similar subjects: images of European men and women with guns, on horseback, or with dogs. These images, like those of supernatural beings, refer to transformational powers — in this case, the powers of European wealth and technologies. In fact, combs themselves possess this connotation of transformational and creative power in traditional Haudenosaunee culture. In the Haudenosaunee story of the earth's origins, the miraculous birth of Sky Woman, who became the first inhabitant of the terrestrial earth after she fell from the Sky World, resulted from her mother's becoming impregnated after visiting her father and combing his hair.[3]

1. Charles F. Wray, "Ornamental Hair Combs of the Seneca," *Pennsylvania Archaeologist* 33, nos. 1–2 (1963): 36.

2. Ronald F. Williamson and Annie Veilleux, "A Review of Northern Iroquoian Decorated Bone and Antler Artifacts: A Search for Meaning," *Ontario Archaeology* 79/80, pt. 3: 14–16.

3. J. N. B. Hewitt, "Iroquoian Cosmology" in *Bureau of American Ethnology Annual Report* 21, (1904): 143.

99.

Pipe bowl, ca. 1780

Muscogee (Creek) (?), Georgia or Alabama
Wood, brass (?), ferrous nails (?), tin
3 ½ × 6 × 2 in. (8.9 × 15.2 × 5.1 cm)
Diker no. 531

This ambitiously conceived pipe bowl is carved of maple or sycamore with a brass lining for the bowl. The pipe is carved in the form of a crouching male figure: his elbows are pressed against his knees, while his hands are clasped against his breast. His head is lifted upright. A stem would have fit in an aperture at the anus of the figure, and the tobacco mixture would have been placed in the bowl at the top of his head. Abundant tobacco residue in the bowl confirms the object's long use as a functional smoking pipe.

Pipe smoking played a fundamental role in diplomatic ceremonies conducted between Native Nations of the North American interior and the colonial interests of the Atlantic coast during the eighteenth century, and smoking pipes were often exchanged as diplomatic gifts. A tin inset at this figure's chest represents a crescent-shaped ornament known as a "gorget," a gift from a European ally, implying that the figure represents a chief engaged in diplomatic relations. In fact, the pipe itself may have been a diplomatic gift; this is one possible explanation for how it would have made its way to Great Britain where, after two centuries, it appeared at auction in 1995.

This pipe bowl would seem to relate to a small group of other anthropomorphic wooden pipes with knees-to-elbows poses of Iroquois and Wyandot origin. The figures on those pipes, however, sit upright on small platforms, with bowls excavated in their backs: this is the case in the famous pipe presented to Dr. Caleb Benton by the Mohawk leader Joseph Brant, now in the collection of the National Museum of the American Indian (cat. 18/6071), and in a closely related example in the National Museum of Natural History (cat. 10080), reputedly collected in Rhode Island. To find examples of pipe bowls with human figures in this particular pose — semi-prone, knees to elbows, with the stem inserted in the back — one has to look to much earlier Mississippian pipe sculpture such as a stone pipe bowl (fig. 38) excavated from the Bell

Field site in northern Georgia, a late Mississippian site (1400–1700).[1] The prone posture of this figure echoes those of the bundled remains of revered ancestral chiefs cared for in late Mississippian temples, a familiar subject in Mississippian sculpture throughout the Southeast. The pose suggests a Creek or Cherokee attribution for the Diker pipe.

1. This site has been linked to the so-called Coosa Kingdom encountered by Hernando De Soto (Upper Creek) or, during its latest occupation, Cherokee-related Lamar culture. See plate 128, cat. 119, in David Brose, James A. Brown, and David W. Penney, *Ancient Art of the American Woodland Indians* (New York: Harry N. Abrams, 1985), 175, 214.

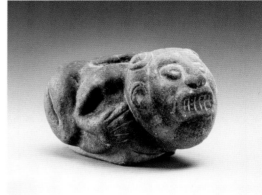

Fig. 38. Crouching human effigy pipe. Little Egypt/Barnett phase, Late Mississippian period, 1400–1600. Bell Field Mound Site (9 Mu 10), Murray County, Georgia. Sandstone, 3 ½ × 5 ⅞ in. (9 × 15 cm). University of Georgia, Department of Anthropology, Athens, Georgia. Photo courtesy The Detroit Institute of Arts

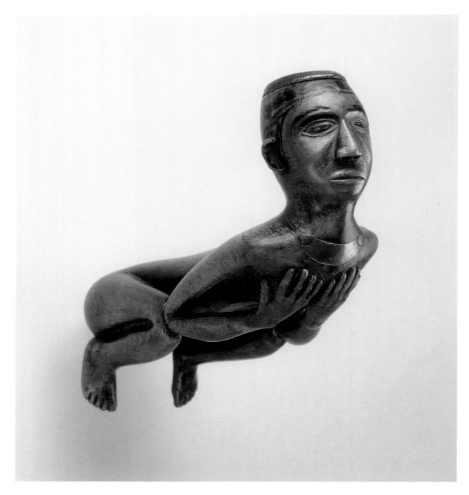

100.
Bowl, ca. 1800

Anishinaabe, Ottawa or Ojibwa,
Ontario, Michigan, or Wisconsin
Maple
6 × 12 ¾ × 4 ½ in. (15.2 × 32.4 × 11.4 cm)
Diker no. 836

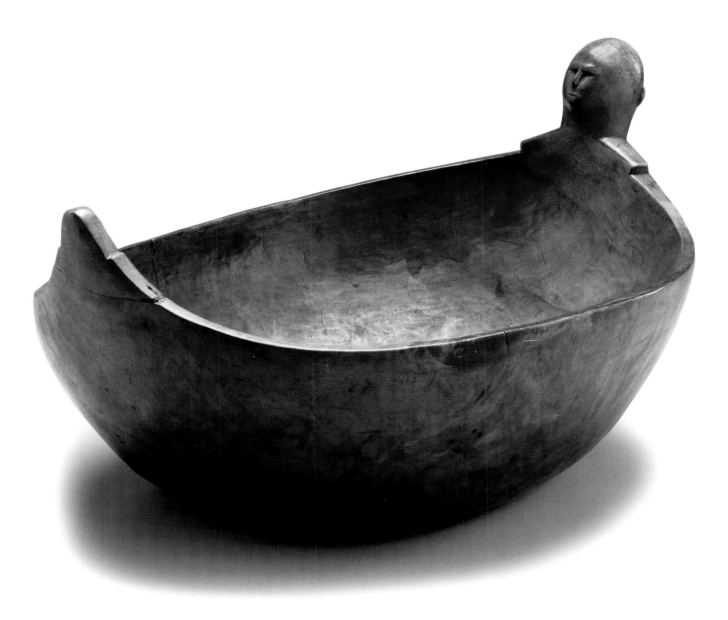

101.
Belt cup, ca. 1820

Anishinaabe, Ottawa or Ojibwa,
Ontario or Michigan
Wood, nail, lead (?), staple
6 5/16 × 3 5/8 × 2 in. (16.7 × 9.2 × 5.1 cm)
Diker no. 515

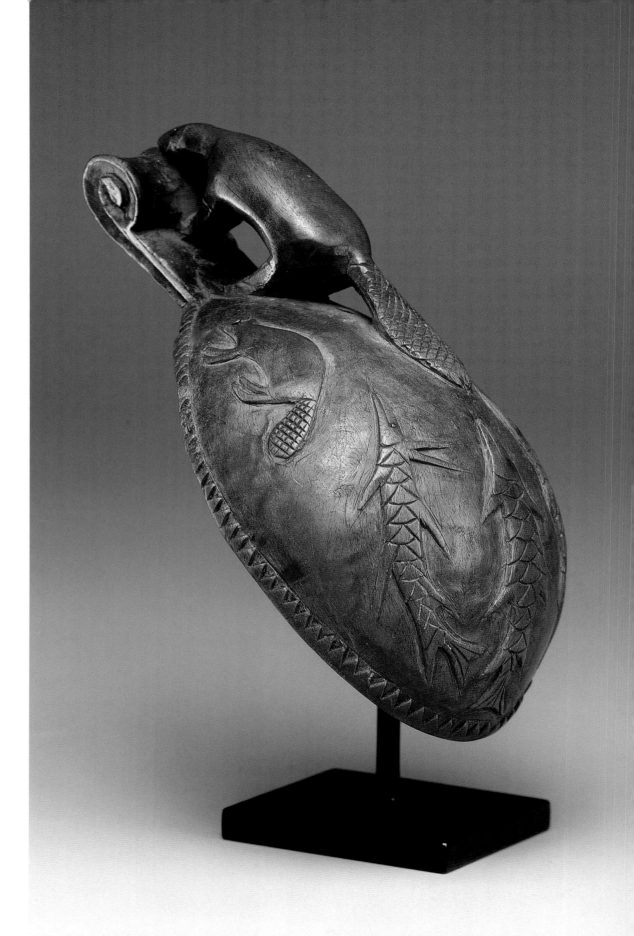

102.
Bowl, ca. 1750

Wendat (Huron), Ohio
Wood
4 ¼ × 6 ¼ in. (11 × 16 cm)
Diker no. 566

This heavily patinated bowl, modest in size, is probably more than a culinary utensil. The carved head on one side evokes the presence of a spiritual being. Spiritual practitioners used bowls like this one for the preparation of medicines, or filled them with water and looked into them to see into the future or over vast distances. Because this bowl came from a Scottish collection, it was very likely collected in British North America during the eighteenth century. Any other insight into its origins or purpose must be gathered by comparing its form and condition to those of other, better documented objects. The function of this object as a "medicine bowl" can be surmised from its size and its sculptural elaboration, which are similar to those of a number of such bowls from the central Great Lakes region carved with images of animals or humanlike heads on their rims.

More particularly, a few features suggest that the bowl was made by an artist of the Wyandot people of the Sandusky River region of northern Ohio, just southeast of present-day Toledo. The Wyandot, also known as the Wendat or Huron, settled in that region during the eighteenth century after fleeing southeastern Ontario during seventeenth-century conflicts with the Haudenosaunee. The head carved on the rim of the bowl, leaning back and seeming to gaze upward, wears a peculiar, cap-like headdress or coiffure that sits on top of the head like a shallow bowl. A closely related carving of a human head appears on a small stone pipe at the Cranbrook Institute of Science (cat. 6245) that was found in Seneca County, Ohio, in the center of the Sandusky country. Furthermore, the way the head is attached to the bowl by a short, solid base and angled back resembles the carvings on a small number of ladles and spoons traditionally attributed to the Wyandot of this era. One of the most significant of these is a belt ladle owned by the Wyandot leader Tarhe, "The Crane" (1742–1818), who lived in the same region. An attribution to the Sandusky Wyandot in the second half of the eighteenth century would also agree with the bowl's Scottish provenance: the British occupied Detroit and the eastern Lakes country in the aftermath of the Seven Years' War (1756–63).

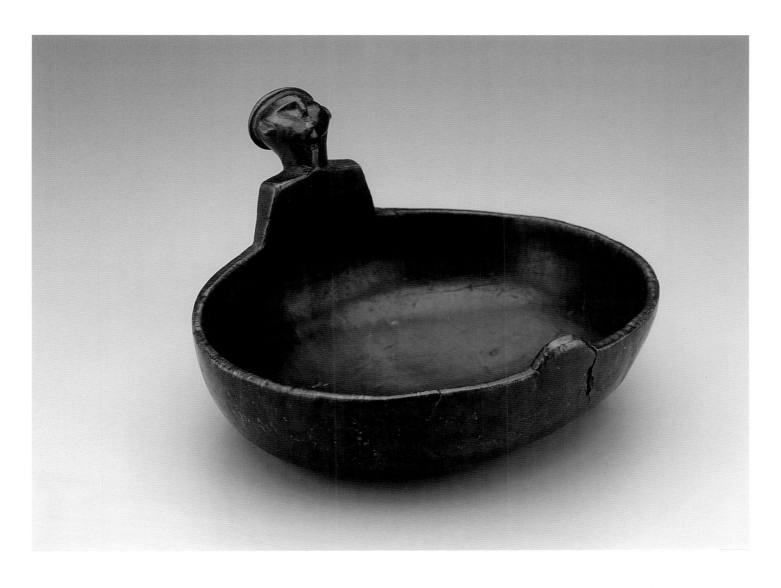

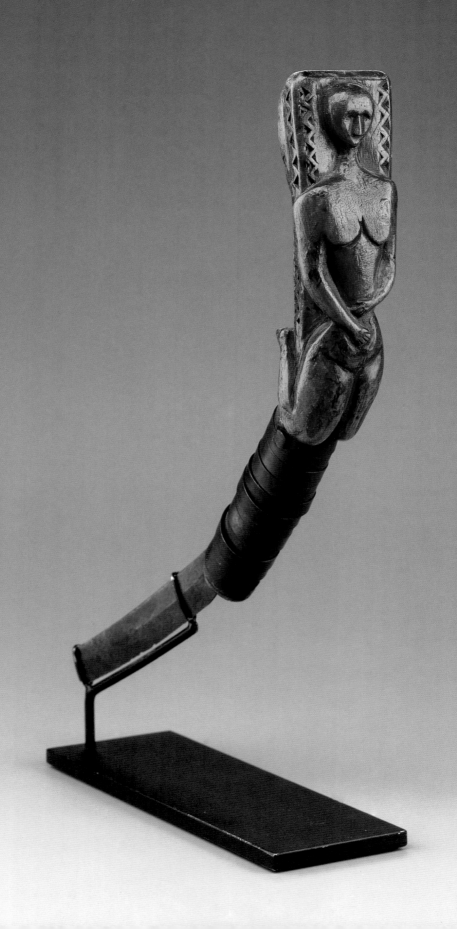

103.
Crooked knife (Mocotaugan), ca. 1840

Anishinaabe, Algonquin, Ontario
Wood, steel, leather
13 × 1⅝ in. (33 × 4.1 cm)
Diker no. 725

104.
Powder horn, ca. 1810

Haudenosaunee (Iroquois),
New York State or Ontario
Cow horn
11¹³⁄₁₆ × 3⅛ in. (30 × 8 cm)
Diker no. 555

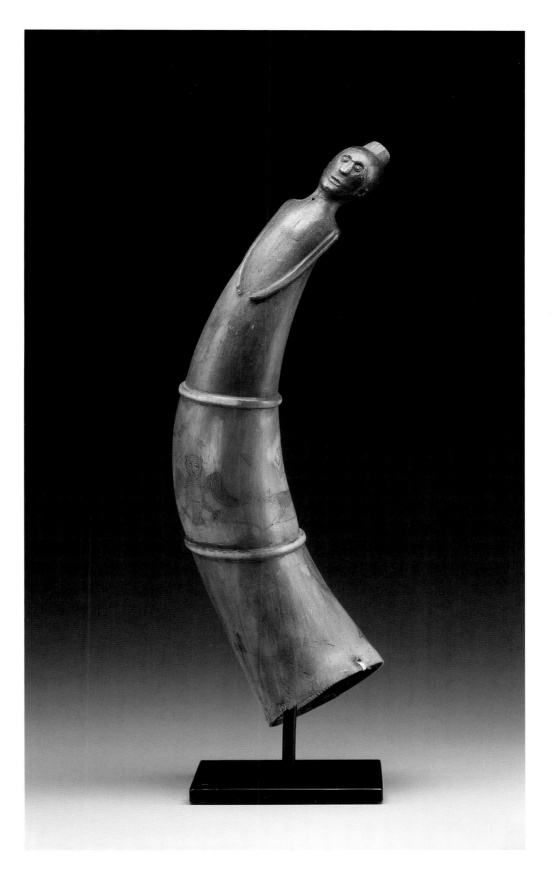

105.
Ball-head club, ca. 1750

Anishinaabe, Ojibwa, Wisconsin or
Minnesota
Wood, pigment
21½ × 3 × 1 in. (54.6 × 7.6 × 2.5 cm)
Diker no. 834

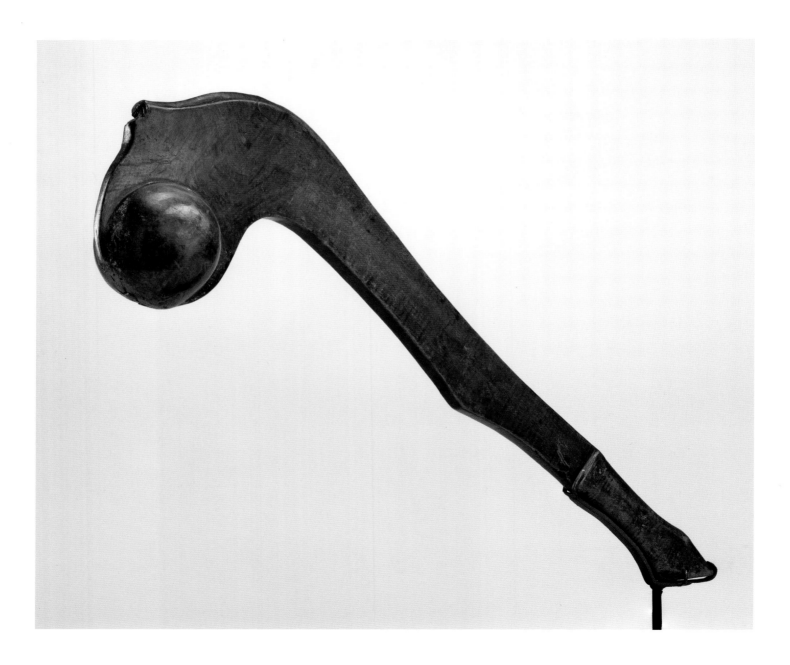

106.
Ball-head club, ca. 1820

Anishinaabe, Ojibwa, Wisconsin or
Minnesota
Wood
4 × 29½ × 5½ in. (10.2 × 74.9 × 14 cm)
Diker no. 851

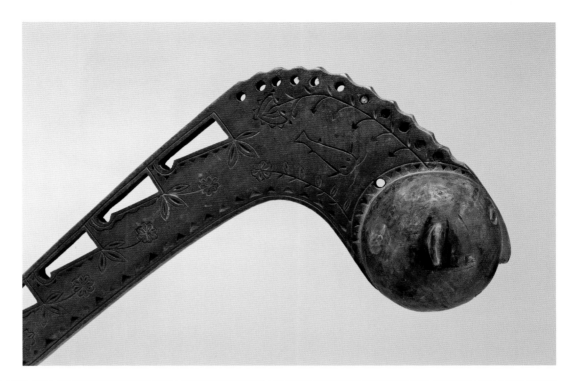

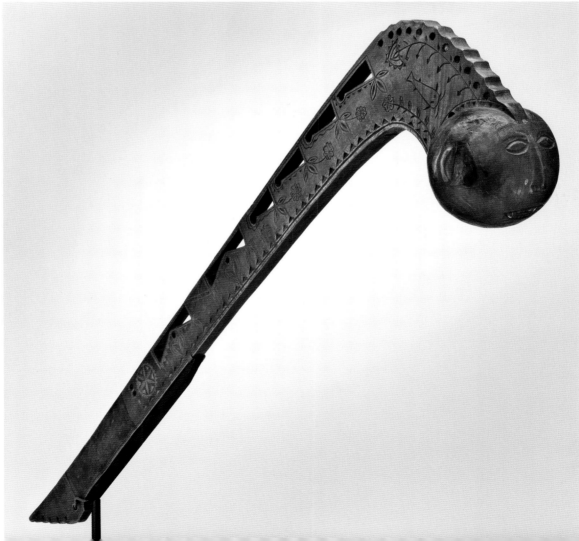

Eastern Regalia and Ornament

David W. Penney

Throughout eastern and central Native North America, the tasks of tanning animal hides, fabricating clothing, and decorating it with a variety of applied materials traditionally fell to women. Clothing conveyed a number of cultural values within the Native world, and its production, distribution by gift or exchange, and display during formal social occasions all helped to reinforce social bonds and mutual obligations linked to leadership, influence, and allegiance. When the colonial outposts of the Atlantic economies in coastal North America forged relations with the Indian interior to support the "fur trade," a system of material exchange, Native women played the central role in creating items to be exchanged, using both Native and non-Native materials acquired through trade to make things of value. Their tanning skills transformed the pelts of animals into the supple deerskins and beaver hides that fed European markets for fine leather and felted beaver fur. Their ingenuity in fabricating clothing converted wool cloth, silk ribbon, glass beads, and other trade materials from Europe into ceremonial regalia and clothing within the communities of the Native world.

The new materials introduced through trade with Europe — milled wool fabric, printed cotton cloth, glass beads, worsted yarns, silk ribbon, silver ornaments, cotton and linen threads, scissors, needles — all contributed to a great expansion in traditional women's work. Women responded with fashion that exhibited innovation, imagination, and technical brilliance generation after generation. In the eighteenth century, white glass beads, silk- or cotton-braid edging, and bent tin cones supplemented porcupine-quill appliqué in the ornamentation of pouches, moccasins, and other dress items fabricated with deerskin. Colorful wool yarns replaced nettle or milkweed fibers in finger-woven sashes and garters. Broadcloths straight from British mills, dyed crimson, dark blue, brown, or green, were cut and sewn into leggings, breechcloths, skirts, robes, and hooded jackets called capotes. Printed cotton cloth contributed not only to these kinds of material transformations of media but also to design innovations. Colorful floral calico patterns entered Native American fashion when tailored into shirts and blouses, worn long and loose. Artists began to incorporate the patterns of printed cotton cloth in their designs for bead and silk appliqué, integrating them into the context of Native-based cosmological iconographies.

New types of objects also resulted from trade between colonists and Native people. The ammunition pouches of the European military

Fig. 39. Ojibwa man, 1918. Photo courtesy Buyenlarge/Getty Images

gave rise to bandoliers, or shoulder bags supported by a strap; these supplemented fire bags, sleeve bags, and belt pouches, which were common, practical accessories among Native people. With its broad strap crossing the chest like a sash and a squared panel at the hip, the shoulder bag provided expansive surfaces for decoration and symbolic design. Similar exchanges of object categories extended in all directions. Large sashes finger-woven with the distinctive *ceinture flèche*, or arrow pattern, became a signature garment and an emblem of ethnic patriotism for the Métis, the descendants of unions between French or British men and Native women. The Métis' quest for a national identity prompted two revolutionary attempts for independence in the nineteenth-century Canadian West.

The volume of manufactured materials brought to Indian country increased exponentially during the American "treaty era" (roughly 1800 to 1860). Overabundant trade credit and huge cash disbursements resulting from coerced land sales resulted in an abundance of cloth, glass beads, silk ribbon, and other materials, which in turn fueled innovations in design and technique for formal clothing. In the early nineteenth century, appliqué decoration for dress clothing became extensive, with silk ribbon work and glass beads stitched to cloth surfaces in elaborate patterns. Through new techniques of heddle weaving and, later, loom weaving, Native women created "woven beadwork": sashes, garters, and decorative panels composed entirely of glass beads strung on an underlying support of cotton or linen thread. Building from a broad synthesis of traditional, floral, and pictorial elements, artists created startlingly original designs (fig. 39).

The trajectory of design innovation that began during the fur trade era shifted out to the prairies of Kansas and Oklahoma during the nineteenth century. Many of the Midwestern nations — the Lenni Lenape (Delaware), the Shawnee, and others — drifted west early in that century to escape entanglement with the new republic. They were followed after the 1820s by the increasing volume of forced emigration resulting from the new nation's removal policies, written into law and funded by Congress in the Indian Removal Act of 1830. These cruel episodes of community rupture prompted broad shifts in cultural relations and allegiances among the displaced Native Nations, as some sought accommodation with the new American system and others worked to protect traditional culture and religion. While "citizen's dress" became an outward strategy of accommodation, decorated "traditional" dress reinforced commitments to maintaining and strengthening tribal cultural values. Revived and renewed ceremonial and social dancing, along with new religious movements stemming from visionary prophecies (such as Keokuk's religion among the Kickapoo, the Osage Faw Faw religion, the Midewiwin, the Dream Drum, and others), created contexts for wearing dress clothing and provided opportunities for rearticulating the ideologies behind its iconography and symbolic significance. For all its traditionalist implications during the nineteenth century, the decoration of dress clothing continued to be extremely innovative. Artists expanded on the repertoire of the fur-trade-era past with increasingly exaggerated emphasis on ornament, visual elaboration, and symbolism for formal dress garments and their accessories.

107.
Shoulder bag, ca. 1780

Anishinaabe, Ojibwa, Minnesota,
Wisconsin, or Ontario
Hide, porcupine quills, metal cones,
wool, cotton thread, deer hair
7 ½ × 7 ¼ in. (19.1 × 18.4 cm)
Diker no. 532

108.
Belt pouch, ca. 1800

Anishinaabe, Ojibwa, Michigan or
Ontario
Hide, porcupine quills
15 × 4 in. (38.1 × 10.2 cm)
Diker no. 747

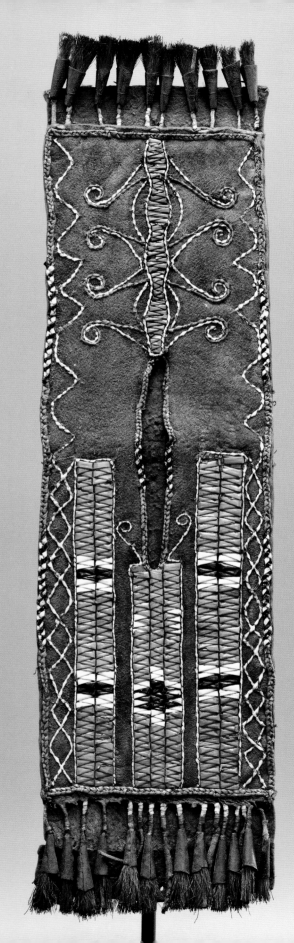

109.
Twined bag, ca. 1800

Anishinaabe, Ojibwa or Ottawa,
Michigan or Ontario
Nettle fiber, wool yarn, hide
8 × 5 ½ in. (20.3 × 14 cm)
Diker no. 672

110.
Fire bag, ca. 1820

Cree or Anishinaabe, Ojibwa,
Western Ontario
Hide, porcupine quills, pigment
10 × 6 ½ in. (25.4 × 16.5 cm)
Diker no. 496

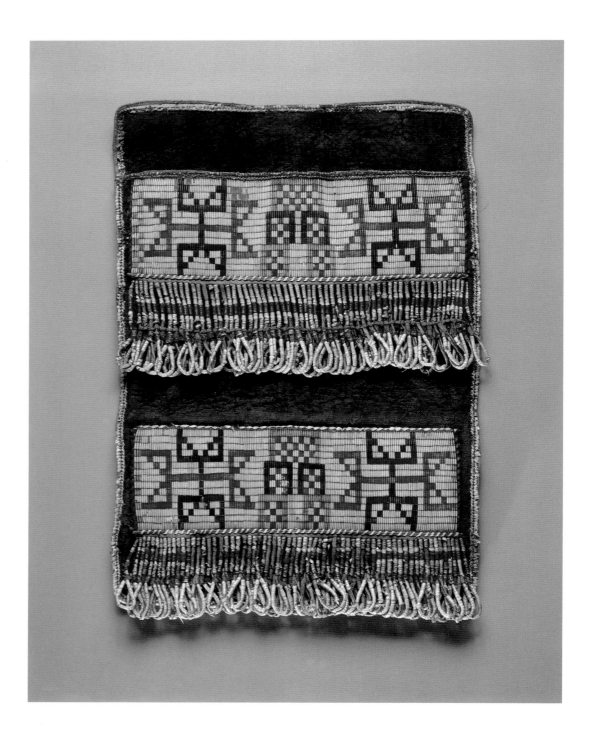

111.
Turtle effigy pouch, ca. 1820

Anishinaabe, Ojibwa, Michigan or
Wisconsin
Hide, porcupine quills, cloth, cotton
thread
10 ½ × 9 ½ in. (26.7 × 24.1 cm)
Diker no. 715

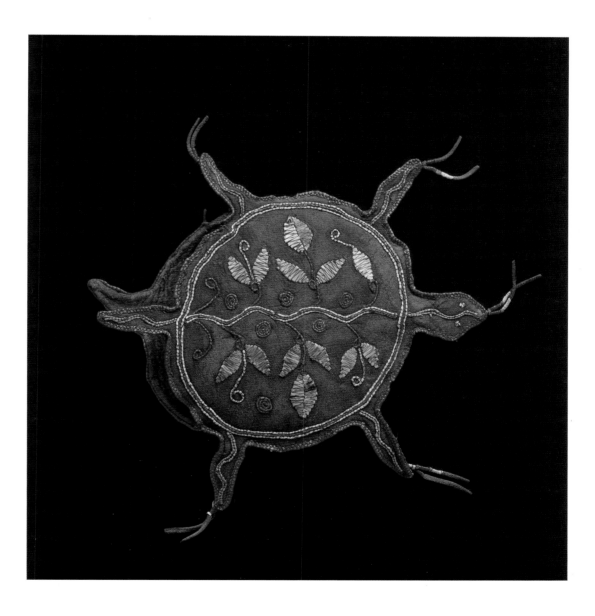

112.

**Shoulder bag (without strap),
ca. 1820**

Anishinaabe, Ojibwa, Ontario
Hide, porcupine quills, tin cones, silk
ribbon, dyed hair
12 × 9 in. (30.5 × 22.9 cm)
Diker no. 586

This pouch from a shoulder bag was
once part of the stage regalia
belonging to the Reverend Peter
Jones (Kahkewaquonaby, or "Sacred
Feathers"), who was photographed
wearing it while in Edinburgh in 1845
(fig. 40). Jones was the son of the
Welsh-American surveyor Augustus
Jones and Tuhbenahneeqauy,
daughter of Wahbanosay, an *ogima*,
or leading man, of the Mississauga
band of Ojibwe who lived at the west
end of Lake Erie, in the vicinity of the
present-day city of Hamilton, Ontario.
Born in 1802, Peter Jones was raised by
his mother until the age of fourteen,
when he went to live on his father's
farm and began to attend a nearby
settlers' school. After experiencing a
camp meeting in 1823, Jones converted
to Methodism and devoted his life to
the Methodist Church. In 1833, he
became the first Canadian Indian to
be ordained a Methodist minister in
British territory that would eventually
become Canada. Jones's tours in
Europe were intended to raise funds
to support Methodist mission work.
During his lectures he wore an
embroidered deerskin coat, sash,
leggings, and moccasins, along with
this shoulder bag, although he
complained in private correspondence
about this "odious Indian costume."[1]

This pouch, which is missing its
strap, is made of finely tanned
deerskin dyed dark brown. The front
of the bag is joined to the back with
stitching around the edges, leaving
an opening near the top with a
portion of the unadorned backing
above. A decorative panel faced with
four lines of quillwork and with its
scalloped lower edge emphasized
with red silk ribbon is sewn to the
front of the bag just below the
opening. This scallop motif suggests
a scalloped flap to close the bag, and
is consistent with a series of similar

bags made in the vicinity of the
Straits of Detroit and southeast
Ontario as early as the 1770s. Images
of a thunderbird, a turtle, and a
human figure, as well as two circles
and an odd linear motif, decorate the
body of the bag. The thunderbird,
some have speculated, may refer to
the Eagle Clan of Wahbanosay,[2] to
which Jones belonged through his
maternal grandfather, who gave
Jones his deceased son's name,
Kahkewaquonaby. This image, along
with the turtle and the human figure,
probably refer to spirit beings.

1. Donald B. Smith, *Sacred Feathers: The
Reverend Peter Jones (Kahkewaquanaby) and
the Mississauga Indians* (Toronto:
University of Toronto Press, 1987), 1–7,
41–44, 57–59, 126, 198–99; and Allan
Sherwin, *Chief Peter E. Jones, 1843–1909:
Bridging Two Peoples* (Waterloo, ON:
Wilfred Laurier University Press, 2012),
4, 168n15.

2. Alan Corbiere and Crystal Migwans,
"Amimkii miinwaa Mishibizhiw: Narrative
Images of the Thunderbird and
Underwater Panther," in *Before and
After the Horizon: Anishinaabe Artists
of the Great Lakes*, eds. David W. Penney
and Gerald McMaster (Washington, DC:
Smithsonian Institution Press, 2013),
45–46.

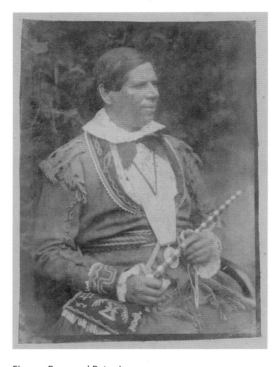

Fig. 40. Reverend Peter Jones,
photographed by David Octavius Hill
and Robert Adamson in Edinburgh,
August 4, 1845

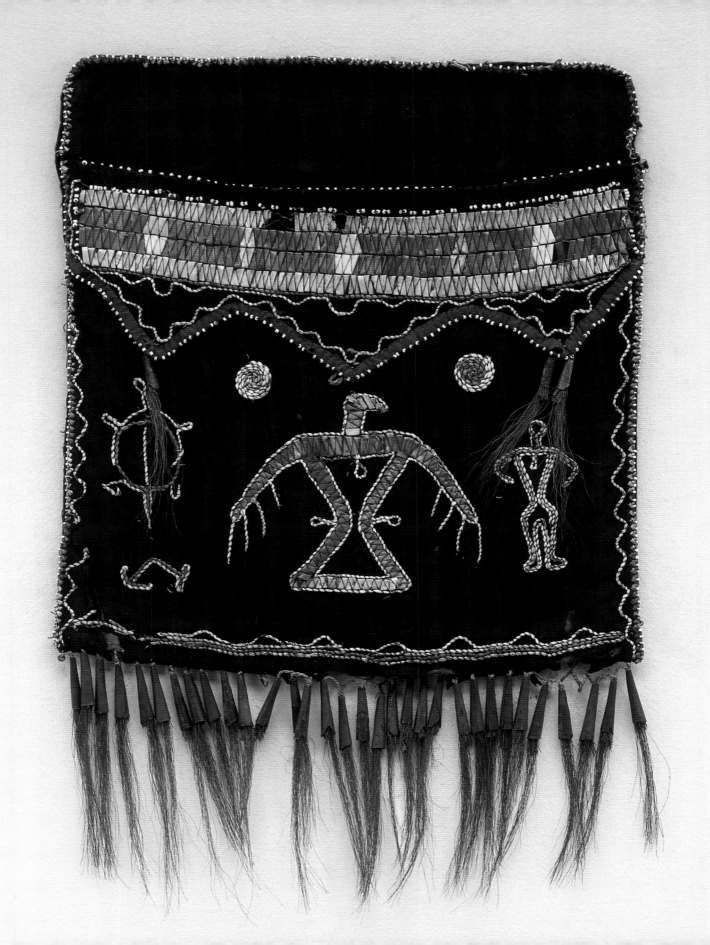

113.
Shoulder bag, ca. 1810

Seminole, Florida
Wool, cotton, glass beads, silk, cotton
thread
Bag: 8 × 8 in. (20.3 × 20.3 cm);
strap: 20 in. (50.8 cm)
Diker no. 576

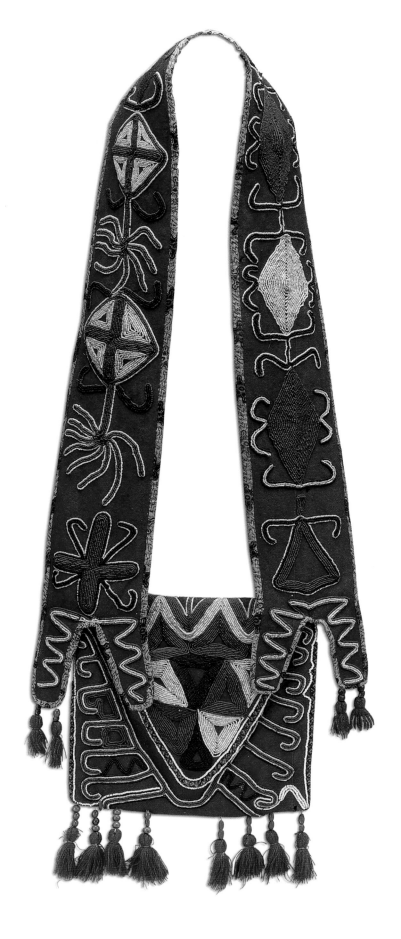

114.
Shoulder bag, ca. 1830

Muscogee (Creek), Georgia or
Alabama
Wool, glass beads, ribbon, silk tassels
Bag: 9 ⅛ × 8 ⅞ in. (23.2 × 22.5 cm);
strap: 55 ⅜ (140.7 cm)
Diker no. 533

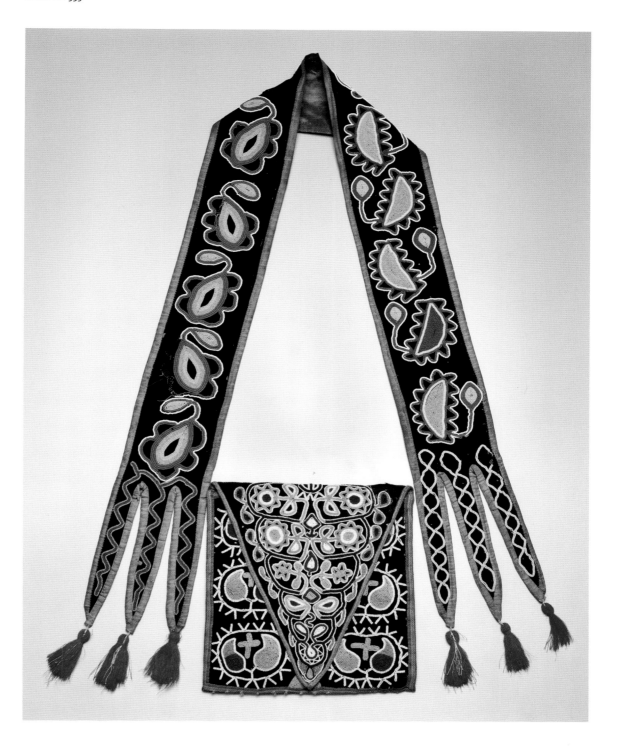

115.
Shoulder bag, ca. 1860

Tahltan, British Columbia
Wool, glass beads
Bag: 13 ⅝ × 7 ⅞ in. (34.5 × 20 cm);
strap: 38 ½ in. (97.7 cm)
Diker no. 169

Although this bag was made by an
artist who lived in northern British
Columbia, the object is based on
eastern North American shoulder
bags and "fire bags" (pouches for
fire-making equipment worn via a
strap around the neck), which were
widely circulated by the fur trade.
Indian workers in the fur trade
traveled extensively across
northwest North America, bringing
with them their traditional objects
and styles of decoration. The beaded
designs repeated on the body of the
bag in two horizontal registers
approximate common traditional
motifs found much farther east,
although here they are executed in a
more free-form style. The four
strap-like pendants hanging from the
bottom of the bag, repeated on the
other side to make eight, are a
common convention for fire bags
from the Northwest; the form is
sometimes referred to as an "octopus
bag." The unique combination of
functional form, motifs, and design
conventions demonstrates the great
mobility of Native people and the
things they made and used during
the mid-nineteenth century, a period
of accelerated cultural change.

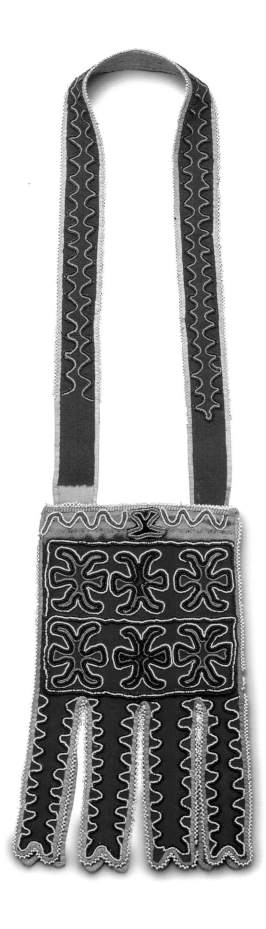

116.
Heddle-woven sash, ca. 1800

Anishinaabe, Ojibwa, Michigan or
Wisconsin
Wool yarn, glass beads
27¼ × 3⅜ in. (69.2 × 8.6 cm)
Diker no. 763

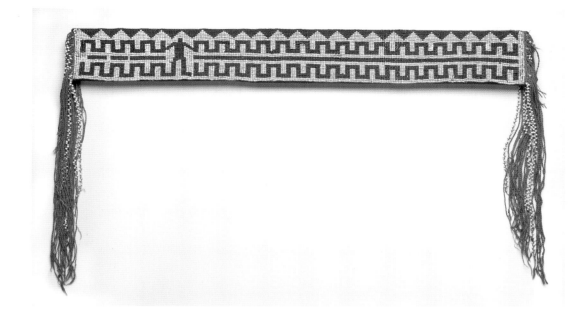

117.
Sash, ca. 1830

Wendat (Huron), Ontario or Quebec
Wool yarn, glass beads
74½ × 10⅜ in. (189.2 × 26.4 cm)
Diker no. 259

118.
Man's summer coat, ca. 1840

Naskapi, Labrador
Hide, pigment
41½ × 69¼ in. (105.4 × 175.9 cm)
Diker no. 490

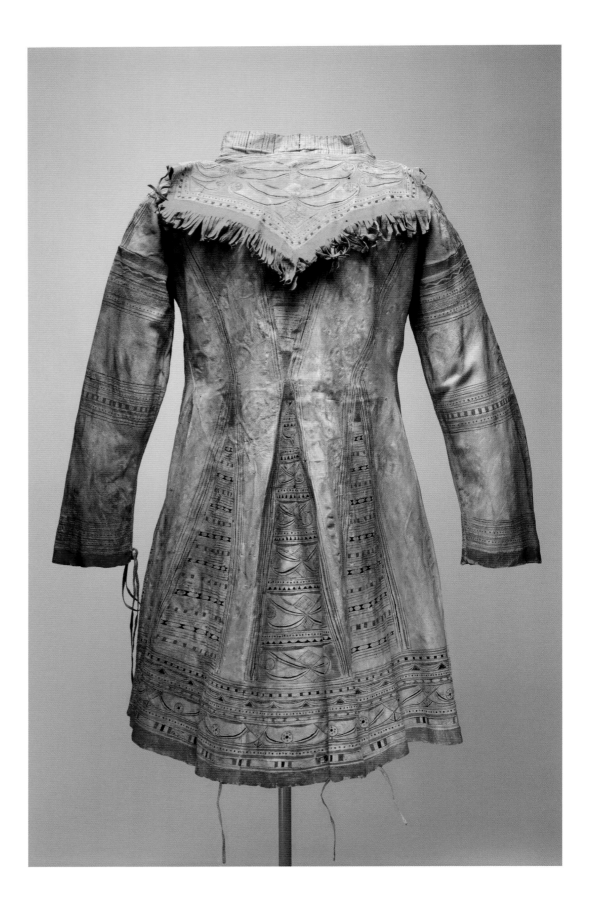

119.

Man's coat, ca. 1840

Lenni Lenape (Delaware), Missouri or
Kansas
Hide, cloth, glass beads
39 × 63 in. (99.1 × 160 cm)
Diker no. 535

The details of this coat's fabrication
are nearly identical to those of a coat
in the collection of the Detroit
Institute of Arts, suggesting that
both were created by the same
individual.[1] Both coats are made
of deerskin, with open fronts,
narrow waists, flaring skirts, cuffed
sleeves, and elaborate three-tiered
short capes over the shoulders.
The abstract floral style and the
color choices for the glass-bead
embroidery are characteristic of
Lenni Lenape artistry. The style

of the beadwork also helps date
the garment to the middle of the
nineteenth century, when the Lenni
Lenape had left western Pennsylvania
and northern Ohio and inhabited, in
close succession, southern Missouri,
Kansas, and Oklahoma.

The distinctive cut of the coat,
however, can be traced to earlier
generations of Lenni Lenape in the
trans-Appalachian West, and to their
entanglement with the emerging
republic of the United States. The
prototype of the pattern is the
Virginian hunting shirt, a garment
that originated among deer hunters
who ranged into Kentucky territory,
where Delaware people may have
first encountered them before the
Revolutionary War. The hunting shirt
was typically a linen garment, open
in the front and closed by a belt or

sash, with short fringed seams and a
short cape on the shoulders. The
hunting shirt was adapted as a
patriotic creole uniform by rebel
troops during the war, and became
the basis for popular frontier garb in
the expanding West of the early
republic.[2]

Responding to the fashion, Native
women of the Midwest made
deerskin coats with a similar cut,
decorating them with styles of
glass-bead embroidery and
silk-ribbon appliqué indigenous to
their own culture. The coats were
sold to both Native and non-Native
buyers. James Otto Lewis painted
an image of the Miami leader
Speckled Loon wearing this type of
coat at the Treaty of Prairie du Chien
in 1825 (fig. 41). Elaborately decorated
coats with large capes continued to

be made in Oklahoma territory after
the arrival of the removed Native
Nations in the 1830s and 1840s, not
only by Lenni Lenape women but
also by Cherokee artists. A closely
related group of Cherokee coats,
one identified and dated to
1850 by embroidered inscription,
features large capes, cuffs, fringe,
and elaborate floral embroidery
executed with silk thread.

1. David W. Penney, *Art of the American
Indian Frontier: The Chandler/Pohrt
Collection* (Seattle: University of
Washington Press, 1992), 88, cat. 23.

2. Neal Thomas Hurst, "'kind of armour,
being particular to America': The American
Hunting Shirt," bachelor's degree thesis,
College of William and Mary, 2013.

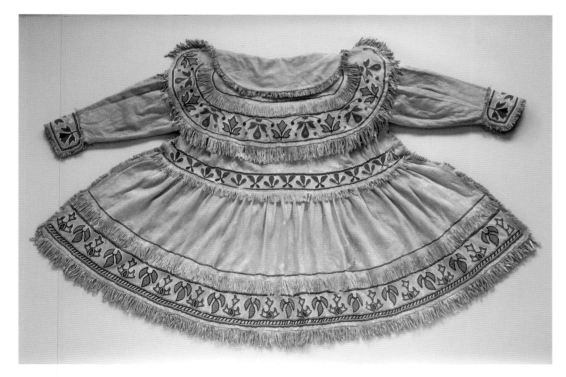

Fig. 41. James Otto Lewis (1799–1858),
*Caa-Taa-Ke Mung-Ga or The Speckle'd
Loon, a Miami Chief,* from *The
Aboriginal Portfolio.* Philadelphia,
1835–36. Hand-colored lithograph on
paper, 18 × 11½ in. (45.7 × 29.2 cm).
Smithsonian American Art Museum,
Gift of H. Lyman Sayen to his nation,
1973.167.26

120.
Moccasins, ca. 1830

Muscogee (Creek), Georgia or
Alabama
Hide, silk, woven cloth, glass beads,
metal beads, cotton thread
3 ⅞ × 9 × 4 in. (9.8 × 22.9 × 10.2 cm)
Diker no. 534

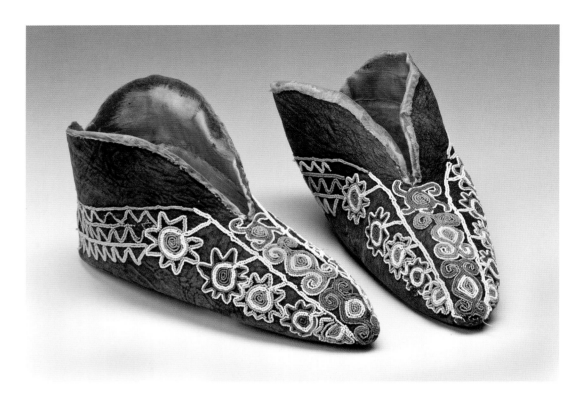

121.
Moccasins, ca. 1850

Cherokee, Oklahoma
Hide, glass beads, silk ribbon
2 ½ × 7 ⅝ × 4 in. (6.4 × 19.4 × 10.2 cm)
Diker no. 424

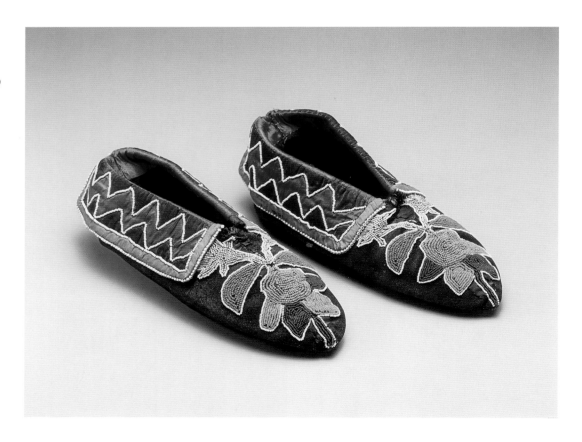

122.

Moccasins, ca. 1890

Otoe-Missouria, Oklahoma
Hide, glass beads, cotton thread
3 ½ × 10 × 4 in. (8.9 × 25.4 × 10.2 cm)
Diker no. 111

This pair of moccasins was made by an Otoe-Missouria woman just after 1890, during a time when the tribe was fighting for its life. Pressure from settlers resulted in enormous loss of traditional lands in Missouri during the 1840s, and an 1854 treaty reduced their tribe's reservation to a ten-by-twenty-five-mile strip on the Big Blue River straddling Kansas and Nebraska. Harassed by settlers and ill-advised by Quaker missionaries, most of the tribe agreed to move to Indian Territory in Oklahoma in 1881. The General Allotment Act of 1887, however, directed government agents to break up the Oklahoma Reservation into individually owned allotments, and to sell the remainder to white settlers.

At this precarious moment, Otoe leader William Faw Faw fell sick and experienced a powerful vision. Like Wovoka, a contemporary Paiute religious visionary who originated the Ghost Dance, Faw Faw saw the traditional world restored through revitalized religious practice. His ceremony and the Faw Faw religion became a rallying point for those resisting allotment and striving to preserve the sovereignty of the Otoe-Missouria Nation. When Faw Faw and other leaders traveled to Washington, DC, to meet with the Commissioner of Indian Affairs, their spokesman testified, "If we hold the land in common . . . we will have a home as long as the world is under heaven."[1]

Followers of Faw Faw created special clothing decorated with symbols of the religion (fig. 42). The birds on these moccasins derive from Faw Faw's vision, in which birds flew around him singing the songs necessary for ceremony.[2] The flowing images connected and outlined by lines of white beads and the abstract flower forms around the heels of the moccasins derive, stylistically, from a pan-tribal style of glass-bead appliqué developed on the Nebraska and Kansas reservations in the 1860s and 1870s sometimes called "Prairie style," or "abstract floral style." Otoe-Missouri artists helped to develop this general design vocabulary while still resident in Kansas and Nebraska. By the time these moccasins were created, in the early 1890s, some of the design elements had taken on new meanings in the context of Faw Faw's religious teachings and ceremonies.

The Otoe-Missouria resistance to allotment was only partially successful. Though the entire Oklahoma Reservation was divided among individual tribal members by 1907, none of the land was opened to white settlement.

1. Marjorie M. Schweitzer, "Otoe and Missouria" in *Handbook of North American Indians: Plains*, ed. Raymond J. DeMallie, vol. 13, pt. 1:447–61 (Washington, DC: Smithsonian Institution Press, 2001), 454–56; and Berlin B. Chapman, "The Otoe and Missouria Reservation," *Chronicles of Oklahoma* 26, no. 2 (1948): 132–58. The quote can be found on page 151.

2. David Wooley and William T. Waters, "Waw-no-she's Dance," *American Indian Art Magazine* 14, no. 1 (Winter 1988): 38.

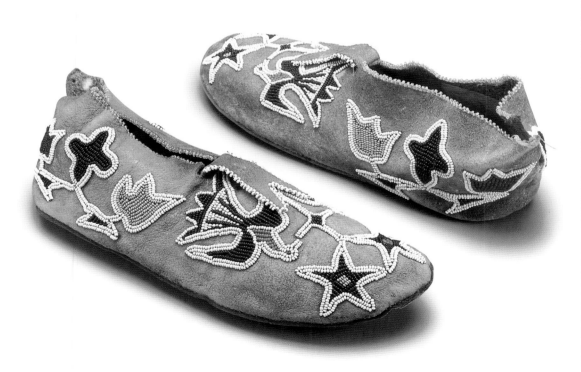

Fig. 42. James Whitewater (Otoe-Missouria), photographed in Washington, DC, in 1898. Whitewater, a leader of the resistance to allotment, wears clothing linked to the Faw Faw religion. Photograph by De Lancey Gill. Photograph courtesy of the National Anthropological Archives, Smithsonian Institution, NAA INV 10017100.

Notes

Introduction

1. Alan Wardwell, ed., *Native Paths: American Indian Art from the Collection of Charles and Valerie Diker* (New York: Metropolitan Museum of Art, 1998); Bruce Bernstein and Gerald McMaster, eds., *First American Art: The Charles and Valerie Diker Collection of American Indian Art* (Washington, DC: National Museum of the American Indian, 2004).

2. Donald Kuspit, "The Spiritual Import of Native American Aesthetics," in *First American Art*, 27.

3. William Rubin, ed., *"Primitivism" in 20th Century Art: Affinity of the Tribal and the Modern* (New York: Museum of Modern Art, 1984), 1:25–28. Rubin addresses the issue of "affinities" explicitly in his introduction to the catalogue.

4. As host curator of *"Primitivism" in 20th Century Art* at the Detroit Institute of Arts, the author of this essay worked closely with William Rubin on the installation of the exhibition, which was on view from February 27 to May 19, 1985.

5. Maruška Svašek, *Anthropology, Art and Cultural Production* (London: Pluto Press, 2007), 11–12.

6. For readers unfamiliar with this incident and its aesthetic reverberations, see Calvin Tompkins, *Duchamp: A Biography* (London: Pimlico, 1996), 181–86.

7. Steven Leuthold, *Indigenous Aesthetics: Native Media, Art, and Identity* (Austin: University of Texas Press, 1998), 14–27.

8. Alfred L. Kroeber, "The Cultural Area and Age Area Concepts of Clark Wissler," in *Methods in Social Science*, ed. Stuart A. Rice (Chicago: University of Chicago Press, 1931), 248–65.

9. Alan Wardwell, *Ancient Eskimo Ivories of the Bering Strait* (New York: American Federation of Arts, 1986), no. 99, and Lin and Emile Deletaille, *Tresors du Nouveau Monde* (Brussels: Musées Royaux d'Art et d'Histoire, 1992), fig. 5.

10. For information about one such community, see Sally McLendon, "Pomo Basket Weavers in the University of Pennsylvania Museum Collections," *Expedition* 40, no. 1 (1998): 34–47.

11. "The 'sun-dance,' the 'scalp-dance,' the 'war-dance,' and all other so-called feasts assimilating thereto, shall be considered 'Indian offenses.'" Department of the Interior, Office of Indian Affairs, *Rules Governing the Court of Indian Offenses* (rules 4th, March 30, 1883, Washington, DC: Government Printing Office).

Ancient Ivories from the Bering Strait Region

1. Froelich G. Rainey, "Eskimo Prehistory: The Okvik Site on the Punuk Islands," in *The American Museum of Natural History Publications in Anthropology*, vol. 37, pt. 4 (New York: American Museum of Natural History, 1941), 465–74.

2. S. A. Arutiunov and William W. Fitzhugh, "Prehistory of Siberia and the Bering Sea," in *Crossroads of Continents: Cultures of Siberia and Alaska*, eds. William W. Fitzhugh and Aron Crowell (Washington, DC: Smithsonian Institution Press, 1988), 124–27.

Yup'ik and Alutiiq Masks from the Alaskan Arctic

1. Ann Fienup-Riordan, "The World Contains No Others, Only Persons: Yup'ik Views of Self and Other," in *Wise Words of the Yup'ik People: We Talk to You because We Love You*, ed. Ann Fienup-Riordan (Lincoln: University of Nebraska Press, 2005), 233, 235. The category of "other-than-human persons" is well-known across Native North America. See, for example, Maureen Matthews, *Namiwan's Drum* (Toronto: University of Toronto Press, 2014).

2. None of these Alaskan Native groups refer to themselves as Inuit, as the related peoples in the Canadian Arctic do. All circumpolar peoples prefer to be named in their own language rather than by the all-purpose term "Eskimo." The term is still used in Alaska, even by Native people themselves, though it is less common now than in the nineteenth and twentieth centuries. Moreover, it has a specific meaning when referring to linguistic taxonomy: the Eskimoan language group includes Yup'ik and Inupiat; it is sometimes referred to as the Eskimo-Aleut group of languages. See Dirmid Collis, ed., *Arctic Languages: An Awakening* (Paris: UNESCO, 1990), 135–37.

3. Dorothy Jean Ray, *Eskimo Masks: Art and Ceremony* (Seattle: University of Washington Press, 1967), 10.

4. Ibid., 49.

5. Ann Fienup-Riordan, "Tumaralria's Drum," *Shaman* 17, nos. 1–2 (Spring/Fall 2009): 11.

6. Although the Arctic explorer Knud Rasmussen (1879–1933) was best known for his work in the Central Canadian Arctic, he briefly visited coastal Alaska, and commissioned drawings. See Birgitte Sonne, "Nunivak Drawings in the Knud Rasmussen Collection," in *Eskimo Drawings*, ed. Suzi Jones (Anchorage: Anchorage Museum of History and Art, 2003), 162.

7. Ann Fienup-Riordan, *Eskimo Essays: Yup'ik Lives and How We See Them* (New Brunswick, NJ: Rutgers University Press, 1990), chapters 4 and 5; and Ann Fienup-Riordan, *The Living Tradition of Yup'ik Masks: Agayuliyararput (Our Way of Making Prayer)* (Seattle: University of Washington Press, 1996), 140–50.

8. Edward W. Nelson, *The Eskimo About Bering Strait* repr. (1899: Washington DC: Smithsonian Institution Press, 1983), 32.

9. For information on the Sullivans, see http://ww2.glenbow.org/search/archivesMainResults.aspx (accessed September 20, 2013) and for a catalogue of the Sullivans's Hooper Bay masks, see Lynn Ager Wallen, *The Face of Dance: Yup'ik Eskimo Masks from Alaska* (Calgary: Glenbow Museum, 1990).

10. Elizabeth Cowling, "The Eskimos, the American Indians, and the Surrealists," *Art History* 1, issue 4 (1978): 488.

11. Edmund Carpenter, "Introduction: Collecting Northwest Coast Art," in Bill Holm and William Reid, *Form and Freedom: A Dialogue on Northwest Coast Indian Art* (Houston: Institute for the Arts, Rice University, 1975), 10.

12. Fienup-Riordan. *The Living Tradition*; *Ciuliamta Akluit/Things of Our Ancestors: Yup'ik Elders Explore the Jacobsen Collection at the Ethnologisches Museum Berlin*, trans. Marie Meade (Seattle: University of Washington Press, 2005); and *Yuungnaqpiallerput/The Way We Genuinely Live: Masterworks of Yup'ik Science and Survival* (Seattle: University of Washington Press, 2007). Also see Aron Crowell, Amy Steffian, and Gordon Pullar, eds., *Looking Both Ways: Heritage and Identity of the Alutiiq People* (Fairbanks: University of Alaska Press, 2001).

Sculpture and Formline Design of the Northwest Coast

1. "Formline" refers to the intricate design made up of flowing lines and curvilinear shapes that are incised and/or painted on sculpture.

2. Bill Holm, Professor Emeritus at the University of Washington, is credited with the codification of the Northern design system and the terminology used to discuss it. See Bill Holm, *Northwest Coast Indian Art: An Analysis of Form* (Seattle and London: University of Washington Press, 1965). The central coast Nations—Heiltsuk, Haisla, Nuxalk, Kwakwaka'wakw, Nuu-chah-nulth, and Makah—took divergent paths in the historic period, creating styles based on prototypical incised positive-negative, two-dimensional design.

3. For an insightful discussion of Northwest Coast style and its development, see Steven C. Brown, *Native Visions: Evolution in Northwest Coast Art from the Eighteenth through the Twentieth Century* (Seattle: Seattle Art Museum / University of Washington Press, 1998).

4. For examples, see Steven C. Brown, ed., *The Spirit Within: Northwest Coast Native Art from the John H. Hauberg Collection* (New York: Rizzoli; Seattle: Seattle Art Museum, 1995), 58–65.

5. According to Harold Jacobs, the Diker ensemble was the possession of the Gaanax.teidí clan (Raven moiety) of the Whale House in Klukwan. For information on the robe mentioned, see Bill Holm, *The Box of Daylight: Northwest Coast Indian Art* (Seattle: Seattle Art Museum / University of Washington Press, 1983), 57.

6. For a discussion of monumental sculpture, see Marjorie Halpin, *Totem Poles: An Illustrated Guide* (Vancouver: University of British Columbia Press; Seattle: University of Washington Press, 1983).

Salish Sculpture of the Southern Northwest Coast

1. The British Columbia Treaty Commission was established in 1992 to advance negotiations between Native Nations and the Canadian government, and especially to redress grievances and claims over land titles and resources as well as aboriginal rights. According to the commission, sixty British Columbia First Nations are participating at this time in the multistage process.

2. Robin K. Wright and Kathryn Bunn-Marcuse, eds., *In the Spirit of the Ancestors: Contemporary Northwest Coast Art at the Burke Museum* (Seattle: University of Washington Press, 2013).

3. Wayne Suttles, "Productivity and Its Constraints," in *Indian Art Traditions of the Northwest Coast*, ed. Roy Carlson (Burnaby, BC: Archaeology Press, Simon Fraser University, 1983), 67–88.

Plains Regalia and Design

1. Barbara Loeb, "An Update of Crow Beadwork: Authors, Beadwork, and Living Crow Artists," Fifth Annual Plains Indian Seminar in Honor of Dr. John C. Ewers (1981) (Cody, WY: Buffalo Bill Historical Center, 1984), 133.

2. See Joseph D. Horse Capture and George P. Horse Capture, *Beauty, Honor and Tradition: The Legacy of Plains Indian Shirts* (Washington, DC: National Museum of the American Indian, Minneapolis Institute of Arts, 2001); and Emil Her Many Horses, ed., *Identity by Design: Tradition, Change, and Celebration in Native Women's Dresses* (Washington, DC: National Museum of the American Indian, 2007).

3. Janet Catherine Berlo, "Creativity and Cosmopolitanism: Women's Enduring Traditions," in *Identity by Design*, 126.

Pictographic Arts of the Plains

1. Castle McLaughlin, ed., *Arts of Diplomacy: Lewis & Clark's Indian Collection* (Seattle: University of Washington Press, 2003); Joseph D. Horse Capture and George P. Horse Capture, *Beauty, Honor, and Tradition*.

2. Jennifer A. Crets, "Little Shield," in *Plains Indian Drawings 1865–1935: Pages from a Visual History*, ed. Janet Catherine Berlo (New York: Harry N. Abrams / American Federation of Arts / Drawing Center, 1996), 86–89.

3. Ted Brasser et al., *Splendid Heritage: Perspectives on American Indian Art* (Salt Lake City: University of Utah Press, 2009), 109 (illustration).

4. Ronald McCoy, "Short Bull: Lakota Visionary, Historian and Artist," *American Indian Art Magazine* 7, no. 3 (Summer 1992): 54–65.

5. Candace S. Greene and Russell Thornton, eds., *The Year the Stars Fell: Lakota Winter Counts at the Smithsonian* (Lincoln: University of Nebraska Press, 2007); Candace S. Greene, *One Hundred Summers: A Kiowa Calendar Record* (Lincoln: University of Nebraska Press, 2009).

6. John Gregory Bourke, unpublished diaries, Library of the United States Military Academy (West Point, NY, 1872–96), 1972–73.

7. Berlo, *Plains Indian Drawings 1865–1925*, 80–85.

8. Nancy B. Rosoff and Susan Kennedy Zeller, eds., *Tipi: Heritage of the Great Plains* (Seattle: University of Washington Press / Brooklyn Museum, 2011).

9. Arthur Amiotte, personal communication, 2011.

10. Janet Catherine Berlo and Arthur Amiotte, *Arthur Amiotte: Collages, 1988–2006* (Santa Fe: Wheelwright Museum of the American Indian, 2006).

Sculptural Objects from the Eastern Woodlands

1. William A. Ritchie, *The Archaeology of New York State* (Garden City, NY: Natural History Press, 1965); see plates 18.4–7, and p. 67 for illustrations and a discussion of wood-carving tools made from beaver incisors and dating to the late Archaic period (3000–1500 BCE) in New York State, of the Lamoka Tradition, and also pl. 80.12 and 81.37 for later examples hafted to antler handles.

2. David W. Penney, "The Origins of an Indigenous Ontario Arts Tradition: Ontario Art from the Late Archaic through the Woodland Periods, 1500 BC–AD 600," *Journal of Canadian Studies* 21, no. 4 (Winter 1986/87): 48, fig. 5.

3. Charles F. Wray, *Ornamental Hair Combs of the Seneca* (Rochester: New York State Archaeological Association, 1963).

Suggestions for Further Reading

Bates, Craig, and Martha J. Lee. *Tradition and Innovation: A Basket History of the Indians of the Yosemite–Mono Lake Area*. Yosemite National Park: Yosemite Association, 1990.

Batkin, Jonathan. *Pottery of the Pueblos of New Mexico 1700–1940*. Colorado Springs: Colorado Springs Fine Arts Center, 1987.

Berlo, Janet Catherine, ed. *Plains Indian Drawings 1865–1935: Pages from a Visual History*. New York: Harry N. Abrams / American Federation of Arts / Drawing Center, 1996.

Berlo, Janet Catherine, and Ruth Phillips. *Native North American Art*. Oxford: Oxford University Press, 1998.

Bernstein, Bruce, and Gerald McMaster, eds. *First American Art: The Charles and Valerie Diker Collection of American Indian Art*. Washington, DC: National Museum of the American Indian, 2004.

Brown, Steven C. *Native Visions: Evolution in Northwest Coast Art from the Eighteenth through the Twentieth Century*. Seattle: Seattle Art Museum / University of Washington Press, 1998.

Cahodas, Marvin. *Basket Weavers for the California Curio Trade: Elizabeth and Louise Hickox*. Tucson: University of Arizona Press, 1997.

Calloway, Colin G. *Ledger Narratives: The Plains Indian Drawings of the Lansburgh Collection at Dartmouth College*. Norman: University of Oklahoma Press, 2012.

Dubin, Lois Share. *Grand Procession: Contemporary Artistic Visions of American Indians, The Diker Collection at the Denver Art Museum*. Denver: Denver Art Museum, 2010.

Fienup-Riordan, Ann. *The Living Tradition of Yup'ik Masks: Agayuliyararput (Our Way of Making Prayer)*. Seattle: University of Washington Press, 1996.

Fitzhugh, William, Julie Hollowell, and Aron L. Crowell, eds. *Gifts from the Ancestors: Ancient Ivories of Bering Strait*. New Haven: Yale University Press, 2009.

Frank, Larry, and Francis H. Harlow. *Historic Pottery of the Pueblo Indians 1600–1880*. Atglen, Pennsylvania: Shiffer Publishing, 1990.

Her Many Horses, Emil, ed. *Identity by Design: Tradition, Change, and Celebration in Native Women's Dresses*. Washington, DC: National Museum of the American Indian, 2007.

Horse Capture, Joseph D., and George P. Horse Capture. *Beauty, Honor, and Tradition: The Legacy of Plains Indian Shirts*. Washington, DC: National Museum of the American Indian, in association with Minneapolis Institute of Arts, 2001.

Jonaitis, Aldona. *Art of the Northwest Coast*. Seattle: University of Washington Press, 2006.

King, J. C. H., and Christian F. Feest. *Three Centuries of Woodlands Indian Art: A Collection of Essays*. Vienna: ZFK Publishers, 2007.

Maurer, Evan, and Joseph D. Horse Capture. *Visions of the People: A Pictorial History of Plains Life*. Minneapolis: Minneapolis Institute of Arts, 1992.

Peckham, Stewart. *From This Earth: The Ancient Art of Pueblo Pottery*. Santa Fe: Museum of New Mexico Press, 1990.

Penney, David W. *Art of the American Indian Frontier: The Chandler/Pohrt Collection*. Seattle: University of Washington Press, 1992.

——. *North American Indian Art*. London: Thames and Hudson, 2004.

Phillips, Ruth. *Patterns of Power: The Jasper Grant Collection and Great Lakes Indian Art of the Eighteenth Century*. Kleinburg, Ontario: McMichael Canadian Collection, 1984.

Secakuku, Alph. *Following the Sun and Moon: Hopi Kachina Tradition*. Flagstaff, AZ: Northland Press, 1995.

Wardwell, Alan, ed. *Native Paths: American Indian Art from the Collection of Charles and Valerie Diker*. New York: Metropolitan Museum of Art, 1998.

Wright, Robin. *Northern Haida Master Carvers*. Seattle: University of Washington Press, 2001.

Wyckoff, Lydia L. *Designs and Factions: Politics, Religion and Ceramics on the Hopi Third Mesa*. Albuquerque: University of New Mexico Press, 1985.